Clash of Symbols

Stephen Webb

Clash of Symbols

A Ride Through the Riches of Glyphs

 Springer

Stephen Webb
Mercantile House
University of Portsmouth
Portsmouth, UK

ISBN 978-3-319-71349-6 ISBN 978-3-319-71350-2 (eBook)
https://doi.org/10.1007/978-3-319-71350-2

Library of Congress Control Number: 2017961109

Printed on acid-free paper

This Springer imprint is published by Springer Nature
The registered company is Springer International Publishing AG
The registered company address is: Gewerbestrasse 11, 6330 Cham, Switzerland

To my nieces, Emily and Abigail

Acknowledgments

I would like to thank Chris Caron of Springer for his invaluable help and advice in preparing this manuscript for publication.

It has been difficult, given the book's subject matter, to find appropriate fonts. The main body font used is EB Garamond by Georg Duffner; the font used for headings is Source Sans Pro by Paul D. Hunt. Various individual glyphs have been taken from the fonts Symbola (created by George Douras), Quivira (created by Alexander Lange), Junicode (created by Peter S. Baker), Bravura (created by Daniel Spreadbury), and Klingon pIqaD (created by Michael Everson). I would like to thank these talented designers for making their work open source. I created certain other symbols myself, using Theunis de Jong's IndyFont script.

I am grateful to Gary Anderson and Erin McKean for swift responses to requests for permission to use images.

Finally, as always, I would like to thank Heike and Jessica for their patience and support.

Contents

Introduction
Glyph riches and the joy of T$_E$X

Most science students, at one time or another, must have asked themselves or their teachers why we use certain symbols in particular contexts: 'why does c stand for the speed of light?'; 'who chose π to represent the ratio of a circle's diameter to its circumference?'; 'what's the deal with using ♂ for Mars and ♀ for Venus?'. And, since bright students are aware that science doesn't act in a vacuum, they are quite likely to ask similar questions of a more general kind: 'why do we use @ in email addresses?'; 'who designed the ♲ sign for recycling?'; 'what's the reasoning behind having a ⌘ key on my computer keyboard?' I wrote this book for the students who ask those sorts of questions.

My own interest in symbols came about in a tortuous fashion. In the mid- to late-1980s I was working towards a PhD in theoretical physics. My research involved calculating various quantities of interest using toy models based on quantum chromodynamics (don't ask). Eventually the time came for me to write up the results of all my tedious labour, which meant I had to find a way of putting mathematics down on paper. My calculations didn't employ particularly intricate mathematics, but what I lacked in mathematical sophistication I made up for with sheer volume — I had short equations interspersed in the text itself, important equations that warranted their own lines, and long equations which, when displayed, occupied most of a page. To produce my thesis I was tempted to adopt the simplest approach: use a typewriter to type the words and leave gaps in which I could fill in the maths later by hand. (For younger readers, a typewriter is a keyboard-based device with an extremely low-bandwidth internet connection.) The trouble was, my particular mixture of typewriting and handwritten maths resembled more a late-period Jackson Pollock than a scientific thesis. I wanted my thesis to at least *appear* professional. The geeks in the department suggested I try a variant of a computer program called troff. I did try it, but I lacked the technical proficiency to make it work. Even the geeks who were able to manipulate troff didn't much like using it. And then I discovered the joy of T$_E$X.

TEX (it's pronounced 'tech', with a soft 'ch' as in the composer Bach) is the creation of Donald Ervin Knuth, one of the greatest of computer scientists. Knuth, among his many accomplishments, is the author of the seminal multivolume work *The Art of Computer Programming*. In 1976 he prepared a revised edition of one of the early volumes in the series, a book containing a lot of mathematics, but found himself frustrated by various difficulties in the production process. He therefore decided to develop his own typesetting system, one that would let him typeset further volumes efficiently and to a quality that met his (extremely exacting) standards. The result was TEX. The first release of the software came in 1978; a rewritten version was released in 1982.

I was fortunate in that, just before I began to write my thesis, the departmental geeks installed TEX on the central computers (we didn't have personal computers back then). I instantly found the system simple to use — it was much simpler than troff — and, in addition to handling with ease whatever equations I chose to throw at it, TEX typeset my words beautifully. Me and my fellow students pounced on TEX and soon we were using it to produce all sorts of important documents, my favourite being a party invitation whose words we typeset in the shape of a guitar.

After the PhD was completed I discovered, not entirely to my surprise, that those quantum chromodynamical calculations I'd slaved over were of little use either to me or anyone else. What *did* surprise me was that the TEX skills I'd developed in writing my thesis were in demand — and they remain useful to me to this day. I've used TEX to write academic papers and teaching materials; I've helped deploy TEX systems in science publishers; and TEX remains my favoured option when typesetting my books. TEX is a bullet-proof piece of software — I can't remember it ever crashing — while documents written in TEX possess remarkable longevity: I can typeset documents written more than a quarter of a century ago, on computers whose manufacturers long ago went out of business, and get exactly the same output today as I did back then. Another factor helping to make TEX so attractive was that Knuth offered it up for free — even when I was a penniless student I could always afford TEX.

The open nature of TEX, its stability, high quality and low price point (it's always difficult to argue with free) led to the development of a worldwide community of practitioners. And as I began to make more use of TEX myself I learned of people who were using it to typeset not only math-

The longevity and stability of TEX has much to do with the fact that Knuth made the source code freely available for the community to study, analyse, and improve. If you spot a coding error in TEX (or simply an error in one of his books) you can write to Knuth and receive one of his famous reward cheques, as shown above. The cheques are typically for small dollar amounts, but are much prized in the community. There's a programming quotation that goes 'Intelligence: finding an error in a Knuth text. Stupidity: cashing that $2.56 cheque you got.' With so many eyes having scanned its source code for errors, TEX is rock solid. (Credit: Baishampayan Ghose)

heavy texts but also critical editions, chess commentaries, general magazines... all manner of publications. In order to facilitate their work these practitioners often developed TEX packages and, in the same community spirit that fired Knuth, they made their work freely available. It was when I dipped into these packages that I began to discover a world full of unfamiliar, oddly shaped glyphs — or characters or symbols; call them what you will. Those packages sparked an abiding interest in glyphs. (Incidentally, many of the glyphs I pondered over were generated by a computer program called Metafont, which is yet another of Knuth's creations.)

Someone went to the bother of creating TEX commands for the production of symbols such as ſ, Ï, ϙ. But why? What was ℘ used for? What did ٦ mean? What did ҏ stand for? Come to think of it, what was the story behind all those symbols that I *was* familiar with — punctuation marks such as ! or mathematical symbols such as ∞ or astronomical signs such as ♓? Where did *they* come from?

Those questions — and similar ones asked of me by students over the years — led to this book, a collection of stories relating to one hundred

glyphs. (Actually, a couple of them — the barcode and the QR code — aren't strictly glyphs. But we see them so often I felt their inclusion was appropriate.) I've chosen to split the book into five equal parts, with each presenting the stories behind 20 symbols.

Part 1, called *Character sketches*, looks at some of the glyphs we use in writing; part 2, called *Signs of the times*, discusses some glyphs used in politics, religion, and other areas of everyday life. Some of these symbols are common; others are used only rarely. Some are modern inventions; others, which seem contemporary, can be traced back many hundreds of years.

Part 3, called *Signs and wonders*, explores some of the symbols people have developed for use in describing the heavens. These are some of the most visually striking glyphs in the book, and many of them date back to ancient times. Nevertheless their use — at least in professional arenas — is diminishing.

Part 4, called *It's Greek to me*, examines some symbols used in various branches of science. A number of these symbols are employed routinely by professional scientists and are also familiar to the general public; others are no longer applied in a serious fashion by *anyone* — but the reader might still meet them, from time to time, in older works.

The final part of the book, *Meaningless marks on paper*, looks at some of the characters used in mathematics. I hesitated before including these symbols since they might seem off-putting to any lay readers of this book. On the other hand, it was the appearance of symbols such as \aleph, \exists, and ζ that got me interested in glyphs in the first place. And surely the stories behind mathematical symbols deserve to be told just as much as the stories behind punctuation marks, say, or political signs? Besides, one can appreciate the history of the symbols with only a basic knowledge of mathematics.

So: here are the stories behind one hundred glyphs. A century might appear to be a surfeit of characters, but there are countless others I could have chosen to discuss. In recent years the computing industry has developed Unicode — a standard for encoding, representing, and handling text in most of the world's writing systems — and it currently contains more than 135 000 entries. Take a brief stroll through Unicode and you'll meet many characters that will delight the eye and, if you research their history, lead to some fascinating insights.

1
Character sketches

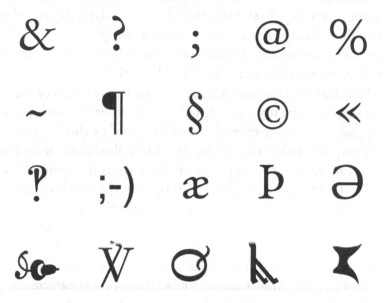

Take a glance around you. If your environment is anything like mine your gaze will take in a plethora of characters. As I sit here in my office I can see letters, punctuations marks, and numerals everywhere I look. Characters cover the numerous papers, magazines, reports, and articles littering my desk; they run down the spines of the books and folders poking out from my overcrowded bookcase; they fill the assorted fliers, maps, and listings I've pinned to a corkboard in the hope one day they'll prove useful. And characters don't appear just on matter made from dead trees, of course: they fill most of my computer screen. If I turn and look out through my office window I catch sight of a variety of characters stencilled on an information board to provide visitors with directions; a different set of characters painted onto the tarmacced courtyard in order to indicate who owns which car parking bay (a source of huge contention in a university setting); and yet another set of characters on traffic signs. If I look down I see characters labelling the keys on my computer keyboard, the keys on a desk phone (it's a newly installed high-tech phone, possessing functions that

frankly baffle me), and the keys on an old-fashioned electronic calculator. Furthermore, and to add to the interest, the characters appear as glyphs in an incredible variety of fonts and styles: the letter A, for example, might appear as A, A, A, or in a thousand other different ways. The *character* A carries meaning, but has no intrinsic appearance; the *glyph* A has no intrinsic meaning, but can possess distinctions in form. Glyph riches add to the lavish mix of characters we all interact with every day.

Letters and punctuations marks, numerals and symbols — they might surround us but we seldom stop to think about their origins.

The characters we use most often are, of course, the letters of the alphabet. The origin of the uppercase letterforms of most Western and European languages lies thousands of years ago; proof of this lies in the fact that we can quite easily recognise the letters inscribed in stone on Roman buildings. Indeed, we still call the set of these letters the Latin or Roman script. (The Latin script derived from a version of the Greek alphabet used by the Etruscans; so the letters we use now date back to glyphs that people scratched on stones and etched on pottery at least 500 years before Christ. The very word 'glyph' is from a Greek word meaning 'carving'.) However, although the letters of the alphabet are the most important characters we encounter, I'm much more interested in all those other characters appearing on the printed page and elsewhere. On my keyboard, for example, I see § and @ and % sharing space with the Latin letters of the alphabet; you won't find *these* characters chiselled into a Roman column. Where did such characters originate? Well, with some them we know the precise date and time of creation; the history of some others remains hazy. In this section of the book I take a look at the stories behind a dozen of the most well known symbols — the three I've just mentioned (§, @, and %) and others such as ¶, ©, and &. I also sketch the background of several characters you are unlikely to encounter, unless you happen to working in a field in which they are used — characters such as Þ, ə, and Ŵ. (In one case I cheat: an emoticon such as ;-) is really three characters treated as one. But I'm in good company in bending the rules this way: in 2015 the prestigious 'word of the year' honour from Oxford Dictionaries went not to a word but to 😂 — the face-with-tears-of-joy emoji.)

There's no pattern, incidentally, to this array of characters I've opted to sketch. A random stroll through the more than 135 000 characters in the Unicode standard provides encounters with a bewildering range of sym-

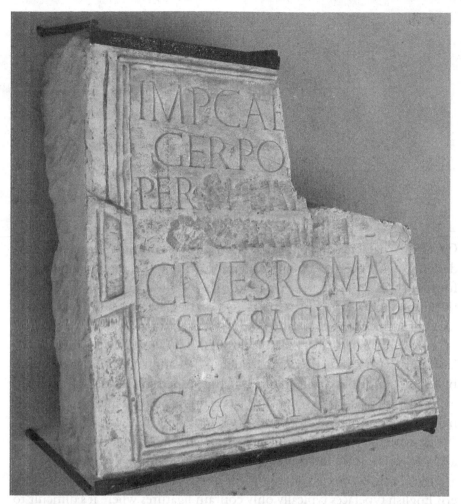

An inscription from the Roman fortress Sexaginta Prista in Ruse, Bulgaria: the uppercase or capital letters are clearly recognisable. The Romans borrowed from even earlier scripts so, with the exception of a few letters added by medieval scribes, the orgin of our letterforms lies in Antiquity. Lowercase letters, on the other hand, have evolved in response to developments in writing technology — as pens and parchment replaced stones and slate, for example. (Credit: Rossen Radev)

bols; in the currency section alone, for example, you'll find ¥, đ, and ₴, to pick three at random — and I'm sure they all have a fascinating backstory. But since I can't write about them all I've had to make a choice. This is my selection of character sketches.

AMPERSAND

&

Of all the characters in common use the ampersand surely presents font designers with the most scope for demonstrating their art. In a sans serif font (such as Source Sans Pro, used for section headings in this book), the ampersand is typically no-nonsense: &. In Garamond, the font you're looking at right now, the ampersand has a traditional vibe with just a hint of flair: &. The particular Garamond version I'm using also contains variants that have a rather baroque touch — & and & — a feature shared by fonts such as Baskerville Italic. But the ampersand is not only a lovely, expressive glyph — it has managed to retain its original meaning, a shorthand for the word 'and', for almost two millennia.

The symbol & was originally a ligature — a joining of two letters into a single glyph. (Old English contained several common ligatures such as æ and œ, which I discuss later in the sections on ash and thorn, but modern English typefaces typically only contain ligatures where it's difficult to kern, or space, particular pairs of adjacent letters. The ligatures tend to involve the letter f: 'fi' rather than 'f i'; 'ff' rather than 'f f'; 'ffi' rather than 'f f i'; and so on. A number of other Latin alphabets use special ligatures, and many non-Latin scripts also employ them.) The & was a ligature of the letters e and t — et — referring to the Latin word 'et' meaning 'and'. Nowadays, in English, we usually pronounce & as 'and', but traces of its origin can be found when people write &c — which is pronounced 'et cetera'. Roman scripts from almost two thousand years ago can be seen to contain the ligature, and even today you can see traces of 'E' and 't' in some representations of the symbol: you can make out the letters in the Garamond variant of the ampersand &, for example. And because the

ampersand dates back to Roman times, its use is widespread; it crops up in many languages that use the Latin alphabet.

The ampersand was, until relatively recently, part of the English alphabet — a letter, just the same as a, b, and c. The influential Benedictine monk Byrhtferth, who lived at Ramsey Abbey in Cambridgeshire around the turn of the first millennium, wrote a textbook called *Enchiridion* or *Manual* and on page 203 of his manuscript he presented an ordering of the English alphabet as he thought it should be: & came after Z, and before Anglo-Saxon additions to the alphabet such as thorn (Þ) and eth (Ð). Even as late as 1857, & was printed in some early-reader books as the 27th letter of the alphabet. And it is the ampersand's status as a letter that gave it the name by which we know it today, a name that first appeared in English in about 1835.

When children recite the English alphabet today, they end it by saying 'ecks, why and zed' (or 'zee' in America). Previous generations would have performed the same recitation, with two differences. First, if a letter could form a word by itself — letters such as A and I, for example — then the children were taught to preface it with the short Latin phrase 'per se', which means 'by itself'. This was useful when learning how to spell, where a word might be repeated after spelling. Second, the alphabet had & (in other words, 'and') as the final letter. So a child would end the alphabet by saying 'why, zed and per se and'. It's not surprising that the mouths of children would slur the words into a single mush: 'ampersand' was the result. There were inevitable variations: a 1905 dictionary of slang records 19 different names for this end-of-alphabet character, including 'Ann Passy Ann' and 'and pussy and', but it was ampersand that won out. (A physicist friend of mine once argued that the name comes from the famous French scientist André-Marie Ampère; it was *Ampère's and*. It wasn't. The & has nothing to do with Ampère.)

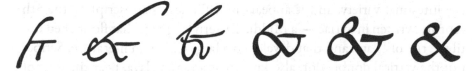

The ampersand throughout history. 1: 131 AD; 2 & 3: mid-4th century (and note the Garamond italic ampersand in the caption here); 4: early 6th century; 5: 7th century; 6: 810. (Credit: Johan Winge)

QUESTION MARK

The earliest writing systems didn't need much in the way of punctuation: the use of marks to clarify the meaning of written material became necessary only when that material reached a certain level of sophistication. Playwrights, for example, would need punctuation marks in order to instruct their actors when to pause between sentences and within a sentence. The same playwrights would also face the problem of conveying *how* a sentence should be spoken. Consider the short sentence *He's here*. Its meaning depends, at least in English and similar languages, upon whether the intonation rises or falls. If the intonation falls, then the sentence is a statement of fact. (The precise intonation, coming from the mouth of a skilful actor, could of course convey much more information than the face value of the words — perhaps, depending upon the context, that 'he' is unwelcome or five minutes late or the target of an assassin.) If the intonation rises, on the other hand, then the sentence becomes a question. That guide to intonation requires a punctuation mark — a question mark.

In 2011, Dr Chip Coakley, a manuscript expert at the University of Cambridge, identified what appears to be the earliest known example of a question mark. The mark resembles a colon, of the double-dotted rather than the intestinal variety, and it appears in a Biblical manuscript of the 5th century written in Syriac — a Middle Eastern language that flourished until the rise of Islam, and that developed a large Christian literature. Scribes put the vertical double-dot, also known as a zagwa elaya, near the start of a sentence in order to indicate that a question followed. (Of course it was unnecessary to add the double-dot if the sentence began with an interrogative such as 'who'.)

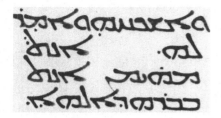

Syriac is an ancient language of the Middle East. This Syriac manuscript contains two dots indicating a question, though it's unclear whether the dots mark grammar or instruct those reading aloud to modulate their voice. (Credit: British Library Board)

The Syriac question mark seems to have had little or no influence on the development of a similar symbol for Latin script, but the need for a standardised system of punctuation in Latin became pressing when copyists started to produce the Bible in large numbers: a monk reading by himself, in silence, would need some guidance on how the text ran together, where to pause or to stop, how to hear the 'music' of the verses. Without such guidance, a monk reading a Biblical chapter for the first time would surely encounter the same sense of disorientation I often feel when reading modern poetry.

According to scholars it was Alcuin of York who introduced a question mark to the western world. Alcuin was born around 735. He was celebrated by Einhard, the servant and biographer of Charlemagne, as 'the most learned man anywhere to be found'. Alcuin rose to become one of the leading intellectuals at the court of Charlemagne, and in his writings he developed something called the 'punctus interrogativus' to signal an inflection at the end of a sentence. The symbol looked something like a tilde over a dot, like so: ⸮ (though in handwritten manuscripts the tilde has much more of a flourish). The punctus interrogativus was used quite liberally at first, but by the 13th century scholars began to standardise punctuation and Alcuin's symbol was chosen to represent purely interrogative statements. At the same time the tilde was tilted upwards — it was recognisably the modern question mark.

Many languages use this curving, hunchbacked symbol to indicate a question. But there are some variations. Spanish, for example, employs opening and closing question marks, with the opening mark being an inverted version of the closing mark (¿Where are you?). This seems to me to be an eminently sensible system: it tells you at the outset that a sentence is a question. Arabic, Persian, and Urdu use a mirror version of the question mark (؟) and some languages go their own way: in Armenian you put the symbol ՞ over the final vowel of an interrogative.

SEMICOLON

;

Some punctuation marks are trouble makers, with the worst offender surely being the apostrophe. An apostrophe that lurks illegally in the vicinity of a terminal letter s — a situation often seen on the chalkboard signs written by purveyors of fruit and veg — has the capacity to drive otherwise placid individuals apoplectic with rage. Personally I've seldom been lured inside a greengrocer's shop in the expectation of seeing a banana in possession of £2 (you don't make that mistake often) so I tend to be quite forgiving of such grammatical lapses. I suppose it's less acceptable in serious writing to misuse the apostrophe; as Kingsley Amis pointed out, there really *is* a difference between the statement

Those things over there are my husband's

and the statement

Those things over there are my husbands.

Even with formal writing, though, I'm happy to cut the author some slack since slips like this can happen easily enough. What really riles *me* is the misuse of the semicolon — and boy is it easy to misuse. Perhaps the main problem with the semicolon is that it's a mixture of two other punctuation marks. As the lexicographer Eric Partridge pointed out: 'by its very form (;) it betrays its dual nature: it is both period and comma'. Another difficulty is that, in principle, an author can always replace a semicolon with another form. Furthermore, some high-profile voices have criticised the mark. Kurt Vonnegut advised against using semicolons on the grounds that 'all they do is show you've been to college'. And Samuel

Beckett has an alter-ego say 'how hideous is the semicolon' (immediately after Beckett himself uses one in the text). So there's a feeling out there that semicolons are stuck-up and somehow ugly. Except they aren't, they really aren't. Semicolons certainly draw attention to themselves when authors abuse them. Some authors employ the semicolon as a fancy way of setting apart two phrases when a dash would work better; others use them interchangeably with colons; a few authors seem to use them whenever the fancy takes them — Herman Melville threw them around like confetti at a wedding. But when used properly, when a semicolon joins two linked ideas together, it works beautifully. Thoreau once wrote that 'if a plant cannot live according to its nature, it dies; and so a man.' Try expressing that sentiment without the semicolon. You can't. Without that mark of punctuation Thoreau's sentence falls flat on its elegant face.

But where does this strange combination of comma and period originate? Well, the Venetian publisher Aldus Pius Manutius is generally credited with a few firsts. The familiar curved appearance of the comma was one of his ideas, as was the use of the slanted type we now call italic (the first italic type itself was cut by Francesco Griffo). Manutius was also the first to use the semicolon in the way we do today: in the 1490s he published copies of various Greek and Roman classic works in which the semicolon appears. The semicolon gradually spread into English from there, with the first appearance being in a chess guide published in 1568. Shakespeare would presumably have grown up without seeing a semicolon, although the typesetters of his First Folio certainly used them.

So the semicolon has a long history. When used correctly it is a beautiful, fluid punctuation mark. Do use them. Do respect them. You could even try joining the Semicolon Appreciation Society.

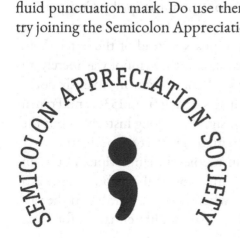

The Semicolon Appreciation Society tells us: 'The semicolon is not used enough; the comma is used too often.' You can find these words of wisdom on T-shirts, coffee mugs, caps, earrings... visit the Society's website for more details. (Credit: Semicolon Appreciation Society/ Erin McKean)

AT

The symbol @ is one of the most widely used in the modern world. If you use the internet you can hardly avoid it seeing it. For such a common symbol it's surprising that many languages lack an official name for it. Spanish and Portuguese possess a formal term: the symbol is called *arroba*, which is the same word that's used for a pre-metric unit of mass or volume. (The word ultimately has its origin in an Arabic term relating to the load that a donkey could carry.) In French it's called the *arobase*, presumably from the same root. But several other languages give it a playfully descriptive name. The Dutch for example call it *apenstaartje*, which translates roughly as 'little monkey-tail'. The Hungarians call it *kukac* ('maggot') and the Danes *snabel-a* ('elephant's trunk a'). But in English it's just the plain old 'at sign' or sometimes the 'commercial at'.

It's not at all clear where the at sign originates. Its earliest known appearance is in a 1345 Bulgarian translation of a manuscript by Constantine Manasses, a 12th century Byzantine chronicler (the manuscript itself is now in the Vatican library), where @ appears instead of the letter 'A' in the word 'Amen'. Bulgarian historians suggest the symbol was merely an ornamentation. Researchers have spotted the @ sign in Spanish documents dating from 1448, Italian documents dating from 1536, and French documents dating from 1674. So the at sign has a long history — but the origin of the commercial aspects of @ remain a matter of speculation.

One idea is that the symbol arose in medieval manuscripts, not as an adornment as in the Bulgarian example mentioned above, but simply as a shorthand for the Latin preposition *ad* when next to a number. If the variant ∂ were used for d (see the section on partial differentiation for more

about ∂) then it's easy to see how this might have morphed into @. The word *ad* appears often, so it's a type of shortcut that might have developed.

Another idea is that merchants in Northern Europe developed @ as a shorthand for 'each at' — and I suppose the symbol does vaguely resemble the letter e with the letter a inside its counter. The argument goes that @ is sufficiently different from a (which was often used to stand for 'per' or 'at') for there to be no confusion. The distinction between 'each at' and 'at' is critical. If a merchant wrote '10 doodahs @ £1' then the cost for the doodahs would be £10; if the merchant wrote '10 doodahs a £1' then the cost would be £1. An @ or an a is the difference between profit or penury.

Yet another idea is that @ is a quick, handwritten form of á, which is the French for 'at'. Try writing á and you'll see that you can't do it without lifting your hand from the paper; in contrast, you can write @ in one flowing symbol. A number of other ideas have been floated for how @ originated, none of which I find particularly compelling. In whichever way it started, though, why did a symbol used mainly in the not terribly exciting world of accounting come to be ubiquitous?

In 1971 the American engineer Ray Tomlinson implemented an email system. It was the first such system that could send messages between users on different hosts connected to ARPANET, the progenitor of today's internet. (In mid-1971, ARPANET had 23 hosts — mostly US university and government institutions. Today there are about a billion hosts.) In order to separate user names from machine names Tomlinson needed a symbol that appeared on a keyboard but wasn't widely used: the @ symbol fitted his requirements perfectly. The exponential growth of email means that you, Gentle Reader, almost certainly have an email address and the @ symbol separates your chosen name from your email provider. (Incidentally, no one remembers the content of the first email message. Tomlinson died in 2016 but in an interview before his death he noted that 'the test messages were entirely forgettable and I have, therefore, forgotten them.')

In recent years, the microblogging service Twitter has generated huge amounts of internet traffic. Twitter launched in 2006, and six years later it was generating 340 million tweets every day from roughly 500 million users. Thus there are about half a billion Twitter user names, each starting with @ (and, if you wish, please feel free to follow @stephenswebb).

The humble @ sign, for so long the province of merchants and accountants, has conquered the world.

PERCENT

%

Even before the decimal system came into widespread use, people would often choose to perform calculations based upon multiples of one hundredth (1/100). Consider the case of the Ancient Romans, for example. They had a system for arithmetic that's about as unwieldy as it's possible to invent (and, if you don't believe it, try multiplying 32 by 23 using Roman numerals — XXXII × XXIII). Even they were aware of percentages, however: the Emperor Augustus levied a tax on goods sold at auction, and the tax was measured in so many hundredths of the value of the goods sold — in other words, it was a tax of so many percent (although Augustus didn't use the term 'percent' itself). The idea of percentages thus goes back a long way. But how do we get the modern symbol for percent, %, a symbol that sits above the numeral 5 on our computer keyboards?

Fast forward 1500 years or so from Emperor Augustus. The Roman Empire is long gone, but Italy has become a global trading centre. Commercial transactions involving significant quantities of money are commonplace in cities such as Venice, Milan, and Genoa. Merchants and bankers begin to appreciate that the number 100 is a useful base for the many common mathematical operations that are required to operate efficiently within the emerging financial environment. Since 'per cento' is the Italian for 'of hundred' Italian scribes find they are writing these two words with increasing frequency. Not surprisingly, they soon start using abbreviations — 'p cento', 'per 100', 'p 100' and so on. Anything to save ink and time.

In 1425, in a manuscript written by an anonymous author, a new abbreviation makes its first appearance: 'pc' with a small loop placed over the c. (Placing a small loop over a number was a relatively common device in

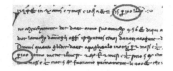

Part of a facsimile of a 1339 Italian arithmetic text. (The text was reproduced in the 1898 book Rara Arithmetica, by American mathematician David Eugene Smith.) The percentage sign as it appeared in 1339 is circled: the scribe wrote 'p 100'. (Credit: William Cherowitzo, text author unknown)

those times. A loop over the number 1 signified 'first', a loop over 2 signified 'second', and so on.) This new abbreviation is shorter and therefore better than the earlier attempts and it catches on. Gradually, over a period of 250 years or more, the unknown scribe's handwritten abbreviation evolves into something more closely resembling our present symbol with a 'loop' above and below a horizontal bar.

The modern symbol for percent, with zeros either side of a tilted bar, was certainly being used in 1836: it appears in an invoice written by a German merchant with the name of A.F. Höschner. The symbol % was therefore presumably in use in the early decades of the 19th century. Soon after Herr Höschner's usage it was used pretty much everywhere in the world when a writer wanted a symbol to express 'percent'.

A couple of close relatives of the % sign are of much more recent origin. The abbreviation permille refers to one part in a thousand, or 0.1%. The symbol for permille is ‰, with an extra zero added to the bottom of the percent sign. The term is not widely used in English, but it's quite common elsewhere. Perhaps the main use for ‰ is to express blood alcohol content, but in many European countries it's also used to express railway gradients. And a rather modern unit is the cpm — the cost permille — the charge levied by some email service providers for delivering 1000 email messages.

There is also the permyriad, symbol ‱, which is more commonly called the basis point (bp). It refers to one part in ten thousand — one hundredth of one percent. Thus 1‱ = 1 bp = 0.01% = 0.0001. I must confess to never having heard of the basis point until the financial crisis of 2008, when banking matters became a subject of front-page news. It seems bankers use the basis point to talk about small changes in interest rates: for example, an interest rate change from 2.34% per year to 2.33% per year involves a change of 10 bp. As Venice in the 15th century, so London now: a global financial centre where bankers and dealers trade in vast sums. A change of 1‱ in an interest rate can equate to a fortune.

TILDE

Of all the symbols in this book my favourite is the tilde. I'm fond of it partly because I first came across it in a maths class where the teacher called it twiddle, so *a ~ b* was read as '*a* twiddles *b*'. I immediately liked the name — twiddle. (The statement *a ~ b*, incidentally, simply means that *a* is equivalent, though not identically equal, to *b*.) But the main reason I'm a tilde fan is that it's a tremendously versatile symbol: not only does it have a variety of uses in mathematics beyond representing the equivalence relation, it also has a place in many other contexts.

In science you will often see ~ used as a shorthand way of saying 'approximately' or 'roughly'. It's also used to express the fact that two things might be of the same order of magnitude. For example, the expression $x \sim 100$ means that x is roughly 100 — it could be a bit more, it could be a bit less, but it's the same order of magnitude as one hundred.

The symbol is also used in logic. In 1897 Giuseppe Peano, an Italian mathematician, started using the tilde to represent negation: ~*p* is to be read as 'not *p*', where *p* is some proposition. Admittedly this can become confusing, since the tilde has so many other uses, and so logicians nowadays tend now to use the symbol ¬ rather than ~ to represent negation.

In computing you'll see the tilde used in a variety of different ways. In the typesetting language TₑX, for example, you can use a tilde to 'tie' two or more words together: when the words are typeset white space will appear between them words, but you can be sure TₑX won't try to insert a line break between the words.

The tilde is even used in juggling. Well, it's used in describing juggling patterns not in juggling itself, obviously.

If you juggle, you'll know how difficult it is to describe a given move. For example, I've been trying for months to master the three-ball Mill's Mess, a trick invented in the mid-1970s by the juggler and unicyclist Steven Mills. (It's interesting to note that Mills was taught juggling by the mathematician Ron Graham, whose name appears in connection with another symbol mentioned later in this book: the Knuth uparrow, a symbol which can be used to represent the eponymous Graham's number.)

This is how one is supposed to do the trick: you start with your arms crossed, left arm over right, and holding two balls in your left hand and one ball in your right; throw one of the balls in your left hand towards the right; uncross your arms and then throw the ball in your right hand in the same direction as the first ball, which is travelling towards the left hand (because you uncrossed them); then... well, it's easier done than said (and it's not easy to do, believe me).

There are various ways of representing juggling patterns, and one of the easiest to get your head round is the beatmap system developed by Luke Burrage. In beatmap, 'beats' are evenly spaced points in time and you write down a juggling pattern by defining what a hand does on each beat. A tilde, in this notation, indicates that on a particular beat the arms are crossed and the hand doing the throw is on top. You need a key to understand the patterns, but once you 'get' beatmap you can write even a complex juggling pattern in just a few characters. The Mill's Mess, for example, is just (2x,1),(~1,2x)(~2x,1). Note that this *doesn't* make the pattern itself any easier to master.

One encounters the tilde more often in languages other than English. The Spanish alphabet, for example, has one more letter than the English: the letter n with a tilde over it, ñ, is a distinct glyph representing a particular sound — it's a 27th letter.

The tilde is not only hugely versatile and useful, it has a long history. It was originally a small letter n in Latin: the n or m following a vowel was often omitted and an n — later a tilde — was placed over the vowel. Indeed, the world tilde comes from a Spanish version of the Latin word *titulus*, meaning 'title' or 'superscription'. It's perhaps surprising, then, that the use of the venerable tilde as a distinct symbol in English, accessible from any keyboard, is fairly recent. The tilde didn't appear in the original 1963 version of ASCII, the American Standard Code for Information Interchange; it was added only in a later version.

PILCROW

¶

When I was first learning TEX and playing around with the symbols it made available, I came across the symbol ¶. I had no idea what it was called or why anyone would need to use it. Eventually I learned that the pilcrow (for that is the name of the ¶ symbol) is used by professional proofreaders and by those writing legal documents, but still I thought I'd never have need to use it. Nowadays, of course, anyone who is forced to use Microsoft Word sees the symbol staring back at them. The pilcrow labels a button in Word which, once pressed, reveals a multitude of 'hidden' characters in a document — spaces, tabs, line breaks... and also pilcrows, one at the end of each paragraph (just as appear at the end of the paragraphs in these facing pages). The pilcrow, then, can be thought of as a 'paragraph mark'.¶

The term pilcrow comes from the Middle English word 'pylcrafte', a mangled form of the French word 'pelagreffe' — itself a corruption of the Old French word 'paragraphe'. So when I learned what the pilcrow was used for I assumed that its shape, a backwards P, somehow referred to the word 'paragraph'. I was wrong. For many centuries, scribes in various languages had used the symbol 'K' to denote the start of a new chapter. By the 12th century, however, scribes working in monasteries were using the letter 'C', standing for 'capitulum', to indicate a chapter break. Medieval scriptoria were run on an assembly-line basis, with a scribe copying out the text and leaving spaces for a specialist illuminator, known as a rubricator, to decorate the text with elaborate flourishes such as versals and section marks. A fashion amongst rubricators was to add a vertical bar or two to various characters, and they did this to the 'C' of the capitulum: the character became ₡ or ₵. The pilcrow was born when rubricators began to

A page from Saint Thomas Aquinas' Summa Theologica, published in Venice in 1477. The use of a capitulum to indicate a break is quite clear; this character evolved into the pilcrow. (Credit: Codex)

decorate the capitulum by filling in the counterspaces (like so: ❡). A few typefaces retain a 'fancy' pilcrow (in Garamond it's ¶, but in general it has a utilitarian appearance, which is why I've chosen the pilcrow from the font Symbola to illustrate this section).¶

At one time rubricators would add pilcrows to the start of every new paragraph, and they tried to outdo each other by creating ever more intricate and beautiful designs. Unfortunately, as authors and editors the world over will confirm, a deadline is a deadline — whether it's one dictated by the modern digital publishing process or one by the medieval hand-carved variety. Rubricators increasingly found themselves leaving a white space for an ornate pilcrow only to discover they'd run out of time to design and decorate it. The pilcrow started to vanish, leaving behind just a ghostly trace — the familiar indent that signifies a new paragraph.¶

Professional editors and proofreaders never abandoned the pilcrow: indeed, to this day they use it as a symbol informing typesetters where to break a single paragraph into two. And legal scholars continued to use the pilcrow in conjunction with the section mark (so that §9, ¶3, for example, would refer to 'section 9, paragraph 3'). But the rest of the world barely noticed the pilcrow — until, that is, Microsoft chose to use it to label a button in Word.¶

SECTION

§

The symbol § doesn't really draw attention to itself. Unlike the caret, ampersand, and other assorted characters it doesn't appear above the number keys on a standard PC computer keyboard (although the symbol does appear on a Mac keyboard, at least in the UK, just underneath ±). It isn't one of those non-printing hidden characters in a Word document that appear, as discussed in the previous section, when you press the ¶ button. You probably don't even know its name. I certainly don't. In fact, I don't think it *has* an 'official' name. The character does its job steadily, quietly, efficiently. But it's not much of a job. It's a character that could do so much better for itself.

The most common use for § is to refer to a particular section of a document, so if the symbol has a name then it's probably 'section mark'. At least, that's what English speakers are likely to call it; in some European countries it's known as the paragraph mark which is, as we discussed earlier, what we call the pilcrow. This use of the symbol to mark a section is probably the reason it has the shape it does: its Latin name is 'signum sectionis', the abbreviation for which would be SS. Put one letter S on top of another and you have the section sign.

As we saw in the discussion of the pilcrow, lawyers use the symbol § in legal documents. It's much quicker to write a statement such as 'see the sixth paragraph of section eight' as §8, ¶6. And if lawyers need to refer to sections in the plural, well they simply double it up: §§1–5 means 'sections one to five'. The symbol thus performs an honest enough task, but it's a fairly specialised role. Other symbols have multiple uses. The tilde, for example, as we saw in an earlier discussion, has been pressed into use in a

wide variety of applications. Couldn't such an eyecatching symbol as § be used for something else other to mark a section?

Well, sometimes § is used to link to a footnote[†]. I once worked on an academic journal in which consistency[‡] was considered to be an absolute good. One element of this slavish devotion to consistency was that authors had to observe a particular order of footnote symbols on a page: first came the dagger, then the double dagger, then the section symbol[§]. It didn't dawn on the editor to limit footnotes and ask authors to weave footnote text into the main argument on the page[*]. The use of § as a footnote symbol is dying out, however, as a more logical system replaces it: rather than using an arbitrary list of footnote symbols publishers are increasingly using superscripted numbers[1] or superscripted letters[a].

Surely there must be something else we can use § for? One existing use, which I spotted when I sat with my daughter as she played the game *SimCity* on one of her many gadgets, is as a symbol for the fictional currency, the Simoleon. Apparently in the game you can earn 'money' in the form of Simoleon and then 'spend' it on virtual items. There seems to be little or no relation between the Simoleon currency and any real world currency: a pizza in her game cost §40 whereas a new car was only a hundred times more expensive at §4000. (I once owned a car that cost only a hundred times as much as a pizza, but it certainly wasn't a new vehicle.)

Let's be creative like *SimCity* authors and make more use of §!

[†] Just as the dagger denotes a link to this footnote.

[‡] Consistency is certainly important but I think Emerson got it right when he wrote that 'a foolish consistency is the hobgoblin of little minds'.

[§] I have no idea whether there was a reason behind this ordering.

[*] This would have had the benefit of vastly increasing the readability of the text, particularly since the footnotes tended to be at a small font size and contained swathes of subscripted and superscripted mathematics that could only be made out by using a magnifying glass.

[1] This usage runs the risk of being confused with 'proper' superscripts.

[a] Much better!

COPYRIGHT

I'm in two minds when it comes to copyright. On one hand, as someone who has worked in a number of universities, the word 'copyright' fills me with dread. Copyright places restrictions that can at times seem arbitrary, unfair, and unnecessary, and I've heard many colleagues complain that copyright hinders a creative approach to teaching. Furthermore, the subject of intellectual property is dry, technical, and often difficult to understand — particularly since the law seems to differ in different jurisdictions. So engaging with copyright issues in this context can be challenging. On the other hand, I'm the author of several books and articles. I find the protection that copyright provides me to be easy to understand. Indeed, it could even be considered a necessary condition for me to write — if I can't earn from my creative work, or at least get recognition for my work, why should I bother creating? Of course, the world will get by just fine without my 'creations'. Surely, though, it's important that society protects the likes of say Picasso, Dickens, and Lennon and provides an environment in which *they* can create. A system of copyright helps to do that.

I suspect most people's attitude to copyright is as confused as mine. There's a general acceptance that writers and composers, directors and performers, photographers and coders — *anyone*, indeed, who develops new and creative ideas — deserve recognition for and profit from their work. In the modern digital age, however, the ease with which one can download and copy all sorts of material means it can be difficult for people to appreciate they may be doing something ethically dubious if not downright illegal.

At least the history of the copyright symbol is easier to explain than our attitude to copyright itself.

The copyright symbol — a circled, capital letter C, with the C standing for 'copyright' — was introduced in the US Copyright Act of 1909. The intention behind the symbol was to help painters, who typically want to add as little as possible to their work beyond their name. Rather than having to add the word 'copyright' on a work of art, the 1909 Act allowed painters to add the tiny symbol © next to their name. The Act also allowed authors and other artists to use © as an accepted abbreviation for 'copyright'.

For many years, at least in the US, it was a requirement for a person to place a copyright notice on his or her work in order to receive protection for that work. The copyright notice consisted of the symbol © (or the word 'copyright') along with the year of first publication and the name of the copyright owner. That particular formulation is still widely seen on many manuscripts from authors keen to stake their ownership. In 1989, however, the United States signed the Berne Convention for the Protection of Literary and Artistic Works. For authors in countries that have signed up to the Berne Convention there's no need to plaster © on one's work to establish copyright: the act of creating the work automatically establishes copyright.

An alternative to copyright, in the computing world at least, is to distribute a work under a copyleft license. The symbol typically used to denote copyleft is, logically enough, a reversed copyright symbol, Ⓒ, although to the best of my knowledge the symbol Ⓒ enjoys no legal status and it's not — at the time of writing — in Unicode. (There are related characters, such as ® and ™, whose meaning should be obvious.) So what's the difference between copyright and copyleft? Well, copyleft depends upon copyright. But under copyright the intention is that only the owner has the right to copy, adapt, or distribute the copyrighted work. Under copyleft, the owner of the work gives others permission to copy, adapt, or distribute the work — so long as any copies or adaptations are bound by the same licence. A copyleft license can thus ensure a work that an author has made freely available to users will *always* be freely available to users. Copyleft is a beautiful idea, but it can get as complicated to understand as copyright (there are strong and weak copyleft licenses, and full and partial licences).

The Creative Commons (CC) movement offers several licenses which let people build legally on the work of others; the CC Share Alike licence is essentially the same as copyleft, but there are numerous other CC options. Copyright, copyleft, CC... nothing is simple when the law is involved.

GUILLEMET

Despite the ever-growing influence of English, different languages retain their own distinct typographic conventions. Take the symbols used to denote speech. In English we use either single quotation marks:

'Always forgive your enemies; nothing annoys them so much'

or their doubled cousins:

"One should always play fairly when one has the winning cards"

Such marks have been the standard in English since the early 18th century, with the British being happy to use either single or double quotation marks and the Americans tending to favour the doubled variety. In some European countries, such as Germany, the same quotation marks can be placed differently:

„Human life must be some form of mistake"

and entirely unrelated symbols are used in some other countries:

«Judge a man by his questions rather than by his answers»

The chevron-like signs « and » are known in English as guillemets, a term that derives from a diminutive form of the French name Guillaume. The Guillaume so honoured is the French printer, engraver, and punch cutter Guillame Le Bé, who was active in the mid- to late-1500s; however, the « symbol had already appeared in French when Guillaume was only two years old. (Since the English equivalent of Guillaume is William, I guess we should call them something like bills or wills. In Eire, the term

for the mark is Liamóg, from Liam.) Guillemets are used to denote quotation not only in French but in many other languages, from Albanian to Vietnamese. And just as the situation with 'English' quotation marks is complicated, so it is with the guillemets. For example, some languages use inward-pointing guillemets to denote speech:

» Prediction is very difficult, especially if it's about the future «

In Finnish, the guillemets are allowed to both point right:

» All that I am, I am because of my mind »

The monoglots amongst us in the UK and US are more likely to see the guillemet on a media player than on the printed page, with the symbol » indicating fast-forward and « fast-rewind. Any other use of the guillemet appears foreign. Indeed, the very word 'guillemet' looks and sounds so strange to English speakers that Adobe Systems, the multinational software company that developed the font technology that many desktop publishing packages still use, got the spelling wrong. In all Adobe fonts, the glyphs are spelled 'guillemot' not 'guillemet'. A guillemot, of course, is a seabird.

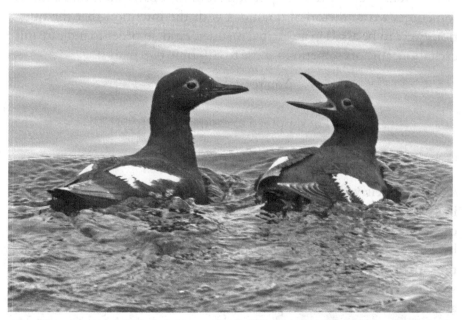

A guillemot's open bill looks like a guillemet—but the two are different! The birds shown here are pigeon guillemots. (Credit: Dick Daniels)

INTERROBANG

The interrobang, whose flashy symbol ‽ is a mash-up of the question and exclamation marks, to my mind fills a much-needed gap in the register of traditional punctuation.

Martin Speckter, the head of an American advertising firm that handled the promotion of a number of high-profile publications including *The Wall Street Journal* and *The National Observer*, invented the symbol in 1962. Speckter took inspiration from his observation that authors sometimes wrote rhetorical questions with the intention that the questions were to be asked in an excited manner. And, in order to indicate this excitation, authors sometimes chose to combine two marks:

You're pregnant?!

I'm supposed to eat that stuff?!

Do I *look* like I'm crazy?!

Speckter believed such sentences would look better in advertising copy if a single symbol were used — hence the interrobang. He wrote an article about this idea in the March–April issue of *Type Talks,* a magazine he edited, and asked readers for suggestions for a name for the character. Speckter himself suggested interrobang or exclamaquest, but subsequent letters columns floated several other possibilities including rhet and exclarotive. In the end Speckter settled on interrobang, which comes from the Latin *interrogatio* meaning 'a rhetorical question' and *bang* from American printers' slang for the exclamation mark. (As mentioned in part

5, in the discussion of the factorial symbol, printers in Britain sometimes called the exclamation mark a 'dog's cock'. We must be grateful that it was an American who invented the interrobang. Would we really want to call it an exclamacock?)

A number of commonly used fonts contain the interrobang, and if your computer has one of those fonts installed then you'll be able to access it quite easily through a word processor. But, frankly, why would you bother? If you *really* need to spell it out that your words are a mixture of a question and an exclamation then it's easier just to type a question mark followed by an exclamation mark. It's not surprising that the interrobang didn't catch on.

The interrobang (and it's inverted brother, the gnaborretni ¿, which is sometimes used in Spanish) is just one of several proposed additions to punctuation.

For example, in the 1580s Henry Denham, an industrious English printer who at one time ran four presses, introduced the symbol ⸮ into some of his works. Denham called it a percontation point and intended it to be used to introduce a rhetorical question. Three centuries later the French poet Marcel Bernhardt, better known under the anagrammatic pseudonym Alcanter de Brahm, proposed that a symbol similar in form to the percontation point be used to indicate irony. (How, though, could the reader be sure that Bernhardt's *point d'ironie* marked an ironic statement rather than being used itself ironically? Self-referencing punctuation marks are *way* too much trouble.)

More recently, the French novelist Hervè Bazin proposed several other punctuation marks in addition to the irony mark — marks to indicate or express acclamation, authority, certitude, doubt, and love. More recently still, a company in America has patented the SarcMark™ — a symbol whose use guarantees that your readers won't miss your use of sarcasm. (I'm not allowed to use the mark here since it's trademarked and I haven't paid for a license to use it.)

Now, I agree absolutely with those who argue written communication should be clear and transparent. If extra punctuation marks can render written communication more effective, then great. But I can't help thinking that if Shakespeare had used the interrobang — or the SarcMark™, *point d'ironie*, acclamation point, and their ilk — then we wouldn't hold his sonnets in quite such high regard.

EMOTICON

My daughter is young and therefore, in the eyes of some, a 'digital native'. She can hold a mobile device in her left hand, prod, tickle, and stroke the screen of a second device with the fingers of her right hand, and still have sufficient brain capacity to explain why I'm wrong about whatever it is I'm telling her. She stares at me, uncomprehending, when I recall how music was once distributed in the form of hard, black plastic disks; she looks pityingly at me when I tell her about music cassettes, and how the tape sometimes got tangled and you'd have to wind the spool on using a pencil. Only once have I managed to impress her about digital matters, and that was when I told her that the symbols she used in her texting — symbols such as ;-) and :-, — aren't the modern inventions she thought they were. They are older than she is. Indeed, emoticons are older even than her dad.

For example, in 1887 the American satirist Ambrose Bierce, a man seemingly incapable of constructing a sentence that wasn't sardonic in nature, wrote an essay entitled *For Brevity and Clarity*. In it, Bierce suggested a variety of ways in which the English language could be improved. In one section he writes: 'While reforming the language I crave leave to introduce an improvement in punctuation — the snigger point, or note of cachinnation. It is written thus ‿ and represents, as nearly as may be, a smiling mouth. It is to be appended, with the full stop, to every jocular or ironical sentence; or, without the stop, to every jocular or ironical clause of a sentence otherwise serious — thus: 'Mr. Edward Bok is the noblest work of God ‿.' 'Our respected and esteemed ‿ contemporary, Mr. Sylvester Vierick, whom for his virtues we revere and for his success envy ‿, is going to the devil as fast as his two heels can carry him." Needless to

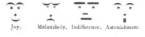

The March 1881 issue of Puck magazine had the earliest examples of emoticons. Above the emoticons shown here was the text: 'We wish it to be distinctly understood that the letterpress department of this paper is not going to be trampled on by any tyranical crowd of artists in existence. We mean to let the public see that we can lay out, in our own typographical line, all the cartoonists that ever walked. For fear of startling the public we will give only a small specimen of the artistic achievements within our grasp, by way of a first instalmet. The following are from Studies in Passions and Emotions. No copyright.' (Credit: Puck magazine)

say, Bierce was being his usual cynical self when writing this. I have to say, though, that his proposal for a note of cachinnation is at least as sensible as the proposal for the percontation point and similar marks, as discussed in the previous section. (I had to look up the word cachinnation; apparently it means loud or immoderate laughter.) My daughter's generation would no doubt write lol, but to my mind ‿ is much better.

At the height of his fame, in the mid-20th century, Vladimir Nabokov, one of the truly great writers and a man of immense erudition, was once asked the following question by an American journalist who specialised in writing personalised obituaries: 'How do you rank yourself among writers (living) and of the immediate past?' Nabokov's response was typical: 'I often think there should exist a special typographical sign for a smile — some sort of concave mark, a supine round bracket, which I would now like to trace in reply to your question.' What surprises me in his response is that he seems not to have heard of Bierce's proposal; cachinnation is the sort of polysyllabic word that Nabokov used to wield with such precision.

Even emoticon use in the online world has a relatively long tradition. Scott Fahlman, a computer scientist at Carnegie Mellon University, was the first to propose the use of :-) and :-(in message board postings to mark a joke or that something wasn't funny. He made the proposal on 19 September 1982 (at 11:44, to be precise; the original posting survived on backup tapes). People soon took up Fahlman's suggestion, and so have been using emoticons for over three decades. The Unicode consortium have even assigned a code range for emoticons. My daughter's favourite amongst them is 'grinning cat face with smiling eyes', or 😸. If you need it, it's at code 1F638.

ASH

æ

Some characters are dying before our eyes. Take æ. There was a time when this character made ostentatious appearances in the occasional highbrow word — æon, æsthetic, anæmia, and so on. Nowadays its occurrence is rarer than a transit of Venus. Even its name is dying out. Its traditional title is 'ash' but in the computer age it possesses the far less evocative label of 'Latin ligature ae'.

Its name 'ash' dates back a long way. The Angles, Saxons, and Jutes who came to England brought with them a runic system of writing. Archae-ologists (or should that be archæologists?) aren't entirely sure where the runes originated, but it's possible the Germanic tribes took existing Greek and Roman letters and reshaped them, making them more angular so the characters could be cut into stone or wood or bone (which would have been necessary since those early tribes didn't have much of a paper-making industry). Anyway, from about the 5th century Old English was written in a runic script called futhorc, the name coming from that script's first six letters: feoh (ᚠ, whose name originally meant 'wealth'); ur (ᚢ, meaning 'cattle'); the unfortunate-looking Þorn (ᚦ, meaning 'thorn', which is the 'th' in the name futhorc); ós (ᚩ, meaning 'mouth'); rad (ᚱ, meaning 'ride'); and cen (ᚳ, meaning 'torch'). The futhorc script was quickly extended to include five additional runes. The letter æsc, with the runic image ᚫ, was one of those five additions. It meant 'ash tree'.

The letter ash found its way into the Latin-derived alphabet that scribes used, starting from about the 9th century, to write Old English; an addi-tion such as æ was necessary because some sounds in the English of that time just didn't fit the Latin letters.

The letter ash, a joining of the letters a and e into æ, was considered to be a distinct letter in Old English. It still is in Danish, Faroese, Icelandic, and Norwegian. In other words, for the Old English scribes ash wasn't a typographic ligature (in the way that f and i are sometimes run together to form the single character fi); it was a letter representing a vowel, on a par with a, e, i, o, and u. It represented the short 'a' sound you get in a word such as bat — or, indeed, ash.

The Norman Conquest initiated a gradual change in the language used in England, and Old English began to give way to Middle English. The newly arrived Norman scribes had their own idea of how things should be spelled, and they ditched the special symbols introduced by their predecessors. The letter ash managed to hang on until the 13th century, but eventually ash vanished from English. This begs the question, however: if æ had already vanished, how is it achieving the remarkable feat of vanishing all over again?

Well, in the 16th century æ made something of a comeback. It found a use because certain Greek words include the letter combination αι, and when such words were introduced into Latin form scribes needed a character to represent it: æ was chosen for the job. In turn, English appropriated these words from Latin and æ could be seen once more. You'll probably have encountered the word encyclopædia spelled with the æ ligature, and perhaps words such as æther and dæmon. (The latter two spellings are sometimes used by fantasy writers to invoke a sense of the archaic; færie is another word often used this way.) Also, when English scholars were looking for a way of generating English plurals of Latinate words ending in 'a' (nebula, larva, antenna, and so on), they chose to use æ (so we had nebulæ, larvæ, antennæ).

The way we choose to spell words is under constant change. Some words, particularly in the British version of English, kept ash until quite recent times. But the use of æ is clearly dying; it's been a long time since anyone spelled 'museum' as 'musæum'. If two letters really are required then people nowadays simply write 'ae' rather than 'æ'; in many cases people just use the single 'e'. Thus it is that 'medieval' is now more or less the standard spelling; 'mediaeval' looks rather strange; and 'mediæval' looks plain wrong.

Ash, or Latin ligature ae, may retain the status of a fully paid-up letter in some Nordic languages. But in English, I'm afraid, it will soon vanish all over again.

THORN

þ

The letter Þ, or thorn, is a cousin of æ: it's one of several letters from the earliest days of English that we no longer use. Unlike ash, however, thorn lives on — albeit in a rather indirect and undignified fashion.

As mentioned in the previous section, from about the 9th century the old-fashioned Anglo-Saxon futhorc runic alphabet got replaced by a Latin script; Latin was used by Christian missionaries to England. However, futhorc influenced the new alphabet in several ways. In addition to ash, or æ, the digraph œ was adopted as a letter and named after the rune ᛟ called ethel (which meant 'estate' or 'ancestral home'). Futhorc also provided the early alphabet with the letter wynn (meaning 'joy' or 'bliss', which in runic form appeared as ᚹ) and, the letter that concerns us here, thorn (Þ, which in the angular runic script, as we have seen, appeared as ᚦ). Some time later the letters eth (ð) and yogh (ȝ) were added to the alphabet. Around about the end of the first millennium, then, an Old English alphabet would have consisted of 23 familiar Latin letters (they didn't use j, u, or w back then) plus the six 'native' letters thorn, ash, ethel, wynn, eth, and yogh.

The native English letters eventually died out. The letter wynn morphed into 'uu' in the 14th century and eventually became 'w'. The letter yogh lasted a little longer, but by the 15th century ȝ had been supplanted typically by the letter pair 'gh'. The ligatures æ and œ were subsequently reintroduced but have been replaced by simpler spellings. We have already discussed the replacement of æ by e; the only place I can think of where the œ character might still be used is in the word diarrhœa — and even that use is dying out since it's never a good idea to suffer from a complaint you can't spell. Thorn and eth are more interesting.

Both thorn and eth were used to represent the 'th' sound. The letters seem to have been used interchangeably, although there is a later distinction whereby thorn represents the sound appearing in the word 'thick' while eth represents the sound in the word 'thus'. Anyway, by the 14th century both thorn Þ and eth ð were being replaced by the digraph 'th', with Þ managing to hang around in writing rather longer than ð. Scribes continued to use Þ in abbreviations, particularly for the word 'the', which they abbreviated by writing a letter 'e' above Þ. Gradually, though, the shape of the thorn changed: it lost its ascender and eventually became almost indistinguishable from the letter 'Y'. The abbreviated 'the' thus became 'e' above 'Y'. William Caxton used this form in his printing press; it worked well for him — thorn didn't exist in the printing blocks he imported from Germany.

So thorn lives on in those horrible pseudo-archaisms such as 'Ye Olde Tea Shoppe', 'Ye Olde Inne', and 'Ye Olde Internete Service Providere'. Whenever I see 'Ye' in these signs the voice in my head can't help but say 'Yee'. But the word was never pronounced that way: 'Ye' is just a mangled abbreviation of the normal word 'the'. So thorn lives on in English, in a roundabout way, but possesses none of the dignity of the archaic ash.

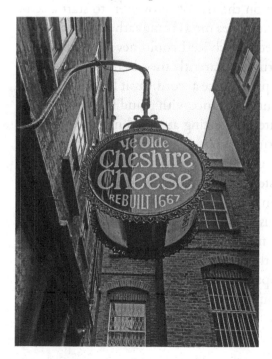

I guess it is just about acceptable to name a pub 'Ye Olde Cheshire Cheese'. In the vicinity of my office, however, is an establishment called 'Ye Olde Bike Shoppe'. That's just wrong. (Credit: Duncan Harris)

SCHWA

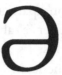

Many teachers will tell you the only writing guide worth reading is *The Elements of Style* by William Strunk Jr and E.B. White. It's a small book, originally published privately in 1919 by Strunk and updated and expanded by White in 1959. The major part of *The Elements of Style* consists of a set of rules which, if followed, are intended to help produce clear writing. Personally, I'm not convinced. A rule such as 'Omit needless words' is perfectly sound advice — but *which* words are the needless ones? Strunk doesn't say. And the prohibition on the use of 'However' to start a sentence when 'Nevertheless' is meant strikes me as being rather arbitrary and too prescriptive. One further piece of advice I could never take to heart was this piece of wisdom that Strunk apparently used to intone in his lectures: 'If you don't know how to pronounce a word, say it loud!' As White goes on to explain, why compound ignorance with inaudibility?

While I understand what White was getting at, you'd need to have the hide of a politician to follow Strunk's advice. I still remember my vicarious embarrassment when a German colleague, a man who had a wonderful range of English vocabulary, insisted on pronouncing the word 'paradigm' as 'paradiggum'. Or the time when, in a union meeting in a crowded lecture hall, an academic kept loudly accusing university management of adopting a 'macko' posture when what he meant was 'macho'. Murray Gell-Mann, one of the greatest physicists of the 20th century, is also a noted linguist with a phenomenal memory; apparently Gell-Mann feels embarrassment when he makes a slight mispronunciation in a foreign tongue — even if the mispronunciation happened years in the past. I hate to think I might be making daily errors of pronunciation and people are too kind to tell me.

However — and, yes, I'm disregarding Strunk's advice — there is fortunately a solution to the problem of not knowing how to pronounce a word: you can look up its phonetic spelling.

The international phonetic alphabet (IPA), which was devised by the International Phonetic Association in the late 19th century, is a means of representing the sounds of language. The IPA contains 107 letters (which represent consonants and vowels), 31 diacritics (which modify the letters), and 19 additional signs (which represent tone, stress, intonation, and similar qualities). Many of the letters are the same as appear in the traditional Latin-based alphabet, but some of the IPA symbols are unfamiliar. Take the schwa, for example.

The schwa — otherwise known as the mid-central vowel — is a sound that appears in many languages. It was first identified as a vowel by Jacob Grimm, the 19th century German philologist who is much better known as being one half of the Brothers Grimm and the editor of *Grimm's Fairy Tales*. The word 'schwa' is a German form of a Hebrew word for a symbol that indicated the lack of a vowel sound. In English the schwa is the unstressed sound that appears at the start of words such as 'ago' and 'around' and at the end of words such as 'sofa' or 'Tina'. In German, a language I've struggled to learn since I was at school, it's the unstressed sound that appears at the end of a word such as 'bitte'. Well, the IPA representation of that sound is ə and you can use symbols such as ə to represent how words sound in *any* spoken language.

In order to represent the clicks, trills, and fricatives of all the world's languages, the IPA necessarily contains an interesting array of characters. The full set isn't needed to represent English, but you still encounter several strange-looking symbols if you look up the phonetic spelling of a word in a decent dictionary. Here are just five:

ŋ appears in the middle of 'symphony' — [ˈsɪmfəni] in IPA.

ɳ appears at the end of 'sing' — [ˈsɪŋ] in IPA.

ʒ appears in the middle of 'vision' — [ˈvɪʒən] in IPA.

ɒ appears in the middle of 'hot' — [ˈhɒt] in IPA.

ɔ appears in the middle of 'call' — [ˈkɔːl] in IPA.

HEDERA

At school I'm sure your teachers drummed into you the orthographic con-
ventions present in English, and they'll have taught you how to use com-
mas, full stops, and apostrophes. Perhaps, if you were lucky, your teachers
will have taught you how to employ the semicolon with profit. Punctua-
tion doesn't remain static, however; marks come and marks go.❧ We've al-
ready seen how some people occasionally call for new punctuation marks:
in the 1960s, for example, advertising firms favoured the interrobang but
after a while its popularity dropped. Many of our 'standard' punctuation
marks — the colon, semicolon, question mark, and exclamation mark —
first made their appearance as late as the 17th century. The comma dates
back only a little bit further, to about 1520: prior to that English books
used a virgule or slash (/) to denote a brief pause in reading. The very earli-
est manuscripts pretty much lacked any punctuation. Text could go from
left to right, or from right to left, or boustrophedonically (backwards and
forwards, like the stripes on a mowed lawn).❧ A paucity of punctuation
in ancient times didn't much matter since most texts were meant to be
read out loud in public rather than privately in silence. One punctuation
mark that classical writers of Greek and Latin *did* have available to them
was the so-called capitulum to mark a chapter, a symbol that developed
into the pilcrow (as discussed earlier). They also had a mark called the hed-
era, which could be used to indicate the end of a text or, as I'm doing here,
to separate one long paragraph from another, in much the same manner
as a pilcrow.❧ The hedera is thus one of the oldest punctuation marks.
It took its name from its appearance: it was drawn as a horizontal ivy leaf
(❧) and the genus name for ivy is *Hedera*. (The common English ivy is

known as *Hedera helix*, in which the word 'helix' refers to the spiral-like growth of the stems.) Exactly why the ancient scribes chose an ivy leaf as a punctuation mark is a complete mystery to me: the hedera must have been an absolute pain to draw. Presumably the difficulty of drawing the leaf contributed to the mark's demise: the hedera was used in eight-century illuminated manuscripts, dropped out of fashion, made a comeback in early printed books, then died a well deserved death. Although the hedera is no longer used for punctuation, it lives on as an occasional typographical ornament — a fleuron. You'll occasionally see a hedera in books where the designer has gone for a particular 'arty' feel, centering it on a line of its own to denote a section break, for example, or as a bullet symbol in a list. Several well-known fonts contain a hedera; indeed, font designers continue to develop fleurons in their digital typefaces. The hedera thus, of course, has its own space assigned to it in Unicode, along with rotated and reverse rotated versions. So the hedera is still there, used on occasion for decorative purposes, but it will surely never be used again as a punctuation mark. If people struggle with the semicolon then the hedera has no chance.

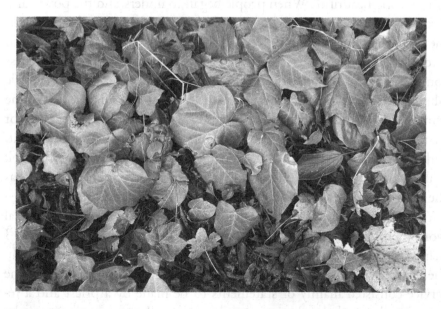

A mix of Hedera colchica (the large leaves) and Hedera hibernica (the small leaves). These plants are not native to Britain; horticulturalists have naturalised them. (Credit: MPF)

VERSICLE

In the preface to *The TEXbook*, Knuth wrote that his intention was for TEX to be used 'for the creation of beautiful books — and especially for books that contain a lot of mathematics'. Since he released his typesetting system, TEX has been used in the creation of thousands of books containing mathematics and hundreds of thousands of mathematical articles. I've contributed to that list of books and articles myself, though I'd hesitate to call any of my work 'beautiful'. When people began to understand the power and flexibility of TEX as a general typesetting system, they started using it for the creation of books beyond the narrow range of mathematics. They used it to typeset chemistry texts, foreign language novels, critical editions, chess commentaries, genealogies, musical scores, hypertexts — even beer bottle labels. In each of these cases there's a chance the author will have used some symbol specific to the field in question, some way of referring to a concept that is conventional in that field of endeavour but little used outside it. Indeed, as I wrote in the introduction, my motivation for writing the book you're currently holding (or viewing on screen if you prefer e-readers) was the wish to explore some of the symbols that TEX-ies use in their work.

Yet another application of TEX has been in the typesetting of liturgical works. This is a completely foreign subject to me, but on one occasion I helped a colleague use TEX to typeset an order of service. Sure enough, the service contained a couple of (to my eyes at least) strange glyphs. The service consisted mainly of statements to be made by a priest and a response to be made by the congregation. My colleague was insistent the priest's utterance must be introduced by a V with a line through it (so: ℣); the congregation's reply had to be prefaced by an R with a line through it

(so: ℟). These symbols stand for versicle and response, and sure enough Unicode contains slots for them. A typical example of their use would be:

℣: O God, make speed to save us.
℟: O Lord, make haste to help us.

This type of prayer dates back to the earliest Christian times, but the symbols ℣ and ℟ themselves are, by comparison, a relatively modern invention.

Incidentally, Knuth, a devout Lutheran, used TEX to typeset a biblical study: *3:16 Bible Texts Illuminated* is a commentary on 59 texts found in chapter 3, verse 16 of most books in the Bible. (Knuth's slicing approach to biblical studies has been called 'the way of the cross section'.) Even to someone like myself, who defers to Richard Dawkins in matters of doctrine, Knuth's book is a delight: it contains some gorgeous illustrations by the world's greatest calligraphers. This is TEX typesetting a work of art.

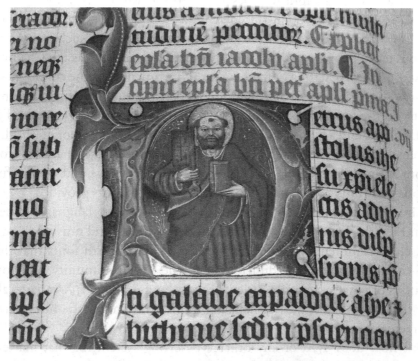

An illuminated letter P, the work Gerard Brils, from the 1407 Malmesbury Abbey Bible. No typesetting system can compete with this, but at least one project hopes to duplicate a 16th century Bible using TEX. (Credit: public domain)

BINDING SIGNATURE

When Knuth first developed his typesetting system in the late 1970s, TEX was able to access 256 characters in a font. That allowance seemed more than enough 'room' for a font to contain some interesting characters. After all, when using a font to typeset a plain English text you don't really need 256 characters: you just need A–Z, a–z, 0–9, some common punctuation marks, and maybe a few accents (to write words such as piñata, or to refer to people such as Emily Brontë and places such as the Champs Élysées). The typesetting of mathematical documents was the commonest use-case for TEX, and if your intention is to typeset mathematics then the font you use must inevitably contain various other symbols (you need \oint and $\sqrt{}$ and \pm and a whole load of other characters). But even for maths the system seemed more than adequate to me: a limit of 256 characters for a font seemed generous as I scrolled through the strange and wonderful glyphs that fonts such as wasysym, stmaryrd, and pxfonts provided.

Times change. People started using TEX to typeset languages other than English. They used it to typeset critical editions, and musical scores, and chess commentaries. They wanted to do things with fonts that the 256-character limit made difficult. Well, the TEX community built on Knuth's original system in a variety of ways, and modern TEX variants allow the user to access the full character set of a font, no matter how many characters it contains.

But how does TEX, or any other typesetting system for that matter, 'know' where it can access all the characters of a font?

When you press a particular key on a computer keyboard the computer turns that character (which it can't handle) into a number (which it can

handle). There thus has to be an agreed encoding that assigns a particular number to a given character. However, even for a single language such as English there are many different encodings in use, which means you run the risk of data corruption whenever you transfer documents between different software systems or between different computers. And when you begin to consider the complex requirements of typesetting different languages, and the need to encode symbols for scientific, mathematical, and technical use... well, the problems multiply.

The solution is Unicode. As mentioned earlier, the intention of Unicode is to provide 'a unique number for every character, no matter what the platform, no matter what the program, no matter what the language'. The system encodes 1 114 112 characters and, at the time of writing, well over 135 000 graphic characters have been assigned. Unicode thus makes the 256-character limit of early TEX seem ridiculously small.

It's fascinating to browse through a full Unicode font. You might think that some characters in this book have only a niche application, but you can see some *really* specialised symbols in Unicode. Take Ꝗ, which has the name 'rotated capital Q' and the Unicode slot U+213A. What on Earth does Ꝗ represent?

Well, back in the days when books were purely physical objects, printers printed 'signatures' — units of perhaps 16 or 32 pages, which were then sewn together to form the book. (They were also called 'gatherings' or 'sheets'. If you look down the top of the spine of an old-fashioned hardback book you'll be able to see the signatures bound together.) In order to ease the bookbinding process, and ensure the signatures were collated correctly, publishers would often place a binding mark on the bottom edge of the first leaf of a signature. Look carefully at an old book, particularly one printed in the UK or in Europe, and you'll likely see such binding signature marks. Often the signature mark was just a number or letter: the first signature might be indicated by 'A' or '1'; the second by 'B' or '2'; and so on. Occasionally, however, publishers used special characters for a signature mark. One such special character was Ꝗ, which presumably was just a normal Q picked by some anonymous typesetter and then placed sideways.

I find it rather wonderful that a picayune symbol such as Ꝗ has found its way into Unicode. But with about one million slots still available there's plenty of room left for more — even for those described in the final two sections of this chapter.

CIRTH LETTER J

I've read J.R.R. Tolkien's *Lord of the Rings* five or six times and I hope I'll get time to read it at least once more. His trilogy is a wonderful creation. Nevertheless, there are stretches of the books that are — how can I put this without offending my friends who are also huge Tolkien admirers? — well, they're *boring*. I'm thinking about the pages and pages devoted to songs and to discussions of chronology and to epic deeds written in a made-up script. Some readers devour this sort of thing, but not me. The good bits more than outweigh the bad, but in some places the books are a real slog.

On the other hand, if any author was entitled to create such mythic tales, complete with artificial alphabets and writing styles, it was John Ronald Reuel Tolkien. While writing *Lord of the Rings* Tolkien was first a professor of Anglo-Saxon at Oxford University and later professor of English Language and Literature at the same institution. He was thus one of the world's experts on Old English literature, and of the Norse sagas too. Tolkien was completely familiar with the ways in which certain civilisations used a runic alphabet. (As we saw in the sections on ash and thorn, the Anglo-Saxons employed a runic alphabet called futhorc, and various symbols derived from those runes survived into English until relatively recently.) So Tolkien, more than almost anyone else, was in a position to create his own systems of writing.

In the Middle Earth mythology of *Lord of the Rings* (and related works such as *The Hobbit* and *The Silmarillion*) Tolkien imaged that men once lived with elves and dwarves. Early in their history, elves developed a flexible writing system called the Tengwar for use with brushes and pens. To my eye the Tengwar looks like an Arabic script, but people much more

knowledgeable than me argue that the shapes were probably inspired by the various scripts used in Old and Middle English documents — material Tolkien would have read in his professional capacity. For the elves, the problem with the Tengwar was that it could not easily be inscribed onto hard materials, such as wood, stone, or metal. Thus it was, according to Tolkien's mythology, that elvish craftsmen began to develop an alphabet consisting of letters made from straight lines — characters that *could* be carved into the surface of a hard material using a knife. This alphabet was called the Cirth (with a hard 'C'), which means 'runes'. Middle Earth Cirth and the Anglo-Saxon futhorc derived from similar requirements — namely that the letters could be inscribed on a hard surface — and so the two alphabets have a similar appearance: rather harsh and angular.

The writing systems of Middle Earth possess almost as much variety as those in the real world: the historical events imagined by Tolkien caused the runes to evolve in intricate, though plausible, ways. A typical character invented by Tolkien is ⱪ, which is the equivalent of the English letter J. To my eye the rune looks ancient, but that's probably because in real Earth history runes *are* old: the earliest runic inscriptions on stone date back to the second century. (In the Middle Earth of *Lord of the Rings* the Cirth is still in use.) Wading through runes in *Lord of the Rings* may be boring, but they fit Tolkien's purpose perfectly.

A photo of my Folio Society copy of Lord of the Rings. Tolkien began the story as a sequel to his children's novel The Hobbit, which was published in 1937, but it grew into a much darker and complex work. Lord of the Rings was published in three volumes between July 1954 and October 1955 and is, apparently, the second best selling novel of all time. (Top spot goes to Dickens' A Tale of Two Cities.) (Credit: own work)

KLINGON LETTER S

The British author, critic, and editor David Langford publishes an award-winning newsletter on science fiction called *Ansible*. His newsletter first appeared in August 1979 and for the past couple of decades *Ansible* has appeared more or less monthly. In every issue Langford includes a small column entitled *As Others See Us*, which records the incredulity, horror, and general disgust with which journalists, broadcasters, and members of the literati react when they encounter science fiction. It's an hilarious monument to snobbery.

Sometimes, though, I wonder whether the 'outsiders' have a point. Take *Star Trek*.

I'm a child of the sixties, so I grew up with the adventures of Spock, Bones, Scotty, and the crew of *USS Enterprise*. I collected every episode on VHS (for younger readers, VHS was a storage medium). I attended conventions. I've forgotten more about Captain Kirk than you'll ever learn. So I do sympathise with Trekkies, I do. But, really — do we need a Klingon Language Institute whose mission is to promote and support the language of a species that only ever appeared on screen? Is there really a need for guidance on how to insult people in Klingon? ('Your mother has a smooth forehead' is one of the stronger insults you can hurl, apparently.) At least Tolkien's invention of the Cirth and Tengwar scripts were founded on real, historical alphabets that Tolkien himself studied professionally. Shouldn't Trekkies simply get a life?

It's easy to sneer (*As Others See Us* proves just how easy), but it's worth knowing that professional linguists helped to develop Klingon. In fact, the Klingon language was in large part created by Marc Okrand, an Ameri-

can linguist who wrote his doctoral thesis on the grammar of an extinct language once spoken in a small area of California. Paramount Pictures hired Okrand to invent a tongue for the spacefaring warrior race, and in the third movie of the *Star Trek* franchise he coached the actors to use the language. So it's not as if Klingon was without a scholarly background (although I must admit that the language sounds like utterances made at chucking-out time in my native Middlesbrough). There are perhaps two dozen fluent Klingon speakers in the world. There have even been translations of classics of literature — including *Hamlet, Much Ado About Nothing, The Epic of Gilgamesh*, and *Tao Te Ching* — into Klingon.

The Klingon alphabet, pIqaD, had been designed earlier by the Astra Image Corporation for use in the first *Star Trek* movie. Klingon letters are all sharp edges and points, like bladed weapons (and are thus as appropriate to the supposed Klingon character as the Cirth and Tengwar are for Tolkien's creations). The letter S, for example, is X and my surname is ꓚꓩ ꓩꓩ. A proposal to encode the Klingon alphabet into Unicode was rejected on the grounds that hardly anyone uses it — even *Star Trek* fans generally prefer to use the Latin alphabet — but the linguist Michael Everson went ahead and mapped Klingon into the Private Use Area of Unicode. That enabled several font designers to create pIqaD fonts based on that mapping. If playing about with imaginary languages is your sort of thing, several Klingon fonts are available for download. In recent years, pIqaD has shown something of a revival. It wouldn't surprise me if Klingon eventually becomes part of official Unicode.

A Klingon warrior, with forehead ridges that look something like a letter from the pIqaD alphabet. (Credit: Cristiano Betta)

2

Signs of the times

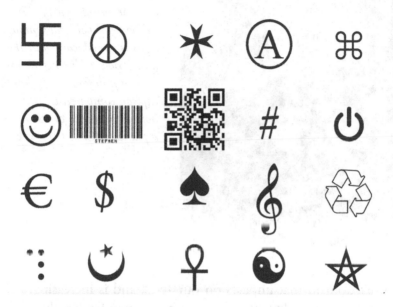

The domains of political and religious life make extensive use of signs and symbols. This is hardly surprising: a visual representation of a faith or an idea can, for some people, be overwhelmingly powerful. And history, unfortunately, repeatedly demonstrates that there is no shortage of religious or political symbols over which people are willing to fight. Many of these most recognisable signs tend to be set large and alone — on placards, buildings, flags. Those same symbols are typically not designed to be typeset at the font sizes used in a book such as this one; they can get lost in a muddle of letters, numbers, and punctuation marks. Nevertheless, for a book devoted to the stories behind signs and symbols I could hardly ignore some of the most potent of all characters. In this chapter, therefore, I discuss a personal selection of signs and symbols employed in politics and religion. I look at eight such symbols, taken from a variety of times and places. If you were making the selection you'd be able to choose from a wide range of political and religious symbols represented in Unicode — symbols such as ☫, ⚚, ☦, ☨, ⚗, ⚘, ⚙, ⚛,...

A demonstration held in May 2012 in Madrid. Alongside the slogan 'Eat the rich' is a fork-and-sickle sign, a take on the hammer-and-sickle sign ☭ of the Communist party. The natural home of political symbols and signs is the placard and the flag; notice how indistinct ☭ appears at the small font size of this figure caption compared with the clear, bold appearance of its sibling on a placard. (Credit: Barcex)

Another domain that impacts on our lives, and is increasingly affecting us more profoundly than the patter emanating from politicians and priests, is technology. This chapter therefore also includes a discussion of a few technology-related characters. Most signs used in technology are, as you'd expect, of relatively modern design — though one or two can trace their lineage back a surprisingly long way. Unicode of course contains hundreds of characters relating to technology, but I also examine here a couple of ubiquitous marks that lie outside the realm of Unicode: the barcode and the quick response code.

The most important glyphs to many people are those appearing on banknotes. If I knew more about economics, or had I been better travelled, then I could have included various currency signs from Unicode such as ₡, ₲, ₥, ₦, ₩, ₪, ₴, and ₰. Instead, I'm forced to take a conservative approach and stick to the stories behind the world's two most important currency symbols — $ and €.

And then there are glyphs relating to the more fun things in life. There are special signs used to annotate chess games, for example, or to record the runs scored in cricket. Perhaps it's the symbols used in card games that

are most easily recognisable, so in this chapter I've chosen to discuss a sign representing one of the card suits. Music notation has its own large set of signs, of course, but again I can find space to discuss just one.

Politics and religion, technology and currency, games and music — people have devised dozens of weird and wonderful signs for use in these fields. This chapter contains just twenty of them. Browse Unicode to see many, many more.

SWASTIKA

Many years ago, while browsing in a second-hand bookshop, I came across a small, battered volume of Rudyard Kipling's poetry. Since I'm fond of his poem *If*, and since the price sticker indicated I could have the book for pennies, I bought it. When I got home and examined the book properly I came across an image that provoked a visceral reaction in me. The image was of an elephant head and, just above it, a swastika. The book appeared many years before the rise of the Nazis so I knew that, for its original readers, the swastika could have had none of the detestable connotations it conjures up for people today. But for someone knowing that the swastika was a symbol of the Nazi regime — well, it came as a physical shock.

The image of an elephant's head with a swastika was so bizarre I immediately had to look up its history. The elephant, it turns out, represented Ganesh — a Hindu deity known among other things as the Lord of Beginnings and the Patron of Letters, a symbol of wisdom and foresight. It's therefore not surprising that Kipling, who was born and brought up in Bombay, would use an Indian good-luck symbol at the start of his books.

The swastika is an even older symbol. The Hindu traders with whom Kipling dealt would be quite likely to open their annual account book with a swastika to help ensure a good start to the year. But the symbol is far older than that. For example, the swastika can be seen on European stone-age pottery and on Cretan buildings. And it appears on ornaments of the Indus Valley Civilisation dating back many thousands of years. In Sanskrit the word 'swastika' literally means 'to be good' or 'well-being' and so, like the Ganesh symbol, 卐 was used as a good-luck symbol. So how did the Nazis come to defile such a venerable symbol?

The Nazis took the hakenkreuz — an angled version of the swastika — and formally adopted it as the party symbol in 1920. It was Hitler who forced this through, as it was Hitler who designed the red, white, and black colouring of the Nazi flag. Hitler was building, however, on the misguided thinking of earlier German thinkers who believed the swastika to be a symbol of the 'Aryan race'. The Nazis thought that the German people were culturally descended from the early Aryans of India, the original 'white invaders'. In Nazi thinking the Aryans — and thence the German peoples — were 'racially purer' and therefore superior to other people. The swastika was meant to symbolise all that nonsense, and on 15 September 1935 the Nazi emblem complete with the angled swastika was adopted as the German national flag.

Kipling was disgusted by the rise of the Nazis and he hated the sight of their flag. He ordered the swastika to be removed from his bookbindings — so the book I bought pre-dated all of this. Kipling died in 1936, before he could learn of the full horror perpetrated by the regime represented by his ancient good-luck symbol.

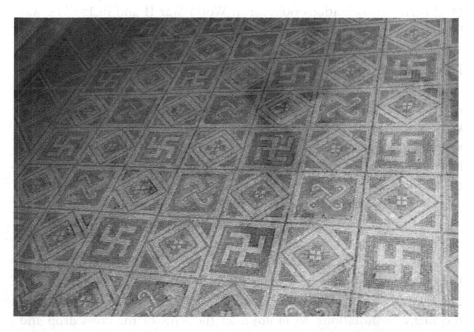

The swastikas shown here are part of a mosaic in the Roman villa at La Olmeda in Spain. Much earlier examples of the symbol have been found. (Credit: Valdavia)

PEACE

I've heard more than one fundamentalist Christian condemn the peace symbol as an ancient pagan sign with occult associations and Satanic over-tones. In some depictions I suppose the symbol does indeed look like some sort of ancient rune, but the peace sign is a modern invention and the cir-cumstances surrounding its design are well documented.

Gerald Holtom, an English artist and textile designer, held pacifist views. He'd been a conscientious objector in World War II and in 1957 he was involved in the Direct Action Committee (DAC) — an organisation that aimed to conduct non-violent protests against nuclear weapons. In April 1958, the DAC organised a protest march from London to Aldermaston, the site of the UK Atomic Weapons Research Establishment. The organ-isers obviously wanted the media to report the event, so they considered various ways to make the march eyecatching. They decided the marchers should carry 'lollipops' — cardboard signs on wooden poles, which would look good in photos and in newsreels. Holtom designed a peace symbol for the lollipops.

Holtom's initial lollipop design showed a white circle within a black square, but he thought again and changed the design to a cross within a circle. He showed this version to the Direct Action Committee; to people at *Peace News* (a UK newspaper, published since 1936, that opposes vio-lence); and to the inaugural meeting of the London Campaign for Nuclear Disarmament (CND). The consensus seemed to be that the cross carried too many connotations, so Holtom let the arms of the cross drop and so was born the ☮. Not only did the dropped arms indicate a gesture of human despair, it turned out the symbol formed a composite of the sem-

aphore signals for the letters N and D. The ⊕ symbol was thus a perfect match for CND.

Protesters made about 500 lollipops for the march (250 with a black-on-white design and 250 with white-on-green). They also carried white clay badges with the ⊕ symbol painted in black. The badges were made by Eric Austin, a CND member, who distributed them alongside a leaflet explaining how these small pieces of fired pottery would be one of the few human-made objects to survive a nuclear attack on London. The march from London to Aldermaston lasted four days; carrying this sort of glum material with them, it must have seemed to the protesters like a four hundred day march.

Members of the Direct Action Committee decided to wind up the organisation in 1961, but the Campaign for Nuclear Disarmament continued (as it does to this day). CND organised Aldermaston marches each year until 1963, and the ⊕ symbol became widely recognised amongst the British public. The symbol made the journey into the American consciousness early in its existence, when in 1958 Albert Bigelow sailed his ketch *Golden Rule* towards Eniwetok Proving Ground in an attempt to disrupt a nuclear weapons test: *Golden Rule* had the ⊕ symbol fitted to it. Two years later and the Student Peace Union in America were distributing thousands of badges on college campuses. By the end of the 1960s, Holtom's design had become a generic sign for peace.

A CND peace badge from the early 1960s. (Credit: Gerald Holtom)

MALTESE CROSS

A bewildering variety of crosses has been developed over the centuries. There's the saltire, the archiepiscopal cross, the Cross of Lorraine, the Canterbury cross, the coptic cross, the crux fourchette... There must be hundreds of different types of cross. That's perhaps not so surprising: the basic cross is simple to draw and, of course, it has a profound meaning in Christian countries. Moreover, it lends itself to additions and flourishes and embellishments. My own favourite variant is the Maltese cross, ✳, with its distinctive V-shaped arms. Look carefully, and you can see it used in many different situations.

The Maltese cross is the symbol of the Sovereign Military and Hospitaller Order of St John of Jerusalem of Rhodes and of Malta (the Knights Hospitaller, for short), a group of Christians initially associated with a pair of hospitals — one for men and one for women — based in Jerusalem. The hospitals had been set up to provide care for sick and poor pilgrims to the Holy Land. The Blessed Gerard Thom became the leader of the men's hospital, and it was there he founded his religious order of the Knights Hospitaller. In February 1113 Pope Paschal II officially recognised the order, and so the Knights Hospitaller have recently celebrated their 900th birthday. Following the First Crusade, the group became an increasingly military one, and in the aftermath of the Crusades the Knights Hospitaller moved their base to Rhodes and then to Malta. They administered Malta until 1798, when Napoleon captured the island and forced them to disperse. This close association of the Knights Hospitaller with the island is why their symbol is called the Maltese cross — and why the cross, in turn, is the national symbol of Malta.

A grano (a Maltese copper coin) dated 1726 and minted under the reign of Antonio Manoel de Vilhena, the 66th Grandmaster of the Knights Hospitaller. Before 1798, the scudo (=240 grani) was the official currency of Malta. Note the familiar Maltese cross. (Credit: Classical Numismatic Group)

By 1834 the Knights Hospitaller had made its headquarters in Rome, where it remains to this day. (The Knights have the power to issue passports, print stamps, and receive ambassadors. The order thus functions in many ways as an independent state.) Following the Napoleonic dispersal several humanitarian and charitable organisations sprang up from remnants of the original order, but all these organisations can trace their origin back to the original Knights Hospitaller. In the UK, for example, the Most Venerable Order of the Hospital of Saint John of Jerusalem was founded with a mission to 'prevent and relieve sickness and injury, and to act to enhance the health and well being of people anywhere in the world'. The Order of St John is best known for its organisation of the St John Ambulance — the nation's leading first-aid charity — which has, of course, the Maltese cross as its symbol. The Maltese cross, indeed, can be seen on emblems across the world, ranging from the fire service in the United States through to the royal orders of merit in Sweden. But how old is it? When did ✳ become a symbol for the Knights Hospitaller?

It's romantic to imagine that it dates back to the First Crusade, or perhaps even earlier to the time when the Blessed Gerard worked in his hospital. Unfortunately, there's absolutely no evidence that the Knights Hospitaller used this particular symbol during the Crusades. The evidence from coins, seals, and contemporary paintings suggests that the Knights Hospitaller used symbols such as ⵙ, †, ⵜ, and ✠. The ✳ makes no such appearance.

The first clear association of ✳ with the Knights Hospitaller is on a coin struck in 1567. (It's on a coin struck in Malta, which confirms that the term 'Maltese' is entirely appropriate when talking about this cross.) So ✳ has been the symbol of the Knights Hospitaller for perhaps half of the order's long existence.

One last point about this symbol: look in any font for the Maltese cross and where the symbol ✳ should be you'll almost certainly see ✠. The latter is the cross pattée, not the Maltese cross.

ANARCHY

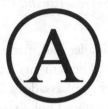

Memory tells me that the England in which I grew up was a far more con-
frontational place than it is now. Of course memory can play tricks, but
the England I recollect is one of unions calling strikes on a frequent basis,
students staging sit-ins, and politicians having real and vocal arguments
over policy. Nowadays, the unions are neutered, the main concern of stu-
dents is whether they can afford to study, and its impossible to fit a fag
paper between the main political parties. Although the shift away from
violence is welcome I can't help feeling that, in a country suffering from
the effects of three decades' worth of ruinous behaviour from bankers,
there should be much more placard-wielding taking place.

The symbol Ⓐ appeared frequently in the demonstrations and protests
that punctuated the television news programmes of my youth. I didn't
understand the symbol's political significance at the time; for boys of my
generation the symbol had much more to do with the *Sex Pistols* and other
punk bands than with a political philosophy. Indeed, I'm sure it was the
absorption of punk rock imagery into mainstream culture that raised the
profile of the Ⓐ symbol. Nevertheless, Ⓐ has a history that's more high-
brow and intellectual than its association with Johnny Rotten and Sid
Vicious would suggest.

The A in Ⓐ stands for 'Anarchy' (which comes from a Greek word and
takes a similar form in most of the main European languages). The O in Ⓐ
stands for 'Order'. Together, the two letters are said to represent a famous
statement made by the French politician and philosopher Pierre-Joseph
Proudhon: 'the highest perfection of society is found in the union of order
and anarchy'.

Pierre-Joseph Proudhon, who became a member of the French parliament after the February Revolution of 1848, was the first philosopher to call himself an 'anarchist'. His writings contain a number of well known notions, including the notion that 'property is theft' and 'anarchy is order'. Marx was a correspondent of Proudhon, but later criticised Proudhon's work. (Credit: Public domain)

In the 1840s Proudhon defined anarchy as the 'absence of a master, of a sovereign' and argued for a 'society without authority'. His works were not a series of utopian fantasy novels: he wrote carefully reasoned books and pamphlets, and corresponded with influential thinkers such as Karl Marx about their implications. His notion of anarchy was quite different to the modern common understanding of the term. For many of us, anarchy implies a form of rebellious chaos; for Proudhon, order was important.

Although the idea itself is venerable, the anarchy symbol is more modern. Photographs show anarchists fighting in the Spanish Civil War with a circled-A marked on their helmets. A quarter of a century later, in 1964, a French anarchist group called Libertarian Youth used Ⓐ on its newsletters. Use of the symbol gradually spread from there, but it was only with the popularity of punk rock that the symbol Ⓐ became widely known.

There's a subcategory of anarchy called anarcho-punk and it's perhaps this movement the Ⓐ symbol best represents. (To truly represent anarcho-punk, though, the symbol shouldn't be drawn so nicely: it should be a crude, hand-drawn, DIY effort.) The anarcho-punk movement is only one of a number of different schools of anarchic thought, however. There are anarcho-communists, anarcho-naturists, anarcho-syndicalists, eco-anarchists, anarcho-pacifists... their sheer variety sounds like Polonius boasting to Hamlet about the acting troupe arriving at court ('tragedy, comedy, history, pastoral, pastoral-comical, historical-pastoral, tragical-historical, tragical-comical-historical-pastoral'). In whichever way these groups offer protest and confrontation, they do it in a much less visible way than the organisations that protested in my youth.

APPLE COMMAND

Apple devices seduced me relatively late in life. For many years I was quite happy to get by with a steam-powered PC and a phone one step up on the evolutionary ladder from a pair of tin cans connected by string. And then I met the iMac. Now it's difficult to imagine life without an iPhone on my person, an iMac at work, an iPad at home, and an iPad mini for those in-between times. These devices are things of beauty.

I did, however, struggle with the Apple keyboard when first making the transition to an iMac. To the left of the spacebar there's a modifier key — a key which, when pressed, modifies the usual action of a second key — and it's labelled with ⌘. Apple calls it the 'Command key'. That symbol had never appeared on any other keyboard I'd ever used, so I was naturally suspicious of it. (It's not as if I thought pressing it would cause the computer to explode, or anything, but I was hesitant to use it in case I lost work.) Once I'd 'got' it, though, I realised that the Apple keyboard was better, or at least more consistent in use, than a PC keyboard: the ⌘ key does just one thing (it allows you to enter keyboard shortcuts) whereas with a PC both the Alt key and the Ctrl key work as keyboard shortcuts and I was always forgetting which one to press.

The earliest Apple computers lacked a ⌘ key. Before the Macintosh range of devices appeared in 1984 the modifier key instead had the Apple logo as its label. The late Steve Jobs, however, a man with an impeccable eye for design, decided the company logo shouldn't appear on a mere key. Jobs demanded a change. An Apple artist, Susan Kare, saw the ⌘ sign in a book of symbols (it was then used in Scandinavia as a 'place of interest' traffic sign, as it is increasingly being used in Britain) and she showed it to the

development team, who approved. Since 1984, the Apple Mac Command key has had that ⌘ sign on it.

The symbol itself has several names. In Unicode it's the 'place of interest' sign, because of the usage noted above. However, it's also known as 'Saint John's Arms' or 'St Hans' Cross', which reflects a far older usage. These names arise from Viking times, when Scandinavian people celebrated Midsummer Eve with a great festival. During the festival the people consumed 'healing' waters: thus the St Hans' Cross represents flowing water. The symbol name arises because Christians later commandeered the pagan Midsummer Eve for their own St John's Eve (the John or Hans in question is John the Baptist), but they kept the festival and the ⌘ symbol. It's quite a thought: a Viking symbol sits on computer keyboards.

The symbol also has a clear resemblance to an heraldic design called the Bowen knot. Actually, the pedant in me has to point out that topologically the Bowen knot isn't a knot. It's an unknot — a closed loop of rope with no knot in it at all.

Picture stones were ornate limestone slabs erected in Scandanavia during the Viking age. They were probably some type of memorial stone. The picture stone here, which is decorated with a St Hans' Cross, lies in the Gotland Museum in Fornsalen, Visby, Sweden. (Credit: Wolfgang Sauber)

SMILEY

I find the smiley face deeply creepy, on a par with the circus clown and the ventriloquist dummy. (Apparently I'm not alone with the latter. So many people find clowns and ventriloquist dummies unsettling that these phobias have names: coulrophobia and automatonophobia, respectively. Surely there must be a name for smiley face phobia?) I used to believe that no individual could be blamed for inflicting that mindless grin upon me, since it's such a simple and generic image. Nevertheless, the smiley possesses a definite history.

The craze for putting ☺ on everything seems to have started in 1970 thanks to a pair of Philadelphia businessmen, Bernard and Murray Spain, who were looking to create some cheerful novelty items that they could flog for a profit. The brothers decided that a yellow smiley face would go down well with the masses; Murray added the phrase 'Have a nice day' and they then proceeded to plaster it on badges, stickers, posters... anything they thought might sell. So the Spain brothers are in large part to blame for the ubiquity of the smiley. But they didn't invent it. They were almost certainly influenced by a design created in 1963.

In the early 1960s the State Mutual Life Assurance Company of Worcester, MA, took over another, similar organisation, the Guarantee Mutual Company of Akron, OH. As often happens following a takeover or a merger, employee morale plummeted. In an attempt to improve matters the State Mutual promotions director commissioned Harvey Ball, a local graphic artist, to compose a design for a feel-good, mood-boosting logo. It took Ball about ten minutes to come up with a smiley face on a sunshine-yellow background.

The company initially produced one hundred smiley badges to give to employees (as a reminder to smile when dealing with customers; the employees probably found the smiley even creepier than I do). The badges undeniably struck a chord, though, and were soon being produced in their thousands. Decades later and the Harvey Ball smiley face — oval eyes, smile with creases at the side of the mouth — had been printed on tens of millions of badges. However, in an instance of oversight that merits the use of a far-from-smiley face, State Mutual didn't bother applying for a trademark or copyright on the symbol ☺. The only money Ball made was the $45 State Mutual paid for his work.

But can we be sure that Harvey Ball was the culprit for designing ☺? Perhaps he gained inspiration from earlier versions of the disembodied head?

Well, a similar-looking smiley face appeared on sweatshirts in the year before Ball designed his version; a decade earlier still and a smiley face made an appearance on a Hollywood movie poster; and in 1936 Monro Leaf wrote a book called *Manners Can Be Fun* in which a stick characters are drawn with a smiley face. (I can't bring myself to blame Leaf for the smiley face, though. As a child I loved his book *Ferdinand the Bull* far too much to blame him for anything.) In fact, I'm certain the Spain brothers, Ball, Leaf, and probably others before them were all just tapping into a generic symbol: surely children have been doodling the smiley — circle, two dots, curve — on misted windows since people started glazing their houses. The smiley face has probably been grinning out at people for centuries. Still don't like it, though.

A rogue's gallery—ten versions of a smiley face. (Credit: own work, adapted from public domain)

BARCODE

I guess younger readers won't have seen a shopworker armed with a price gun labelling goods, will never have experienced the joy unconfined of finding a can of beans with an incorrect low-price sticker on it. Nowadays the price sticker has been replaced by the barcode. It's difficult to enter a supermarket and not immediately encounter one since a barcode is on pretty much everything you can buy. And it's not just in supermarkets that you meet them. Barcodes get wrapped around your luggage when you check in for a flight, and in some places they get wrapped around your wrist when you check out and end up on a mortuary slab. Barcodes are increasingly used in place of preprinted admission tickets for cinemas and theatres and sporting events. Barcodes are placed on driving licenses and library books and hip replacements. You can see them on registered mail, store cards, medicines. Those black and white stripes are perhaps the defining mark of our western civilization.

The idea that patterns could be used to classify and identify articles dates back to 1948, when the owner of a chain of food stores asked the Drexel Institute of Technology in Philadelphia to investigate whether a method could be developed to automatically read product information at the point of sale. Bernard Silver and N. Joseph Woodland, graduates of the Institute, worked on a solution.

In 1952, Silver and Woodland patented a barcode system based on patterns of concentric circles. The system languished for a while but in the mid-1960s food store chains across America revisited the idea of using barcodes for automated checkout. By 1970 a committee had developed a standardised 11-digit code that could be used to identify any piece of mer-

chandise, with the code being represented by the Silver–Woodland concentric circles. The circular barcodes didn't work too well (how different the world would look today had their system taken off) but by 1973 the familiar rectangular barcode had been developed. This *did* work and a prototype system was installed at Marsh's supermarket in Troy, Ohio.

Clyde Dawson has the honour of being the first person to buy a product with a barcode plastered over it; Sharon Buchanan was the first to scan a barcoded product. The event took place at 8:01 am on 26 June 1974, and that historic piece of merchandise was a 10-pack of Wrigley's *Juicy Fruit* chewing gum. It took a further five years before the first barcode was scanned in a UK supermarket. The event happened on 7 October 1979 at Keymarkets in Spalding, when a shopper handed over a barcoded box of Melrose teabags to be scanned. (I can't help but think that those first items — chewing gum in the US, teabags in the UK — are somehow strangely appropriate for the respective countries.)

A variety of different barcode types are now in existence. The barcodes on packs of gum and teabags sold back in the 1970s, and the barcodes we still typically see in supermarkets today, refer to the Universal Product Code (UPC). The UPC is a code involving 12 numerical digits, thus giving a possible 10^{12} (one million million) unique patterns. The European Article Number (EAN), which although it retains the acronym EAN is now called the International Article Number, has added a further digit to the 12-digit UPC, and has thus increased the number of possible unique patterns by a factor of ten. There are other barcode systems that allow for letters as well as digits; the barcode shown on the facing page, for example, represents the characters in my name and it uses Code 128, a system widely employed in the logistical industries.

The barcodes themselves are read by a 'scanner' — a device that, in its simplest and cheapest form, simply consists of a fixed light source and a single photosensor. Smartphones, using their built-in camera in conjunction with a suitable app, are also able to decode barcodes. You can use them, for example, to track food intake: simply scan the barcode on the packing from the food you're eating and apps can determine nutritional information.

It's easy to take barcodes for granted, but they've had a profound effect on our world. They manage the flow of materials from initial manufacture through to distribution and final sale. Without them the shopping experience we all enjoy, or at least agree to suffer, simply would not work.

QUICK RESPONSE CODE

Technology affects every stage of life: there's a child growing up with the name Hashtag while the deceased can now have a Quick Response code on their headstone. I'm really not sure about the wisdom of calling a child Hashtag (or Retweet or Newsfeed or @Reply) but interactive headstones could serve a purpose if it's important for you that your name lives on. Wander around a cemetery today and all you'll see on an old tomb is a faded name, some dates, and perhaps a brief inscription. Inscribe a Quick Response code on your headstone and future generations wandering around your final resting place might discover everything there is to know about you.

A barcode is just a one-dimensional code that gets scanned by a narrow light beam, which is nowadays usually a laser. A Quick Response code (or QR code for short) is a two-dimensional code, a pattern of black square blocks on a white background that gets imaged by a digital camera and analysed by a small computer chip. The chip 'locks on' to the three squares located at the top left, top right, and bottom left of the code, and uses the bottom right corner to correct for viewing angle. The chip then converts the other blocks in the pattern into the binary language in which computing takes place.

Clearly, a two-dimensional pattern can encode many more different types of data than is possible with a one-dimensional barcode. One could encode calendar events, email addresses, phone numbers, or plain text. The QR code shown at the head of this page, for example, is in essence a print-based hypertext link: scan it with a QR code reader on your smartphone and you'll be directed to my website.

The invention of the QR code dates back to 1994 when Denso Wave, a subsidiary of the Japanese car maker Toyota, developed two-dimensional codes to allow information about components to be scanned at high speed during the manufacturing process. However, the rise of these codes has been driven by the advent of the smartphone. A few years ago you would never have seen a QR code outside of a few specialised manufacturing installations; nowadays they are plastered over advertising signs, on the covers of magazines, even — as mentioned in the introductory paragraph — on headstones. So will the QR code reach the same levels of ubiquity as the barcode? My guess is not.

There are quite a few problems with how QR codes have been or are being used. Many companies use them simply because they can: they give little thought to how a user might actually scan these blocks of black and white, nor what a user might gain from engaging in that activity. What's the point in putting a QR code on the side of a bus, for example? If the bus is moving, you can't scan the code; if you are interested enough in the bus to notice that it's still then you'll probably just want to sit down inside it rather than scan its side. Or why put a code on a web page which, when scanned, takes you to the exact same web page? And even if a QR code is easily accessible and the user believes the content to which it points is worthwhile, well that user still has the hassle of getting out a smartphone, navigating to a QR reader, holding the phone still while the camera locks on to the code, waiting for the content to show... life is too short. Personally I can seldom be bothered to scan a QR code; the payoff never seems to be worth the effort. I suspect the same is true of many people. And if people don't use the codes, companies will eventually stop generating them.

There's another threat to these high-tech QR codes: technology itself.

A QR code gives information about the object to which it is attached. Would you go to the bother of focusing a code reader on a square of black and white blocks to get more information about an object if your device could itself recognise the object it was looking at? That level of technology — devices with the capacity to recognise their surroundings — will soon be available to us all. It already exists. In 2014 the prototype 'Google Glass' — an optical head-mounted display — could be bought by members of the public and be used to augment reality. The prototype was withdrawn from sale in 2015, but Project Glass continues. Soon, we won't need QR codes. But *barcodes* — I think they'll be around for a while.

HASH

#

The # sign used to be one of those signs you'd see now and then, some-
times in plain view (such as on a telephone keypad), sometimes in techni-
cal or computer usage (such as in TEX, where it's used to represent an argu-
ment in a user-defined macro), and sometimes in quite unexpected places
(such as in television subtitles, where it marks the fact that lyrics are being
sung — at least, that's what I've seen whenever I've switched subtitles on
by mistake). The # sign is often used in text as a symbol for a musical sharp
sign (although this usage is incorrect: the musical sharp sign has angled
lines that don't vanish in the horizontal staff lines — ♯ is the symbol that's
required here). I find myself using # whenever I go through manuscript
proofs from publishers (it's the conventional symbol representing a space
between words or between lines, and if you use it the editors and printers
will know you want extra space in the places marked). The # sign appears
in mathematics (#S is the cardinality of the set S — essentially the num-
ber of elements in the set); it appears in chess notation (where it repre-
sents a checkmating move); and it appears in medical shorthand (it stands
for 'fracture'). So as characters go, # has always been a useful all-rounder:
when people needed a simple symbol to represent something they often
turned to the hash sign.

And then Twitter happened.

Twitter uses 'tags' as a means of identifying topics. You can't watch a
television programme, listen to a radio show, or glance through a magazine
without being urged to interact using a 'hashtag'. # has hit the bigtime.

There are several mysteries surrounding this now ubiquitous symbol.
Take its name, for example.

In the UK we usually call the # sign 'hash', but this is a relatively recent coining. You don't see this meaning of the word in old dictionaries, and modern dictionaries declare that the term dates from the 1970s or 1980s and presumably as a mispronunciation of the word 'hatch'. Americans, on the other hand, often call the sign 'pound'. This irritates the hell out of me (with age comes ease of irritation), but at least there's a good reason for calling it 'pound'. The standard abbreviation for the pound weight is lb, which comes from the Latin 'libra' for scales. The letter 'l' and the number '1' can sometimes be mistaken, however, and so printers would often put a horizontal line across the vertical lines of lb. Over time, this evolved into the # sign we know today. So calling the sign 'pound' makes perfect sense, but clearly it's not something the British can do because of the confusion it would cause with the sign £, which represents the pound sterling. (This does raise a question, however: why don't Americans call the Twitter hash-tag a poundtag?)

There's another widely used name for the symbol. In America # is widely used as an abbreviation for 'number'. Where the British would tend to abbreviate 'number 5' with 'no. 5', Americans write '#5'. This usage is so common that the Unicode name for the symbol isn't 'hash' but 'number sign'.

But there are yet other names for the hash sign.

If you've ever had to listen to a British Telecom customer service message then you might have heard the symbol being referred to as the 'square'. This is plain stupid because # looks nothing like a square, but apparently BT use the name because it can be easily translated into other languages. (Well done, BT: that's multilingual mistakenness.) And some people call it the octothorpe. This usage dates back to the 1960s, when engineers at Bell Labs added two keys to telephone handsets in order to facilitate touch-tone dialling. One of these keys carried the # symbol and engineers felt they needed an unambiguous name for it. But why 'octothorpe'? The pre-fix 'octo' is clear enough — eight lines emanate from the central rhombus — but the suffix 'thorpe' is the subject of numerous stories. The one I like best is that a Bell Labs engineer named it in honour of the great athlete Jim Thorpe — a Native American who won pentathlon and gold medals at the 1912 Stockholm Olympics, who played professional baseball and professional basketball, and who played American football at both college and professional level. A true all-rounder.

POWER STANDBY

Whenever I take possession of a new gadget I tend to poke at it with my index finger much as a chimp prods an ants' nest with a stick. I'm never entirely sure what the results of my poking will be, but it's the way I learn how gizmos work. My wife tells me that reading an instruction manual is a more effective learning experience, but since I'm not fluent in whatever language it is they use to write those documents I find them of little help. Sometimes, though, I'm *forced* to resort to the manual: figuring out what ⏻ meant was one of those times.

You can guess the meaning of some symbols without too much difficulty. If you see ⏩ on a remote control device, for example, then you can imagine what's going to happen to the blu-ray when you press it. But the ⏻ icon always flummoxed me. I'd press it, assuming that its attached device would spring into action, and then find myself unsure whether I'd instead turned it off. My wife would stare at me pityingly and hand me the manual, but it turns out that at least some of the problem lies with the symbol itself.

Things were easy with old-fashioned power controls. There'd be a button labelled 'Start' or 'On' and a separate button labelled 'Stop' or 'Off' and even I knew what was going on. Things got slightly more complicated when power began to be controlled by a toggle switch. English users were relatively unaffected by this because the words 'On' and 'Off' (or 'Start' and 'Stop') appeared on either end of the switch, but of course this approach could not form the basis of an international standard. Gradually, then, the words were replaced by the binary numbers 1 (representing 'On') and 0 (representing 'Off'). There are still plenty of switches marked with 1 and 0 (or, more recently, just a straight vertical line | and a circle ○).

In recent years the power switch has tended to be replaced by a single button, and pressing the button toggles between the two power states. Since the same button controls both states it makes sense to combine the power on and the power off symbols in a single symbol. There are therefore *three* clearly defined power symbols. A circle denotes power off. A vertical line denotes power on. And a vertical line inside a circle is used on a button that switches a device between the on state and the off state. So where does ⏻ come in?

Well, ⏻ indicates a low-power state or 'sleep mode'. The device it's attached to is still drawing some power — but not much, just a trickle. The trouble is, different manufacturers seem to use the ⏻ symbol in different ways on different devices. Sometimes you'll see it on its own, on a button that toggles between on and standby; sometimes you'll see it on its own, on a button which, when pressed, puts the device into its sleep mode; and sometimes you'll see it on a toggle switch at the opposite end of a power on symbol. It's confusing. ⏻ has caused me other problems: this widely used symbol doesn't (yet) appear in Unicode so very few fonts contain the glyph. It's difficult to complain about ⏻ when most fonts don't even support it!

The good old days: simple power controls! (Credit: Michael Holley)

EURO

The euro is one of the world's most important currencies. It's the official currency of 19 of the European Union's member states, and most other member states will adopt the euro eventually. Those 19 countries currently using the euro form a bloc — the eurozone — that by some measures constitutes the second largest economy in the world. At the time of writing it is the world's second largest reserve currency and the second most traded currency; the combined value of euro banknotes and coins is greater than that of any other currency. Given the important role the euro plays in the world's financial markets, and since it came into being relatively recently, you'd think it should be possible to present a definitive account of the origin of the euro's symbol, €. However, as with much else that emanates from the European Union, the story is less than clear.

Provisions for a European currency were first laid down in the Maastricht Treaty in 1992. The name of the currency, 'euro', was adopted in December 1995. But it wasn't until December 1996 that we first got to see the € sign, when Jacques Santer, the ninth president of the European Commission, unveiled the proposed currency symbol in a special ceremony. And it wasn't until 1997 that specifications for the symbol were made public. So according to this timescale, the € sign must have been developed some time in the period 1992–96, and probably towards the end of that period. But who actually designed it?

The European Commission own the copyright to € and, according to the official EC website, the symbol was chosen from an initial pool of 32 proposals. When submitting those initial sketches, the designers were asked to be mindful of three criteria.

First, the design had to be a recognisable symbol of Europe. Second, the design should have a clear visual link with existing currency symbols. Third, the symbol should be aesthetically pleasing and easy to write by hand.

According to the European Commission's official website the initial 32 proposals were whittled down to ten; a public survey reduced the candidates to two; and then from those two, the EC chose the winning design. Their choice of the € symbol could certainly be said to have met the criteria they set. Regarding the first criterion: the shape of the € symbol is entirely appropriate. It not only evokes the first letter of the word 'Europe', it is similar in form to the Greek letter epsilon and thus it harks back to the cradle of European civilisation. The symbol is now seen around the world and it's immediately recognisable. The second criterion has likewise been met with the € sign: two parallel lines appear on some versions of various currency symbols — \$, £, ¥, and so on — and are probably there to certify currency stability (although with the events that have happened since the financial calamity of 2007, and the strains on the eurozone caused by the Greek debt crisis and Brexit, this seems like a bad joke). The third criterion was partly subjective, and several graphic designers have expressed negative comments about the symbol — but the € sign is certainly not difficult to write by hand.

Unfortunately, even though the process for adopting a sign for the new currency resulted in an entirely appropriate choice, the European Commission chose to keep the details of the process secret. So we don't know what the other proposals looked like, nor do we know the identity of the winning designer. (Santer said that a team of four people created the design, although Alain Billiet, a Belgian graphic designer, is widely regarded as the creator of this important symbol.)

In the summer of 1997, Arthur Eisenmenger — a German artist who had once served as the chief graphic designer for the European Economic Community — watched on television as Jacques Santer discussed the new symbol for the euro. Eisenmenger, who was then 82, got up from his wheelchair and shouted to his wife 'Mechthild, look, that's my E, my E!'. Eisenmenger claimed he designed the € as a symbol for Europe about a quarter of a century before the single European currency was established. So in the absence of open information from the European Commission, there remains controversy over who designed the €. Was it Eisenmenger? Billiet? An anonymous graphic design team? We might never know.

DOLLAR

The fogs of European bureaucracy mean we don't know for certain where the € symbol originated; it's the fogs of history that cloud our understanding of where the $ symbol originated. The etymology of the word 'dollar' is well enough understood. There's a spa-town in Bohemia (now the Czech republic) called Joachimsthal — literally, 'Joachim's valley' — and some time between 1515–20 a Bohemian nobleman began to mint silver coins which he called Joachimsthaler after the place where the metal was mined. In common use the coins became known as thaler, and this then found its way into more than a dozen languages — and into English, of course, as dollar. So much for the word; what of the sign?

Over the years people have made numerous suggestions regarding the provenance of the dollar sign. One plausible-sounding idea regarding the double-struck dollar sign $ is that it's a monogram of the letters US, which were printed on money bags from the US Mint. If you put an S on top of a U then the bottom curve of both letters join; you are left with two vertical lines going through an S. At least, that's what proponents of the idea suggest. When I write an S on top of a U the result is a mess. Besides, this can't be the explanation for the origin of the sign because it appears in correspondence in the early 1770s — before the formation of the USA.

Another popular explanation for the origin of the dollar sign, this time for the single-struck version $, is that it came from the practice of putting a line through the number 8 in order to denote 'pieces of eight'. The piece of eight, or the *peso de ocho*, was another word for the Spanish dollar. The silver coin was worth eight reals, hence the name. The idea sounds as if it might be true, but there's little hard evidence to support it.

Various other suggestions have been made to explain the origin of the $ sign, but perhaps the most widely accepted one is that it came about simply as the result of laziness. The Spanish *peso de ocho* would have been in wide circulation in early America and it's known that when writing financial correspondence the peso was abbreviated by the letter P. If the writer wanted to refer to more than one peso, the abbreviation Pˢ was used. Well, imagine a harried English–American colonist having to write Pˢ dozens of times in his correspondence with a Spanish–American colonist. The suggestion is that the P and the S merged, and became the symbol we recognise today before the United States adopted the dollar in 1785.

It's interesting that we know less about the origin of € and $ than we do about £ particularly since, after the adoption of the euro by a majority of European countries, the Great British pound is the world's oldest currency still in use. The symbol we use for the pound sterling dates back ultimately to King Offa, ruler of the Anglo-Saxon kingdom of Mercia between 757 and 796, so the British pound pre-dates the formation of Great Britain — and even of England. During his reign Offa introduced a silver penny, 240 of which weighed one pound. Thus the word 'pound' originally referred to a weight, and the name 'sterling' related to silver of high purity. (Examples of the coins still exist, incidentally, and in case you're interested we know from these that Offa wore his hair with lots of curls.) Anyway, the symbol for the pound was originally just L, the first letter of the Latin word 'Librae' — a unit of weight whose name ultimately derived from the word for 'scales' or 'balance', since that's how weights were measured. Over time L became the cursive capital *L*, which acquired two cross-bars, and which in turn developed into the single-cross L we use today: £.

A silver portrait penny of Offa, the king of Mercia, showing him with curled hair. (Credit: Classical Numismatic Group)

SPADE SUIT

The four playing card suit symbols — ♠, ♡, ◇, and ♣ — are an international standard. Indeed, they are so common I once assumed they'd somehow been handed down from on high, perhaps about the same time Moses received his orders on tablets of stone. Imagine my surprise when my wife, who is German, showed me a card deck with a different set of suits. The heart suit, although subtly different, was at least present in the deck; but the other three suits were represented by bells instead of diamonds, leaves instead of spades, and acorns instead of clubs. Apparently in some places in Germany they still use these strange suits. (They play rock, scissors, paper differently too. They add a fourth category — a well — which completely ruins the game.) It turns out card suits aren't quite as standard as I thought.

Playing cards are a Chinese invention that didn't appear in Europe until the 14th century. The first evidence we have for playing cards in Europe is a proclamation, dated 1367, banning their use in Bern, Switzerland. By the 1380s, however, it's clear people were playing card games all across the continent. The suit symbols on these first European cards were cups, swords, coins, and batons — symbols probably copied from the design on cards imported from Egypt. This so-called Latin design is still used in certain regions, particularly in Spain and Italy. Different designers implemented the suits in different ways, however. Spanish designers altered the rapier-like sword design so that it became a heavy, double-edged Roman blade while the narrow baton morphed into a thick, lumpy club. The German suit system appeared next, with its hearts, bells, leaves, and acorns. And then, in the 1480s, French designers came up with coeurs, carreaux, trefles, and piques — the familiar hearts, diamonds, clubs, and spades.

The French suit system is by far the most widely used: indeed the symbols ♠, ♡, ◊, and ♣ are pretty much universal (although not completely so, as my wife pointed out). As for the designer of these world-recognised symbols: well according to Catherine Hargrave, in her book *A History of Playing Cards*, the design was introduced by Étienne de Vignolles, a French knight who lived during the Hundred Years War, and his friend Étienne Chevalier, a civil servant to the French kings Charles VII and Louis XI. If Hargrave is correct, the design must date to about 1430.

In games where the suit is assigned a value it tends to be spades that are worth most. (When we say that something is happening 'in spades' we mean it is occurring in abundance, and this refers to the spade suit.) Following spades, at least in games where suit matters, comes hearts, diamonds, and clubs. So in value order it's ♠, ♡, ◊, and ♣. The ace of spades, also sometimes known as the death card, has the highest value of any card.

Four playing cards from a French deck dating back to the 16th century. The cards shown here are from the spade and diamond suits: they clearly have the same form we use today. (Credit: public domain)

TREBLE CLEF

My daughter has reached that tricky age: she asks questions of her school homework that give me pause. The particular subject that causes me most anxiety is music, and that will surely remain so until she starts asking me to practice French with her. My daughter has started guitar lessons, you see, and all those lines and squiggly marks in her music textbook cause vivid memories to flood over me of the time when I struggled with music notation as a child. Part of me understands that the notation makes sense, that music looks the way it does because the notation evolved over the centuries. But that understanding doesn't lessen the anxiety I feel when I try to read it.

Take the treble clef, for example. The 𝄞 sign stands for a simple idea but with all its whirls and curls it looks absurdly complicated. Where does all that frippery and finery come from?

Musical notes are placed on a staff or stave which, in modern musical notation, consists of five horizontal lines. The lines, and the spaces between them, represent different pitches: higher pitched notes are higher on the staff than lower pitched notes. So far, so easy. The problem with a blank staff, though, is you can't tell which note corresponds to which line or space. For example, bass and soprano singers have different musical notes available to them; when they see a blank staff, how can they know whether the notes on that staff are suitable for them? That's where the clef comes in.

A clef, which comes from a French word meaning 'key', defines a reference note on the staff. Once the clef is in place, all other notes on the staff are determined. You could put a clef on any of the lines or spaces of the staff, and historically various clefs have indeed been placed in various different positions. Nowadays, though, only a few clefs are in regular

use — and two clefs, the treble clef and the bass clef, are by far the most commonly used. Most modern western music can be represented by using these two clefs.

The treble clef, with its symbol 𝄞, is used for many instruments including the violin, saxophone, cornet (my bane at school), bagpipe (surely everyone's bane everywhere), guitar, flute, oboe... it's the clef with the widest use. In modern music the treble clef is always placed so that the curl of the symbol passes through the second line of the staff, counting upwards: this sets the note G (above middle C), against which all the other notes are then defined. The 𝄞 is, strictly speaking, a G clef; it's only when it defines that second line to be G that it's a treble clef — but since this is now invariably the case, the terms 'treble clef' and 'G clef' are synonymous. And it's this definition of the note G that gives rise to the symbol itself: the symbol 𝄞 is nothing other than a script letter G that has taken on a few frills and fancies over the years.

In similar fashion, the bass clef 𝄢 is an F clef that happens to be placed on the fourth line (where it defines F below middle C). It's used for instruments such as the cello, double bass, and tuba. Since this is so commonly used nowadays, the terms 'bass clef' and 'F clef' are synonymous. And the symbol for the bass clef derives from a fancy script letter F.

A third clef is sometimes used in modern music: the C clef, with symbol 𝄡. When it is used, the 𝄡 is usually placed on the third line of the stave (in which case it's called the alto clef) or on the fourth line (in which case it's a tenor clef). Although 𝄡 looks nothing like the letter C, the symbol is indeed the result of an evolutionary modification of the letter.

Personally I'd be happier if scores were marked with a simple G and F, rather than 𝄞 and 𝄢. But that's probably just me; my daughter gets on just fine with music notation as it is. So I'm trying to learn keyboard to keep up with her.

A great stave as used, for example, for piano. The upper staff has a treble clef, the lower staff a bass clef; middle C is centred between them. (Credit: own work)

RECYCLING

It's one of the most recognisable symbols on the planet, a sign that for the past four decades has encouraged people to recycle materials: ♺. Although the symbol has not been trademarked and is in the public domain, it has become so well known that (in the UK at least) manufacturers must apply for official approval before they can display it on their packaging.

This universal symbol for recycling came into being in 1970. In the years leading up to this, environmental issues were increasingly the focus of debate in America and Europe. I like to think this was due at least in part to the photographs of Earth taken from the Apollo missions: for the first time the general public saw the tiny size of our planet and realised that Earth is the only home we have. One particular environmental disaster, an oil spill in California in 1969, prompted a US senator Gaylord Nelson to call for the establishment of an 'Earth Day' — a nationwide teach-in day on environmental issues. The first Earth Day was held on 22 April 1970. Millions of Americans demonstrated peacefully in favour of a healthy, sustainable environment and, to some extent at least, the Day was a success: it led directly to the establishment of the US Environmental Protection Agency and a number of important environmental Acts.

Partly in honour of that first Earth Day, and partly in an attempt to raise awareness of environmental issues in general, the Container Corporation of America — a manufacturer of corrugated boxes made of recycled material — advertised a competition 'for the love of the Earth' to design a logo that symbolised the recycling process. The competition was open only to students, and the judges received more than 500 submissions. Gary Anderson, who at the time of the competition was a 23-year-old student

Gary Anderson (shown here on the right) explaining his original 1970 design of the recycling logo. (Credit: Gary Anderson)

at the University of Southern California School of Architecture, submitted three similar designs; the judges chose the plainest of his designs, ♻, as the winner. Anderson won $2500 for coming up with ♻. It soon became the global symbol for recycling, and now there are several versions for use with different products (for paper, plastic, lead batteries and so on). For example, ♻ is the symbol to indicate a product contains recycled paper; ♻ indicates that a product contains partially recycled paper; ♻, with its 'flatter' two-dimensional design, is the recycling symbol for generic materials; and ♻ through to ♻ are recycling symbols for seven different types of plastic, which help recyclers to separate materials.

For such a simple design, the ♻ symbol is remarkably subtle.

As a student, Anderson once took a course on topology for non-mathematicians. He would therefore have studied a topological curiosity known as a Möbius strip, an object discovered by August Ferdinand Möbius in 1858 (and independently, at around the same time, by Johann Benedict Listing). A Möbius strip is easy to make: take a long, thin piece of paper; give it a half twist; then glue the ends together to form a loop. Its ease of manufacture, however, belies its many peculiar properties. The most well known property of a Möbius strip is that it possesses only one side. To illustrate this, make a Möbius strip and draw a line down its middle: you'll eventually return to your starting point without your pen ever having left the surface. (Möbius strip conveyor belts last twice as long as conventional belts because the entire surface area of the belt suffers the same amount of wear.) This one-sided shape, which returns you back to your starting point, is thus a wonderful image for the idea of recycling — and if you look closely at the ♻ symbol you'll see that Anderson's design features a Möbius strip.

BRAILLE LIGATURE TH

Recently I've observed Braille lettering in a number of places. I bought a pack of paracetamol tablets and embossed upon the outer packaging was product-related information in Braille. (At least, I assume the information was product related. I don't know for sure since I don't read Braille.) Elevator buttons, I've noticed, usually carry Braille patterns as do an increasing number of cash machines. I've seen Braille on public toilet doors, menus, and microwave meals. It's an impressive move into the mainstream for a communication system that can trace its origins to a Napoleonic code.

Napoleon wanted a system that would enable his soldiers to communicate at night, in silence and without light. A captain in the French army, Charles Barbier de la Serre, responded to his boss's wishes by inventing a system called night writing. Barbier based his system on a code that represented characters or sounds by dots embossed on thick paper. The system assigned 36 letters or phonemes to a unique place in a 6 × 6 grid. The letter 'a', for example, was in the first row and the first column; the letter 'r' was in the fifth row, fourth column; and so on. Positions on the grid were represented by the embossed dots, which were arranged in two columns. The first column, which could contain between one to six dots, denoted the grid row position; the second column, which again could contain between one to six dots, denoted the grid column position. Thus in Barbier's system the letter 'a' would be denoted by two dots next to each other, one dot in each column; the letter 'r' would be denoted by a column of five dots next to a column of four dots; and so on.

Unfortunately for Barbier, his night writing system was too difficult for Napoleon's soldiers to master. The French military decided it was a nice

idea, but not one they could pursue. In 1821, however, Barbier visited the National Institute for the Blind in Paris and there he talked about his system. A 12-year old pupil, Louis Braille, was in the audience.

Braille had been blinded in an accident at the age of three, but he was a bright boy who quickly came to terms with his situation and learned to master it. When Braille heard Barbier's talk he immediately understood its main flaw: a fingertip could not feel an entire symbol in one go and therefore a 'reader' could not move quickly from one character to another. Within three years, Braille had developed a simplified and improved system in which each letter was represented by a pattern of at most six dots. The smaller Braille cell meant that a 'reader' could recognise each letter with a single touch of the finger, while the code itself was quicker to learn than Barbier's. Braille published his system in 1829, and since then it has been adapted for languages throughout the world. (Although Braille was demonstrably easier to learn than Barbier's night writing, I still find it astounding that people can read using their fingertips. When I bought that packet of paracetamol I closed my eyes and tried to feel the difference between one embossed letter and another. Even if I understood Braille my fingertips are so insensitive they seem to have the equivalent of cataracts. I believe I'd struggle to distinguish Braille characters.)

The use of Braille seems to be more widespread than ever, which must be a boon for people who are blind or visually handicapped. Surprisingly, however, the number of Braille readers is in decline and has been for a while. What accounts for this seeming paradox? One reason, I guess, is that blind people increasingly have other options for accessing information: they can hear the words on a webpage via screenreaders, for example. As technology continues to advance, I wonder how long the Braille system will last?

Braille used on an ATM keypad. (Credit: redspotted)

STAR-AND-CRESCENT

I currently work at the University of Portsmouth, and when I first visited the University for an interview I was struck by the number of times I saw the star-and-crescent emblem ☾ around the city. It was on road nameplates, council buildings, licensed taxis... even on the local club's football shirt. The emblem strikes the eye because a rotated version of this symbol, ☪, a typically Islamic symbol, adorns the flags of Turkey, Algeria, Tunisia, and others. It looks somehow out of place on the south coast of England. The 'Welcome to Portsmouth' website claims the symbol of a waning crescent moon, without star, was on the flag of Byzantium (later Constantinople, now Istanbul). Legend has it that in 339 BC the city was under siege. The seagoing army launched a surprise night-time attack, but the forces of Byzantium repelled them in battle. The people of the city gave thanks to their patron goddess Artemis by adopting one of her symbols, a supposed representation of the crescent moon: ☽. When the Roman emperor Constantine later established Constantinople as the capital of the empire he added the Virgin Mary's star to the city's flag. According to this story, then, the star-and-crescent symbol dates back to 330 AD. (This seems late to me. The symbol appears on Macedonian coins much earlier than this.) How it came to be associated with Portsmouth is a convoluted story.

In 1192 Richard the Lionheart's sister and fiancée were shipwrecked near Cyprus and taken captive by the island's ruler Isaac Comnenus. Richard was not best pleased and so en route to the Crusade he took time out to conquer Cyprus. While there, Richard came across the star-and-crescent emblem because Comnenus, being a relative of the Byzantine Emperor, had adopted it as his family coat of arms. A few years later, Richard granted

Portsmouth its first town charter and, so the story goes, the town adopted the star and crescent in his honour. Whatever the truth of the tale, the symbol is known to have been used by Portsmouth mayors from the 17th century onwards, and they probably used it centuries earlier.

The association of the star and crescent with the Islamic faith is perhaps more straightforward. When the Turks conquered Constantinople in 1453 they adopted the city's original symbol, but changed its position so it clearly represented the waning moon (as seen by people living in the northern hemisphere). In other words, the symbol became ☾; only later was a star added and the symbol become ☪. The familiar five-pointed version was common by the beginning of the 20th century. The five points of the star were said to represent the five pillars of Islam:

Shahadah — the declaration of faith
Salat — performing ritual prayers
Zakat — paying a charity tax to help the poor and the needy
Sawm — fasting during Ramadan
Hajj — pilgrimage to Mecca

The ☪ symbol appears in various guises on flags, emblems, and coats-of-arms around the world. The position of the crescent moon varies slightly: usually it's waning, sometimes waxing, occasionally doing something no-one has ever seen it do. The number of points differs too: usually the star has five points, but six points is not unusual and occasionally it has eight points. They are all recognisable versions of the same symbol, however, and most of them have in common an astronomical impossibility: they show a star within the disc of the Moon. That implies the star is closer to us than the Moon is. No star or planet can be that close.

The Southsea bandstand at Portsmouth. The star-and-crescent symbol can be seen on many objects in the city. (Credit: Chris Gunns)

ANKH

The ankh is one of the modern world's most recognisable symbols. In tattooed form it adorns the bodies of numerous celebrities; the design is popular amongst jewellery makers; and it appears in the wonderful *Discworld* novels by Terry Pratchett — check out the Ankh-Morpork coat of arms. The ankh's status as an 'in' symbol is at first glance rather surprising, perhaps, given that it's pretty much synonymous with a long-dead civilisation. Draw someone holding an ankh and your viewers will know you've depicted an ancient Egyptian (of course it will help if you also combine, Picasso-like, frontal and profile views of the person you're drawing). The early ankh had a profound meaning, however, which means the symbol has managed to retain its popularity after 5000 years of history.

The ancient Egyptians often depicted their gods as holding an ankh to the Pharaoh's nose: through the ankh the gods were giving him (the Pharaoh was usually male) the breath of life. Consider, for example, the famous 'Boy King' Tutankhamun. This Pharaoh's name in hieroglyphics was *Amun-tut-ankh*, meaning 'living image of Amun'. (Amun was a local deity of Thebes who rose to make the big time and became top god of all Egypt.) Thus the ankh, and the associated hieroglyphic character, came to represent the concept of eternal life. Perhaps it's not so surprising, then, that the ankh has a high symbolic value, right up there with the cross.

The origin of the ankh is contested. The Victorian Egyptologist Thomas Inman suggested the ankh began as a representation of the female squeeze box and the male dangly bits (though, being a Victorian, Inman phrased this with infinitely more elegance and style). Seems reasonable to me. But other Egyptologists, possessing just as much eminence as Inman, have ar-

Hatsehpsut, who lived from 1508–1458 BC, was one of relatively few female pharaohs and is perhaps the first woman (of whom historians have knowledge) to hold a position of power. She achieved many things, including the development of trade links with the land of Punt. She commemorated the expedition to Punt at her mortuary temple at Deir el-Bahari. The figure shown here, from the temple, is seen holding an anhk. (Credit: public domain)

Thutmose III was for 22 years co-regent with his aunt and stepmother Hatsehpsut. Cartouches from his mortuary temple depict the ankh. (Credit: Hedwig Storch)

gued variously that the ankh signifies the knot used to tie the gowns worn by the gods; that it corresponds to a sandal strap with ankle loop; that it depicts the rising Sun; that it denotes the thoracic vertebrae of bulls; and that it represents the Nile (the oval being the Nile delta and the vertical line being the river itself). We'll probably never know for sure.

YIN YANG

The yin yang (or Tai Chi) symbol is easily constructed. Draw a circle and mark two points on a diameter, each point halfway between the centre and the circumference. Centred on each of these points draw a circle, each with a radius half that of the original circle. Draw two small circles at each of these points. Erase the right half of one of the middle-sized circles and erase the left half of the other middle-sized circle. Then colour one of the halves black, leaving its small circle white; the other half remains white while its small circle is coloured black. It's one of the most graceful, flowing symbols you'll find in this book.

My knowledge of Chinese philosophy is essentially non-existent, but even I know ☯ is supposed to represent the struggle, merger, and co-existence of two opposing quantities: male/female, hot/cold, dark/light, body/mind, expansion/contraction... (although whether these examples are yin/yang or yang/yin isn't obvious to me).

I've never seen a generally agreed explanation for the origin of the symbol, but the one I find most pleasing suggests an astronomical origin (it pleases me since I know more about astronomy than I do about Chinese philosophy). Unfortunately I think the explanation is quite wrong, for reasons I give later, but it is at least an interesting possibility.

Possessing the ability to calculate the dates of the summer and winter solstices and the vernal and autumnal equinoxes would have been as important for the ancient Chinese as it was for other ancient peoples, including the Egyptians and the builders of Stonehenge. The ancient Chinese astronomers studied Earth's annual cycle by making use of a gnomon. (A gnomon sounds fancy but it's just a tall pole stuck vertically in the ground.)

Light from the Sun causes a gnomon to cast a shadow. Every 15 days or so, at the same time of day, the Chinese astronomers would measure the length of the shadow cast by their gnomon. The shortest shadow would be cast on the day of the summer solstice (when the Sun was highest in the sky) and the longest shadow would be cast on the day of the winter solstice (when the Sun was lowest in the sky). The suggestion, then, is that the symbol ☯ is connected with the seasonal changes that occur as Earth makes its annual orbit of the Sun.

The argument is that the ancient Chinese astronomers drew a circle and divided it up into 24 sectors, one sector equating to one of the 15-day periods over which they measured the shadows. Starting from the winter solstice and moving through to the summer solstice they drew lines corresponding to the length of the shadows; the lines were drawn from the circle's centre to the boundary. They did the same starting from the summer solstice and moving through to the winter solstice, but this time they drew the lines from the boundary to the circle's centre. Once they did this they connected the dots and ended up with a divided circle that looks like the modern yin yang symbol. The area corresponding to more sunlight was called yang (Sun); the area that corresponded to more darkness was called yin (Moon). Under this interpretation, then, the original meaning of ☯ is light/dark or Sun/Moon.

Unfortunately, there are problems with this interpretation. For example, follow the procedure outlined above and you find that the diagram you obtain depends on the latitude at which you observe. Someone living at the north pole will draw a quite different diagram from someone living at the equator. Even for someone living at latitudes typical of a Chinese observer, the diagram he or she will draw is not precisely the same as the yin yang symbol. So, to me, this explanation sounds strained.

Rather than ☯ having an ancient origin, other sources suggest that the first yin yang symbol was drawn by the scholar Zhao Huiqian, who lived in the 14th century (according to the western calendar). In other words, the symbol may only be about six hundred years old — and thus of much more recent origin than many other symbols in this book. And some commentators have pointed out that a symbol similar to ☯ appeared on the insignia of certain Roman regiments — so perhaps the truth is simply that ☯ is a pleasant, flowing symbol to draw? Perhaps the deep philosophical attributes people assigned to the symbol came *after* it was first drawn?

PENTAGRAM

The pentagram is an extremely old symbol. Scholars have identified pentagrams in Sumerian writings dating back to about 3000 BC. The Pythagoreans of ancient Greece used the pentagram and considered it to be a symbol of mathematical perfection since it contains within itself several different shapes, including a regular pentagon and ten isosceles triangles; furthermore, the ratio of various line lengths is the golden number ϕ. (These things were important for the Pythagoreans. I won't delve into these matters here, but see the later section about ϕ for more information.)

In medieval times Agrippa, a German writer on the occult, popularised the pentagram as a magical symbol. Later, just as theologians once argued over how many angels could fit on the point of a needle, occultists began to argue over the correct orientation of a pentagram: they decided ☆, with single point up and pointing to heaven, was good (an interpretation boosted by the belief among some Christians that the pentagram represented the five wounds of Christ); on the other hand ⛧, with two points up, was terribly evil. That's probably why satanists use the inverted pentagram, sometimes with the head of a goat inscribed inside it (the two upmost triangles contain the goat's horns and the two side triangles contain the ears; the lowest triangle contains the nose and mouth). In the 20th century Aleister Crowley, the surprisingly influential British occultist, wrote a poem called *The Pentagram* and sprinkled the symbol liberally throughout his barmy writings.

The pentagram isn't used solely by satanists and occultists, however. It has become the official symbol of the Bahá'í faith; it appears on some Mormon temples; and Wiccans employ the pentagram, usually surrounded by

a circle, in the same way as Christians use the cross or Jews use the Star of David — in America, the circumscribed pentagram is an approved religious symbol at the Arlington National Cemetery.

The pentagram is thus a persistent symbol. It was common five thousand years ago; it has been used ever since; and in addition to the ongoing religious uses mentioned above you can see it today in jewellery designs, on the regalia of some Freemasons, and as an architectural flourish on a surprising number of churches (at least I find it surprising, given the symbol's long association with the occult). To my mind, though, the Pythagoreans had it right: the pentagram's mathematical properties are its most interesting aspects.

You can construct a pentagram by making use of a straightforward recipe: simply take a regular pentagon and extend its edges until the lines intersect. This process of extending the edges a polygon (or the faces of a polyhedron) until they meet to form a new polygon (or a new polyhedron) is called a stellation. Thus the pentagram is the stellation of a pentagon; in fact it's the *only* stellation of a pentagon

With the power of modern computers it's possible to take simple recipes such as the one given above and apply them to much more complicated objects than a pentagon. The figure below, for example, shows an icosidodecahedron (a three-dimensional solid with 20 triangular faces and 12 pentagonal faces) and its twelfth stellation.

Left: an icosidodecahedron. Right: its twelfth stellation. (Credit: Tom Ruen)

3
Signs and wonders

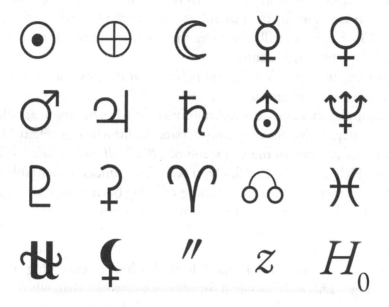

Some symbols are truly old. With a few quick strokes of your pen you can create characters that would have been recognisable to seers in ancient Rome, to astronomers in ancient Greece, even to the scribes in Babylon who had to make do by scratching marks in clay. It's quite a thought: the sign we use to represent the planet Venus, for example, might be as old as the pyramids.

We shouldn't be surprised if some of the signs representing celestial objects have their origins in the dawn of history. The people of antiquity had excellent reasons for scrutinising the sky. For example, the ancient Egyptians, by studying the positions of the sun, stars, and planets on the celestial sphere, could understand the changing of the seasons, predict the flooding of the Nile, fix the dates of their religious festivals. This stuff *mattered* to them. And since celestial objects were important so the signs people used to represent them became important too.

Today, you might think astronomers would be the people who make most use of the various astronomical signs. In fact, many professional

astronomers would be hard-pressed to identify some of the symbols I discuss in this chapter. Open any serious astronomy journal and you'll see a plethora of mathematical symbols, but few of the old astronomical signs. You might, for reasons I discuss in the relevant sections, come across \oplus used to represent Earth and \odot used to represent Sun; but you'd be most unlikely to see signs for the planets, say, or for the constellations of the zodiac. The reason we still encounter those ancient signs has more to do with *astrology* than astronomy.

In past centuries people really did believe that the position of stars and planets affected lives here on Earth.

For example, Shakespeare was certainly knowledgeable about astrology: in several plays he has his characters debate the influence of celestial bodies on human affairs. In the first scene of *All's Well That Ends Well*, for instance, Helena says to Parolles 'you were born under a charitable star' and the two then spar over the meaning of being born 'under Mars'. And in the second scene of *King Lear* Gloucester complains that 'these late eclipses in the Sun and Moon portend us no good'. Of course, this being Shakespeare, we don't know whether he himself believed in astrological concepts. In the same scene he has Edmund deliver a devastating critique of astrology: 'This is the excellent foppery of the world, that, when we are sick in fortune, often the surfeit of our own behaviour, we make guilty of our disasters the sun, the moon, and the stars; as if we were villains on necessity; fools by heavenly compulsion; knaves, thieves, and treachers by spherical predominance; drunkards, liars, and adulterers by an enforced obedience of planetary influence; and all that we are evil in, by a divine thrusting-on.' We know Shakespeare typically had villains such as Edmund speak truth, but whichever side the Bard was on the point is that he knew his audience would understand what his characters were saying. Astrology — which by medieval times had become a strange mix of astronomical observation, mathematics, and fraud — flourished. Even today, long after science has demonstrated the nonsensical nature of astrological concepts, it seems that in western countries about 25% of the adult population admit to a belief in some aspect of astrology. And thus it is that the old symbols used to represent planets and constellations are still often seen in the wider culture even though they are no longer widely used in astronomy. In this chapter, then, I look at some signs that represent objects in the solar system and at a couple of signs that represent constellations.

I also take a look at a few signs that astronomers *do* use when they take their scientific approach to the study of the universe. Symbols such as H_0 and z, for example, appear when cosmologists describe our current best understanding of the universe: that it began 13.8 billion years ago, that it expanded and cooled, and that the rate of expansion is increasing so that one day — in the far distant future — the expansion will carry other galaxies over the horizon and out of sight. It's a vision of the heavens that is so much more interesting than anything the astrologers dreamed up.

SUN

The generally accepted symbol for the Sun is ⊙, and it's one of the few symbols commonly used by non-scientists that professional astronomers still routinely employ themselves. The symbol retains its usefulness in science because astronomers often choose to compare the dimensions of various cosmic objects to those of our Sun. They'll happily write papers describing objects such as a 'black hole with a mass ten times that of the Sun', a 'red giant star with a radius 500 times that of the Sun', or a 'white dwarf with a luminosity 0.01 times that of the Sun'. Rather than keep on repeating the words 'times that of the Sun' they instead add the solar symbol as a subscript to the quantity of interest. So the aforementioned black hole has a mass of $10M_\odot$, the red giant has a radius of $500R_\odot$, and the white dwarf has a luminosity of $0.01L_\odot$. Easy. Simple. Elegant. But where does the symbol originate?

The circle with a dot in the middle is an ancient symbol. (Incidentally, to the best of my knowledge, the symbol lacks an official name. Dan Brown in his thriller *The Lost Symbol* has one of his characters remark that ⊙ is called a circumpunct, but that word appears in no dictionary to which I have access and I trust Brown's historical research about as far as I can throw one of his books. On the other hand, Brown was writing fiction and if he was simply making up a name for this symbol then I guess it's not such a bad choice.) Anyway, whatever it's called — circumpunct or circle-with-a-dot-in-the-middle — the symbol dates back at least as far as ancient Egypt, where it was one of the symbols of the Sun god Ra. To some Egyptians the Sun *was* Ra, whereas for others the Sun was Ra's eye. Sometimes, therefore, Egyptians represented Ra by a circle and sometimes they used

a circle with a dot in the middle — the dot being the iris in Ra's eye. The Egyptian hieroglyph for 'Sun' was a vertical line above which was the encircled dot. Small wonder, then, that astrologers — and, later, astronomers — used the symbol to represent the Sun. (Alchemists also made use of the symbol to represent gold, perhaps because of the metal's shininess and colour reminded them of the Sun.)

To my mind the symbol ⊙ for the Sun is entirely appropriate in the light of our modern understanding of the Solar System.

To the ancient Egyptians, the Sun, Moon, and planets were gods to be worshipped; our modern understanding tells us the Solar System consists of a quite normal central star around which orbits what is essentially rubble. About 99.86% of the entire mass of the Solar System resides in the vast ball of hydrogen and helium gas we call the Sun. (The hydrogen in the Sun gets converted into helium through a process of nuclear fusion, and as a byproduct energy is released. This is fortunate for us. It's the energy from these reactions that sustains life on our tiny planet.) The Sun is about 333 000 times as massive as Earth and more than 1000 times as massive as the biggest planet, Jupiter. The eight planets and their satellites, the five known dwarf planets, and a multitude of asteroids all orbit the Sun — and the overwhelming majority of them orbit in essentially the same plane, called the ecliptic.

The existence of the ecliptic is presumably a hangover from the creation of the solar system itself. Astronomers believe the planets of the solar system formed from a thin, protoplanetary disk of dense gas and dust; the ecliptic is the remnant of the plane of that initial disk. (It's worth pointing out that the Solar System also contains an uncountable number of comets. Astronomers believe the so-called Kuiper belt, which lies beyond the orbit of Neptune, contains more than 100 000 comets with a diameter greater than 100 km. The Kuiper belt objects, like the planets, tend to lie close to the ecliptic. However, astronomers also believe there to be a much larger reservoir of comets — perhaps a trillion or more — lying in the so-called Oort Cloud, and these *don't* orbit in the ecliptic plane. The Oort Cloud is instead a sphere, centred on the Sun, that lies at the very edges of the Solar System.)

So the symbol ⊙ is not a perfect representation of the Solar System — but if you think of the central dot as representing the Sun and the circle as representing the ecliptic it's not too far wrong.

PLANET EARTH

Two symbols are in common use to represent Earth. The symbol often used in astronomy is a cross circumscribed by a circle: \oplus. This ancient sign has been used for a variety of purposes in different cultures; it has been called the sun cross, the wheel cross, Odin's cross, and Woden's cross. Neolithic graffiti artists scratched the symbol on stones. (It's not surprising our ancestors might carve such a sign. I sometimes find myself doodling the same motif on misted glass. There's no deep significance to it.) Anyway, astronomers use \oplus to represent Earth in the same way they use \odot to represent the Sun. When they write about the properties of exoplanets, for example, they can use the symbol as a shorthand: instead of writing 'the newly discovered exoplanet has a radius twice that of Earth and a mass four times that of Earth' they can use $2R_{\oplus}$ and $4M_{\oplus}$ to convey the same information.

The second version of the Earth symbol is a cross on top of a circle: ♁. This is a stylized globus cruciger — literally a cross-bearing orb. It has been used for many centuries as a Christian symbol. Before that it was used in Roman iconography: there's a coin dating back to the reign of Emperor Hadrian, for example, that bears a globe. Gods or emperors were often pictured holding the globus cruciger, images clearly intended to show an all-powerful individual holding the world in his hand.

It's interesting that a globe has long been used as an Earth symbol because a myth has grown up that ancient people believed Earth to be flat. In fact, the notion of a spherical Earth was commonplace in Greek astronomy. After all, some obvious clues point to Earth's sphericity and Greek astronomers couldn't have missed them. For example: during a lunar eclipse Earth casts a curved shadow on the Moon; when a ship sails over the horizon its

A globus cruciger, part of the Danish Crown Regalia. It symbolises Earth surmounted by the Christian cross. The symbol ♁ has thus come to represent planet Earth. In astronomical contexts, however, the symbol ⊕ is more often used. (Credit: Ikiwaner)

mast remains visible for some time after the hull has disappeared; and when the Sun is directly overhead in one southern town on the summer solstice it *isn't* directly overhead at a town many miles to the north. How can one possibly explain these observations without resorting to a spherical Earth?

The latter observation, regarding the position of the Sun, enabled the Greek astronomer Eratosthenes to estimate Earth's circumference. Eratosthenes knew that at noon on the summer solstice the Sun cast no shadow in Aswan; in Alexandria, north of Aswan, the Sun was 7° 12′ south of the zenith and thus cast a shadow. By making some simple assumptions and applying basic trigonometry he calculated Earth's circumference, and was correct to within a few percent (either 2% or 16%, depending the size of the distance measure he used; historians still debate this). Eratosthenes was doing this work more than two centuries before the birth of Christ.

So scholars in medieval Europe would have known Earth is a sphere, and therefore the use of a symbol such as ⊕ or ♁ to represent Earth would have made sense to them. What makes no sense is that some people still believe in a flat Earth. In 1881, Samuel Rowbotham wrote a book entitled *Zetetic Astronomy: The Earth Not a Globe* in which he argued Earth is a flat disc. He died three years after its publication but his ideas did not die with him. In 1956 Sam Shenton founded the Flat Earth Society — and it's still around, with members, lurking in the dark recesses of the internet.

MOON

The Moon demands our attention. Not only is it the brightest object in the night sky — it can appear about 25 thousand times brighter than Sirius, the brightest star — its appearance and location change from night to night in a predictable way. Furthermore, by continuously shifting billions of tons of seawater through gravitational tidal forces, the Moon directly affects us here on Earth. It's not surprising, then, that the earliest civilisations studied the Moon — and, even though those ancient astronomers lacked an underlying theory of the Moon's motion, they eventually learned how to predict where Earth's in the sky satellite would be at any particular time, and how its phase would change. By the time of the Greeks, astronomers had a clear understanding of *why* the Moon has phases. (Understanding how the Moon affects tides was much more difficult. The problem of the tides remained unsolved until Newton came along.)

We don't know the names of the early astronomers who first explained the phases of the Moon, but we do know that by around 500 BC the Greeks had twigged how the relative positions of Sun, Earth, and Moon, in a system in which a spherical Moon is in motion around Earth, would give rise to the lunar phases we observe.

The Sun illuminates half of the Moon's sphere, and when Sun and Moon are on the same side of Earth we see a new Moon (for which the symbol ● can be used). As the Moon moves in its orbit, an increasing amount of its surface is illuminated as seen from Earth: we observe a growing, or waxing, crescent (☽ is the symbol in this case). The Moon waxes until we see a first quarter Moon, where half of the surface is lit, and then a gibbous Moon. Eventually, Sun and Moon are on opposite sides of Earth and we see a

A quite beautiful photograph of the waning Moon at sunrise, taken by the MPG/ESO 2.2 m telescope at La Silla in Chile. The Moon here was 24.3 days old and about 5 days before New Moon. (Credit: ESO)

full Moon (for which the symbol ○ can be used). The Moon then starts to wane, and we see less of it each day. We observe first a waning gibbous Moon, then a last quarter Moon, and then a waning crescent Moon (for which the symbol is ☾). This latter symbol, ☾, is the one that's generally used to represent the Moon and it's an obvious choice to anyone who has ever looked up at the night sky. One month after the new Moon that started the cycle, we get another new Moon.

Greek astronomers deduced many things through a careful study of lunar phases. For example, at full Moon it's possible to see a lunar eclipse: the Moon moves through Earth's shadow. (A lunar eclipse doesn't happen every month because of the Moon's orbital tilt: sometimes the Moon passes above Earth's shadow, sometimes below.) By timing the duration of a lunar eclipse, Aristarchus was able to estimate the distance to the Moon in terms of the radius of the Earth. And by observing a first quarter Moon he was able to estimate the distance to the Sun, also in terms of Earth's radius. His estimates weren't accurate by modern standards, but they are nevertheless impressive when you remember that he was working these things out in around 250 BC!

PLANET MERCURY

Humankind has been aware of the planet Mercury, the planet closest to the Sun, since at least the 14th century BC. We know this because anonymous Assyrian astronomers recorded their observations of Mercury on clay tablets, and these tablets still survive: you can see them in the British Museum. (I find it hugely impressive that these ancient astronomers recognised Mercury, since it's visible only at certain times and when various conditions are met. If you want to see Mercury and you are in the northern hemisphere then your best chances are on spring evenings and autumn mornings.) The Assyrians wrote the planet's name in cuneiform, a name scholars have translated as 'the jumping planet' — so-called because the planet moves quickly from one side of the Sun to the other. The Babylonians, observing a few centuries later, called it Nabu, after their god of wisdom and writing. The ancient Greeks had *two* names for the planet: Hermes when it was visible in the evening sky and Apollo when it was visible in the morning sky. It was only in the 4th century BC that the Greek astronomers fully understood that these two celestial objects were actually the same planet, and they chose the name Hermes for it. The Romans called it Mercury, who was their analogue of the Greek god Hermes. The name chosen by the Romans was entirely appropriate: Mercury, the god of messages and travellers, moved swiftly on his winged shoes; the planet Mercury moves across the sky more quickly than any other planet.

The planet's symbol, like its name, goes back a long way — at least to the Greeks, and possibly earlier.

In Greek mythology, Hermes was usually portrayed carrying a caduceus, a short staff around which are entwined two snakes. (I explain the reason

This piece of ancient Greek pottery shows Hermes holding his kerykeion (in Latin, caduceus). The top part of the caduceus gives rise to the symbol for Mercury. This particular vase, known as a lekythos, is attributed to the Tithonus Painter and probably dates to 480–470 BC. It would have stored oil. The lekythos was used in ceremonies to anoint the dead bodies of unmarried men. (Credit: David Liam Moran)

for this portrayal of Hermes in a later section, when I discuss the caduceus symbol itself: ☿.) A stylised depiction of a caduceus, ☿, came to represent the god and then, later, the planet.

The planet Mercury, we now know, is a world of extremes. It's the smallest of the eight planets in the Solar System, with a surface that's pockmarked with craters — the result of impacts with asteroids and comets over the past few billion years. The night on Mercury is bitterly cold, with temperatures dropping to −173 °C; during the day temperatures can reach 427 °C. It's not a place to visit, and indeed it's a place that hasn't been much visited: at the time of writing, only two probes have made close observations of the planet. A third probe, BepiColumbo, is due to arrive at Mercury in 2024.

PLANET VENUS

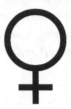

Venus is beautiful. The Moon apart, Venus is the brightest object in the night sky; the Sun apart, it shines more brightly than any star. Because Venus is closer to the Sun than Earth is, the planet can never be very far away from the Sun in the sky. If Venus is near the Sun in the west, then it shines brightly in the evening at sunset. If Venus is near the Sun in the east, then it shines brightly in the morning before sunrise. The early Greeks thought these appearances denoted two objects — Hesperus (meaning 'western') for the 'evening star' and Phosphorus ('light bringer') for the 'morning star'. However, it seems clear from a clay tablet dating back as far as 1581 BC that the Babylonians probably realised that the morning and evening stars were the same object.

Venus seems always to have been associated with concepts of femininity. The reasons for this are lost in the depths of prehistory, but we know that the Babylonians called the planet Ishtar, after their goddess of fertility, sex, and love. The Greeks, once they'd got their heads around the concept that the same object could appear in the morning and evening sky, called the planet Aphrodite — goddess of those same things. We know the planet by the Roman equivalent of Aphrodite: Venus. It is the only planet in the solar system with a feminine name.

The symbol for Venus, ♀ is associated with several other concepts: it represents the female sex, for example, and the chemical element copper. But why should ♀ symbolise Venus or femininity or copper? It's possible the reason could date back as far back as 4000 BC, when Mesopotamian artisans made mirrors from polished copper. If you were to draw a hand mirror even nowadays, you'd probably come up with something similar to

This lekythos, or oil bottle, dates to 470–460 BC, and was painted by someone who is now known as the Sabouroff Painter. More than 50 red-figure bottles such as this one are attributed to him. The picture here is of a seated woman holding a mirror. Note the resemblance between the mirror and the symbol for Venus. (Credit: Marsyas)

♀ — the circle representing the mirror itself and the cross representing the handle. So ♀, the stylised depiction of a hand mirror, could quite plausibly have become the symbol for copper in a time when mirrors were made from metal rather than glass. And since Aphrodite was often depicted admiring her beauty in a mirror, the symbol came to represent femininity — and thence the planet Venus. The story at least seems plausible.

A more recent link between Venus and mirrors happened in 2012 when, as viewed from Earth, Venus crossed the Sun's disk (an event that won't re-occur until 2117). The Hubble Space Telescope couldn't observe the transit directly — the Sun would have blinded it — so instead it used the Moon as a mirror with which to observe Venus. The idea was to detect Venusian-filtered sunlight reflected from the Moon. One day this technique could help us learn about the atmospheres of planets orbiting distant stars.

PLANET MARS

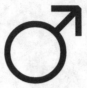

Even to the naked eye the fourth planet from the Sun has a definite and clearly recognisable colour. It's the colour of blood. Perhaps for this reason the ancient Greeks named the planet after Ares, their god of war. The Roman equivalent, of course, was Mars.

The symbol for the god Mars was a shield and a spear, represented by a circle and an arrow, and it's from this we get the symbol for the planet: ♂. Just as the symbol for Venus, ♀, is also the symbol for the female, so the symbol for Mars has become the symbol for the male. In both cases the symbols display rampant sexism, but we're stuck with them.

The shield-with-spear symbol ♂ is appropriate for the planet Mars for a reason the ancient astronomers could not possibly have known. Humankind has sent several robotic explorers to Mars. (At the time of writing the *Curiosity* rover, a robotic vehicle the size of a family car, is exploring the Gale crater; but *Curiosity* is building on the results of several previous missions.) These robot explorers have analysed the thin layer of reddish dust that covers Martian surface, dust that gets blown by winds into the thin Martian atmosphere and gives the planet its red, bloody appearance. These explorers confirmed that the dust consists of particles of iron oxide — the more familiar name for which is rust. Mars is thus covered in iron, and the ancient alchemical symbol for iron is... ♂.

It's interesting that iron not only gives rise to the rust-red colour of Mars, it also gives rise to the colour of blood itself. Our red blood cells hold a molecule called haemoglobin whose function is to carry oxygen around the body. Haemoglobin contains iron, to which oxygen atoms can attach themselves, and this particular combination of atoms in the haemoglobin

A painting of Mars, standing on a plinth holding his shield and spear. (The fresco is in the House of Venus, Pompeii.) The Romans had a more positive attitude to Mars than the Greeks had to Ares. The Greeks believed war brought with it disruption and violence, wheras for the Romans war was a way of securing the nation's peace. The Romans so revered Mars, in fact, that they dedicated a whole month — March — in his honour. (Credit: Carole Raddato)

molecule tends to absorb short-wavelength blue and green light; longer wavelengths are scattered, producing blood's characteristic red hue. It's another connection of which the ancient astronomers were ignorant.

The Red Planet continues to have an association with war: more than two thousand years after the Romans named the planet Mars, western civilisation was enjoying books such as Wells's *The War of the Worlds* and films such as *Mars Attacks!* and *Invaders from Mars*. Nevertheless, there are more benign associations. Mars was not only the Roman god of war, he was also the god of agriculture. Those who are in favour of terraforming the Red Planet, and making it suitable for human colonisation, may prefer this gentler symbolism. And our robotic explorers are finding evidence that water once flowed on Mars; perhaps one day people will grow crops there.

PLANET JUPITER

It is perhaps fitting that civilisations throughout history have named the fifth planet from the Sun — the biggest, most impressive, most massive planet in the solar system — after their 'top' god. Although the ancient Babylonian astronomers could have had no idea of the planet's tremendous size, they named it after the most important god in their pantheon: Marduk. The later Greek astronomers named it after Zeus, the 'father of gods and men' who ruled from Mount Olympus. We know it as Jupiter, after the Roman equivalent of Zeus.

The symbol for the planet Jupiter is ♃, and over the years different people have offered different explanations for its origin. Perhaps the commonest interpretation of the symbol that you'll encounter is that it's intended to represent a bolt of lightning.

According to Greek mythology the three giant Cyclops — Arges, Brontes, and Steropes — gave Zeus the lightning bolt as a weapon for use in the Battle of the Titans, a decade-long war fought between two sets of gods long before mankind came into being. The lightning bolt, or thunderbolt, became a symbol for Zeus himself, and Greek artists often depicted him striding forward with a bolt clutched in his raised right fist. The Romans appropriated the myth, tweaking it a little so that the Cyclops gave the thunderbolt to their own god Jupiter. The argument goes, then, that ♃ is a stylised representation of the lightning bolt. Sounds good, except that (to my eyes at least) ♃ looks nothing like a bolt of lightning, stylised or otherwise.

A more plausible suggestion is that ♃ stands for the Greek letter zeta, ζ, which is the first letter of the name Zeus. The difficult with this suggestion

is that ζ doesn't look much like ♃; if the Greeks wanted to use the letter zeta to represent Zeus surely they'd have just used ζ? But I guess it's possible that, over time, copying imperfections caused ζ to morph into ♃.

Yet another suggestion is that the symbol ♃ represents an eagle. Zeus was often depicted standing beside a giant golden eagle, a bird that served as his personal messenger as well as a companion. (A bit like Hedwig the snowy owl was to Harry Potter, I suppose.) This eagle was a sacred bird, which was honoured with its own constellation, no less; the eagle of Zeus is the constellation Aquila. Anyway, the eagle became a symbol for both Zeus and Jupiter — and I guess that, in the right sort of light and if you scrunch up your eyes, you can convince yourself that ♃ is not unlike the profile of a bird of prey...

Finally, I've heard people argue that the symbol ♃ is a stylised version of the number 4. The symbol ♃ certainly *looks* like the number 4, but that's where the plausibility of this particular suggestion ends. Even if the early astronomers used the Arabic number 4, rather than say the Roman numeral IV, what would be the significance of 4 with regards to the planet Jupiter? Some people have argued that, before astronomers understood that Earth was just another planet in the Solar System, Jupiter would have been classed as the fourth planet from the Sun. Well, I'm sorry, but that has to be the dodgiest of all the interpretations.

Perhaps that initial interpretation was correct, and ♃ really does represent the arm of Jupiter clasping a thunderbolt. If it does, then the symbol has turned out to be an appropriate one.

The one fact most people have heard about the planet Jupiter is that it's home to a storm known as the Great Red Spot. This anticyclone is *vast* — easily big enough to swallow three Earths — and has been raging for at least 350 years. But Jupiter's atmosphere contains many more features than just the Great Red Spot. For example, terrestrial telescopes and probes sent to the planet itself have revealed the presence of many smaller, shorter-lived storms. These are typically 500 miles or so in diameter and last between a few days up to a month. And those Jovian storms are invariably accompanied by lightning. The lightning flashes on Jupiter are similar to the strikes we experience on Earth, except they can be many times more powerful. The thunderbolts fashioned by those three Cyclops — Arges, Brontes, and Steropes — were puny compared to some of the superbolts unleashed by storms on planet Jupiter.

PLANET SATURN

Saturn is the most distant of the five planets visible to the ancient astronomers. Even so, its yellowish light was bright enough for Babylonian astronomers to have recorded in detail its movements across the sky. For the Babylonians, the planet was associated with a god of agriculture called Ninurta. The Greeks also named the planet after a god of agriculture: Cronus. The Roman equivalent of Cronus was Saturn.

Cronus wasn't a pleasant chap. He was a Titan, the son of Uranus (the sky) and Gaia (the Earth). His parents had a falling out after Uranus imprisoned two of Gaia's children in the underworld dungeon Tartarus, a place of horrible torment. (Perhaps Uranus simply didn't like the look of the children: one of them, Hecatonocheires, had a hundred hands; the other, Cyclopes, had a single eye in his forehead.) In order to get revenge Gaia made an adamantine sickle and asked for volunteers for what seemed to be a suicide mission: use the sickle to castrate Uranus. Only Cronus was brave enough to take on the challenge. Cronus ambushed Uranus, attacked him with the sickle, and threw his father's testicles into the sea. Nice. Since Uranus was now in no fit state to rule, Cronus took over. He released Hecatonocheires and Cyclopes but soon after, in the way of dictators throughout history, he changed his mind and had them re-imprisoned back in Tartarus. Cronus did get his comeuppance, though. When Cronus learned that his destiny was to be overthrown by his son, just as he had overthrown his own father, he took preventative measures: when his wife (and also sister) Rhea gave birth to the gods Demeter, Hestia, Hera, Hades, and Poseidon, he ate them. However, Rhea gave birth to her sixth child Zeus in secret. She presented Cronus with a stone wrapped in swaddling clothes and he swallowed

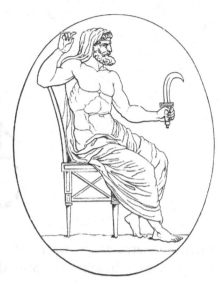

The ringed planet (left) and the god Cronus/Saturn, depicted here with his trade-mark sickle. (Credit: photo, NASA; drawing, public domain)

it (both the stone and the story). When Zeus grew up he forced his father to regurgitate his siblings. Zeus then set Hecatonocheires and Cyclopes free and, with their help, overthrew Cronus and imprisoned him in Tartarus.

Cronus was nearly always depicted holding a scythe, although whether this was to commemorate his act of patriarchal castration or in recognition of his position as the god of agriculture I don't know. Either way, Cronus — and the Roman equivalent, Saturn — became to be symbolised by a scythe. And a stylised version of this emasculator/grain-cutting tool became the symbol for Saturn the planet: ♄.

Thanks to its magnificent ring structure Saturn is probably the most recognisable of all the planets. The first person to see the rings was Galileo, though he didn't recognise them as such. Galileo pointed a handmade telescope towards Saturn on 25 July 1610, and what he saw confused him. Through his primitive telescope the rings appeared as two blobs on either side of the planet, and naturally he thought the blobs were satellites. When he repeated his observations some time later the orientation of the rings had altered so they were edge on, which meant he was unable to see the 'satellites'. Making reference to the myth, Galileo is reputed to have said: 'Perhaps Saturn has devoured his own children.'

PLANET URANUS

When compared to the seven astronomical symbols discussed earlier in this chapter — those for the Sun, the Earth, the Moon, and the planets Mercury, Venus, Mars, Jupiter, and Saturn — the symbol that represents Uranus is of relatively recent origin. It has to be. Uranus was entirely unknown to people living in ancient times. The discovery of Uranus was made on 13 March 1781, from the back garden of the house at 19 New King Street in Bath, and this was the first time in recorded history that astronomers were free to make up a name for a planet — and therefore a symbol to go along with it.

It was William Herschel who discovered the seventh planet from the Sun. (His house in New King Street, incidentally, is now a museum that's well worth paying a visit.) Uranus had in fact been seen long before Herschel saw it, but nobody dreamed it was a planet: John Flamsteed for example, the first Astronomer Royal, saw Uranus as early as 1690 — but he thought it was just a star, which he called 34 Tauri. Herschel's discovery came about as he was studying the sky through a telescope of his own design. On that March night he spotted a small patch of light that seemed to him to be a comet or nebula. Subsequent observations, however, soon demonstrated that this object had to be something quite different. It was a new planet, unknown to the ancients. King George III gave the astronomer an annual stipend of £200 for this unprecedented discovery and in return, in a literally astronomical piece of fawning, Herschel called the new object Georgium Sidus: George's Star or, as we would now call it, George's Planet. Needless to say, the rest of the world was not overly enamoured of Herschel's proposal and other astronomers suggested alternatives.

The French astronomer Jérôme Lalande, showing a singular lack of imagination, suggested the planet be named after Herschel himself. The associated symbol would be ♅ — a globe, with the first letter of Herschel's surname on top of it. The symbol is apparently still sometimes used in astrology and for some reason is the default Unicode symbol for the planet.

The Swiss mathematician Daniel Bernoulli weighed in with the ugly name Hypercronius (see the section on Saturn for why this makes a sort of sense), and various other scientific luminaries put forward several different other names. But it was the German astronomer Johann Elert Bode who proposed the name that would provide fodder for future generations of sniggering schoolboys — at least for those who speak English.

Bode argued that just as Saturn (the sixth planet from the Sun) was the father of Jupiter (the fifth planet), so the name of the seventh planet should represent the father of Saturn. Well, as we saw in the previous section, in Greek mythology the god Saturn was known as Cronus; and, again according to the Greeks, the father of Cronus was Uranus, the god of the sky. Bode's suggestion of Uranus as the name of the new planet caught on quickly, but it wasn't until 70 years after Herschel's discovery that there was full agreement amongst the astronomical community that this should be the planet's name.

So much for the name. What about the symbol?

Well in 1785 Johann Gottfried Köhler, a German astronomer who discovered a number of galaxies, invented a symbol that was intended to represent another recent scientific discovery — in this case the discovery of the metal platinum. Köhler's symbol, which looked similar to ♅, was a mixture of the alchemical symbol for iron (♂) and the alchemical symbol for gold (☉). His reasoning was that platinum had been found mixed with iron and the new metal was also called 'white gold'. After a bit of tweaking by Bode, the symbol soon came to represent the planet Uranus.

The attentive reader will already have realised that the alchemical symbol for gold is the same as the astrological symbol for the Sun; furthermore, the alchemical symbol for iron is the same as the astrological symbol for Mars. One can therefore read another story into the symbol for Uranus. Since in ancient Greek mythology Uranus was the god of the heavens, he could be represented by a combination of the light of the Sun (☉) and the power of the war god Mars (♂). For people who believe in such nonsense, ♅ isn't a bad choice of symbol.

PLANET NEPTUNE

Sixty-five years after Herschel discovered Uranus, the French astronomer Urbain Le Verrier predicted the existence of an eighth planet in the Solar System. And since Pluto has sadly been demoted from the brotherhood of planets, Le Verrier remains the last person to have discovered a planet orbiting our Sun.

Le Verrier's discovery came about through an analysis of the orbital motion of Uranus based on Newton's law of universal gravitation. Uranus lagged behind where Newton's theory said it should be and, rather than suggest Newton's law was wrong, Le Verrier argued that the mass of some unknown planet must be affecting the orbit of Uranus. He calculated where the putative planet would have to be and astronomers at Berlin Observatory, in their first session spent looking for the planet (the night of 23 September 1846), found the planet where he had told them it would be. How's that for a prediction? (As with Uranus, astronomers had seen the planet before without recognising it as such. Galileo saw it in 1612, for example, but he thought it was a star.)

So another newly discovered planet. What to call it?

Unlike Herschel, Le Verrier didn't toady up to some luminary: he instead gave the naming job to his colleague François Arago who suggested the name... Le Verrier. (The authors of French almanacs, who had been dismissive of using the name Herschel for Uranus, briefly changed their minds and agreed to use Herschel for the seventh planet if it could be Le Verrier for the eighth.) The Berlin Observatory astronomer Johann Gottfried Galle, the first person to actually *see* the new planet and know he was looking at a planet, suggested the name Janus: the two-sided face of this god would

signify the planet's position at the edge of the solar system. But Le Verrier offered another option: Neptune. This was quickly adopted by the astronomical community, and that's how the planet has been known ever since.

There doesn't seem to have been a particular reason for choosing the name Neptune except that all other planets (Earth excepted) were named after Greek or Roman gods and Neptune was an important god who had not yet been so honoured. It turns out to have been an appropriate choice: modern telescopes show that Neptune has a deep blue colour — not unlike the sea.

The symbol for Neptune is ♆, and this is an easy one to explain: it's just a stylised version of the sea god's familiar trident.

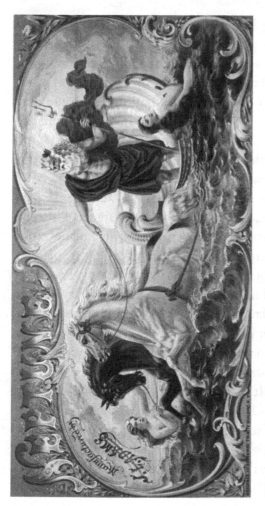

This tobacco box label, manufactured by J. L. Adams in 1866, shows two nymphs and two horses pulling Neptune through the water. Neptune's trident can be clearly seen. In Roman mythology, Neptune used a trident to create new bodies of water; if he struck the Earth in anger with his trident he caused earthquakes. (Credit: Library of Congress, https://www.loc.gov/item/2001697765/)

DWARF PLANET PLUTO

♇

As a child, thrilled by the Space Race, I gobbled up space-related facts. One important fact was this: the Solar System has nine planets. My favourite planet — perhaps because it was the most distant and thus most mysterious — was Pluto. You can understand, then, how my flabber was never more gasted than in August 2006 when the International Astronomical Union defined a planet to be (i) a celestial body that is in orbit around the Sun; (ii) is massive enough to assume a nearly round shape; and (iii) is big enough to have cleared the neighbourhood around its orbit. Fine, I suppose, except this definition excludes Pluto. It's no longer a planet.

Astronomers had good reasons for this act of cosmic sabotage. In particular, they were finding in the solar system bodies as large as Pluto. If Pluto was a planet then presumably these other objects were planets too. Instead it made more sense to demote Pluto to the status of 'dwarf planet', a class to which all these newly discovered objects would belong. Poor Pluto's official name is now asteroid number 134340. So much for romance. The solar system thus has *eight* planets: four rocky planets close to the Sun and four gas giant planets farther out. The dwarf planets are expected to be much more numerous than planets, but only Eris, Pluto, Makemake, Haumea, and Ceres (in order of size) are currently recognised as dwarfs.

But I haven't forgotten Pluto. It was discovered on 18 February 1930 by Clyde Tombaugh at the Lowell Observatory in Flagstaff, Arizona. Tombaugh had spent a year looking at pairs of photographs of the night sky taken a few days apart. Tombaugh's hope was that by flicking between photographs he would detect nearby objects: planets, for example, would move position over a fortnight whereas stars would be fixed. Sure enough,

A hi-res photo of Pluto, taken by cameras on the New Horizons spacecraft on 14 July 2015. Before New Horizons flew past, little was known about the dwarf planet; these images contain details of features as small as 1.3 km. Unfortunately, there are no plans to return to Pluto in the foreseeable future. (Credit: NASA/Johns Hopkins University/SRI)

he spotted a shifting fleck of light on a pair of photographic plates. The Lowell Observatory took further photographs of the star field to confirm the existence of the planet, and then announced the discovery to the world.

The discovery, of course, caused headlines; over a thousand names were proposed for the planet. Constance Lowell, the widow of the observatory's wealthy founder, proposed the name Zeus; then she ventured Percival (just think: instead of Uranus and Pluto we could have had George and Percy); and then she really tried her luck and suggested Constance. Her proposals were politely ignored. On 14 March 1930 Venetia Burney, an 11-year-old schoolgirl in Oxford, was told of the discovery by her grandfather. She suggested the name Pluto and her grandfather passed it on to a professor of astronomy who in turn cabled it to his colleagues at the Lowell Observatory. Everyone there liked the name: it was suitably classical (Pluto, the ruler of the underworld, was the brother of Neptune and Jupiter) and its first two letters were the initials of the observatory's founder. Job done. The name was formally adopted six weeks later. (Young Venetia did well out of it too: her grandfather gave her £5, a decent sum back then.)

As for the symbol, it's a simple monogram of the letters P and L: ♇. A variant symbol for Pluto is apparently favoured by astrologers. I don't know whether astrologers believe Pluto, following its demotion to a dwarf planet, still influences us. My guess is, sadly, that they probably do.

CERES

♀

Following Pluto's demotion the Sun's kingdom contains just eight planets. There are, however, numerous smaller objects that follow planetary-type orbits. Take for example the asteroids.

The first asteroid to be discovered was a block of rock and ice, with a diameter roughly the length of Great Britain, spotted in 1801 by the Italian priest and astronomer Giuseppe Piazzi. At first, it was thought the object might be a 'missing' planet. (The astronomers Johann Daniel Titius and Johann Elert Bode developed a 'law' that seemed to provide an excellent fit for the distances of the planets from the Sun. However, the Titius–Bode law could only work if there were a planet between the orbits of Mars and Jupiter. In later years this hypothetical planet was given the name Phaeton.) Piazzi's object certainly occupied the right space — but astronomers soon realised it was too small to be a planet and they quickly found many more even smaller objects with similar orbits. We now know there are *millions* of rocky objects in a belt between Mars and Jupiter. These are the asteroids, of which Piazzi's object is by far the largest: it contains about a third of the mass of the asteroid belt. Indeed, the object is so large that it's now classed, along with Pluto, as a dwarf planet.

Piazzi, when exercising his right to name his discovery, suggested it be called Cerere Ferdinandea: Cerere after Ceres, the Roman goddess of agriculture, and Ferdinandea after the reigning king of Sicily. (You'd have thought Piazzi would have learned from the Uranus episode that you shouldn't try to name planets after living people. It just doesn't work.) So, the second name got quietly dropped, and the object became known as Ceres. As for the symbol: well, the German astronomer Franz Xaver von

Zach argued that its symbol 'may represent a sickle, as Ceres is the goddess of corn and tillage'. Seemed reasonable, and the sickle did indeed become the symbol for Ceres: ⚳.

But there's a problem with this naming and symbol scheme.

The year after astronomers discovered Ceres they found another asteroid: Pallas (which is named after the Greek goddess Pallas Athena). Two years after that they found a third asteroid: Juno (named after the daughter of Saturn, and also the sister — and wife — of Jupiter). And three years later still there was a fourth: Vesta (after the Roman goddess of home and hearth). So four asteroids, four names, four symbols:

Ceres: ⚳ Pallas: ⚴ Juno: ⚵ Vesta: ⚶

The problem is that as they found more asteroids, astronomers had to dream up more symbols. Benjamin Gould, founder and editor of the noted *Astronomical Journal*, described the problem in 1852, by which time the fifteenth asteroid had been discovered (and called Eunomia, after one of the Greek goddesses of the seasons and the natural divisions of time). In an editorial he wrote: 'As the number of the known asteroids increases, the disadvantages of a symbolic notation analogous to that hitherto in use increase much more rapidly even than the difficulty of selecting appropriate names from the classic mythology. Not only are many of the symbols proposed inefficient in suggesting the name of which they are intended to be an abbreviation; but some of them require for their delineation more artistic accomplishment than an astronomer is necessarily or generally endowed with. The symbol proposed for Irene [the fourteenth asteroid to be discovered, and named after the Greek personification of peace], for example, has not only never appeared, but I am not aware that it has ever been actually drawn.'

The editor of the *Berlin Astronomy Yearbook*, Johann Franz Encke, was also aware of the problem. For his journal Encke developed a simple symbolic system for asteroids: a circle containing the number of the asteroid in chronological order of its discovery. So the symbol for Ceres became ①, Pallas became ②, Juno became ③ and Vesta became ④. Nowadays, however, astronomers tend not to use symbols at all. Once an asteroid has had its orbit confirmed, it's given a number and possibly a name. Thus astronomers refer to 1 Ceres, 18 Melpomene, 433 Eros and so on.

VERNAL EQUINOX

As Earth makes its yearly lap of the Sun, the Sun itself appears to move across the celestial sphere. Over the course of a year Earth's orbital motion causes the Sun to trace a path on the sky; that path is called the ecliptic. Of course, Earth also rotates daily on its axis. If Earth's axis of rotation were perpendicular to the ecliptic — in other words, if the celestial equator (the projection of the Earth's equator onto the celestial sphere) coincided with the ecliptic — then day and night would always have the same duration. However, Earth's axis of rotation is tilted at an angle of 23.5° to the ecliptic. It's this axial tilt that provides us with the seasons: we get long summer days and long winter nights (in the northern hemisphere).

There are two times in the year when the path of the Sun intersects the celestial equator. At these two intersections, day and night are of equal duration everywhere on Earth. Since the Latin word for equal is 'aequus' and the Latin for night it is 'nox', we get the term equinox. The spring, or vernal, equinox occurs around 21 March; six months later, around 22 September, comes the autumnal equinox. These two equinoxes mark the start of spring and the start of autumn, respectively, so it's hardly surprising that the ancient astronomers, and indeed ancient communities in general, celebrated these dates. Even nowadays one can still be treated to the faintly bizarre spectacle of watching Druids celebrate the vernal equinox at Stonehenge. (Actually, an equinox refers to a particular point in time — the instant when Earth reaches a particular point in its orbit — rather than the length of a day. Dates when the length of day and night are the same are more properly referred to as equiluxes. An equilux can be a few days before or after an equinox. But this is just quibbling.)

In 45 BC, Julius Caesar established his calendar and he set the vernal equinox to be 25 March. The Julian calendar was intimately related to the apparent motion of the Sun across the sky and so, although this calendar was much better than previous attempts, it suffered a problem. Earth's rotational axis is tilted at an angle of 23.5°, and this causes our planet to 'wobble' — the technical term for which is precession. This precession is exactly the same sort of periodic wobbling you can see with a spinning gyroscope. The wobbling of Earth's axial tilt causes the pole star — the star closest to the north celestial pole — to change: at present it's Polaris; about 3000 years ago it was Kochab; in about 12 000 years it will be Vega. The wobbling also causes the equinoxes to drift very slowly across the sky. For every four centuries that pass, the date of the vernal equinox moves by about three days. By the time of Pope Gregory XIII, in 1582, the vernal equinox had moved to 11 March. For complicated reasons of theology I don't pretend to understand (except it had something to do with the date of Easter), Gregory decided to 'skip' 10 days, decree the vernal equinox to be on 21 March, and at the same time reform the Julian calendar so that calendar dates and the motion of the Sun would stay consistent for longer. (Britain and its empire didn't adopt the Gregorian calendar unit 1752, by which time it was necessary to 'skip' 11 days to ensure that the vernal equinox was back where it should be. In Britain that year, Wednesday 2 September was followed by Thursday 14 September.) The Gregorian calendar is what we still live with in the western world, and it works pretty well.

Messing about with the calendar still can't disguise the fact that the equinoxes precess. And this makes the standard symbol for the vernal equinox completely inappropriate. When ancient Greek astronomers such as Hipparchus were observing the sky the vernal equinox was in the constellation of Aries, and this fact gave rise to another name for the vernal equinox: the first point of Aries. The symbol the constellation of Aries, ♈, represents the long face and two horns of a ram. (According to Greek mythology it represents the golden, flying ram that rescued a brother and sister from a sacrificial offering to Zeus.) The symbol for the first point of Aries, or the vernal equinox, thus became ♈. But even at the time that Julius Caesar was reforming the calendar, the first point of Aries was actually in the constellation of Pisces. In another 500 years or so the vernal equinox will pass into Aquarius. In fact, the last time ♈, the first point of Aries, was actually in Aries was around 100 BC.

ASCENDING NODE

When a small body orbits a larger body — think of an artificial satellite orbiting Earth, or Earth orbiting the Sun — then in most cases the orbit will be an ellipse. For people who work in the satellite business there's a clear requirement to be able to specify that ellipse accurately: after all, satellites for telecommunications, GPS, or Earth-mapping are of little use if their owners don't know where they are in the sky. It turns out that six elements are needed to specify an orbit at any particular time (or 'epoch', as celestial mechanics say).

Two of the elements describe the general form of an elliptical orbit: the semimajor axis a defines the size of the ellipse and the eccentricity e defines its shape. A third element, the argument of periapsis ω, defines where in the orbit the smaller body comes closest to the body it's orbiting. (For Sun-centred orbits we typically talk about perihelion rather than periapsis; for Earth-centred orbits the more familiar word is perigee.) A fourth orbital element, the mean anomaly at epoch M_0, is a way of indicating the position of the smaller body in its orbit at any particular time or epoch. A fifth element, the inclination i, simply defines the orientation of the orbit with respect to some reference plane; if the Sun is the primary body then the relevant plane is the ecliptic, while for the owner of a communications satellite the relevant plane is the projection of Earth's equator. Finally, there's the most clumsily named of the six orbital elements: the right ascension of the ascending node.

Two orbital elements — the right ascension of the ascending node and the inclination — are there to specify the orientation of an orbit. Why are two numbers needed? Well, think of a satellite orbiting Earth. If the

orbital inclination is 0° then the satellite is in an equatorial orbit because it stays close to the equator, and we've already defined the projection of Earth's equator to be a reference plane. If the orbital inclination is 90° then the satellite is in a polar orbit because it will pass over the north and south poles; its orbit intersects the equator at only two points, or nodes. However, in this case the number of possible orbital planes is infinite: those two nodes could be anywhere along the equator. To fully specify the plane we need to say *where* along the equator those nodes are. Actually, we need only specify one of the nodes: by convention astronomers specify the ascending node, symbol ☊, which is where the satellite crosses the equator going from south to north. The descending node, symbol ☋, is where the satellite crosses the equator going from north to south; it's determined once we specify ☊. (In old almanacs the symbols ☊ and ☋ were called the 'dragon's head' and 'dragon's tail', respectively. The nodes are involved in calculating the times of eclipses; the names derive from the ancient belief that eclipses were caused by a celestial dragon.)

The simplest way of specifying the location of a satellite's ☊ would be to use the everyday system of latitude and longitude. We can't do that, though, because Earth spins on its axis: the latitude/longitude system doesn't work on the celestial sphere. Astronomers instead use a coordinate system, based on right ascension and declination, that doesn't rotate with Earth.

Declination is similar to geographic latitude. The term 'right ascension' sounds fancy, but it's really just the celestial equivalent of geographic longitude. Now, with longitude we need to define a reference against which we can measure east–west angles; by convention that reference is the prime meridian, with 0° longitude, which passes directly through the Greenwich Observatory in London. Similarly, with right ascension we need to define a reference against which we can measure angles; the point in the sky with 0° right ascension is defined to be the vernal equinox, ♈. The vernal equinox, which we discussed in the previous section, is simply the ascending node of the Sun's orbit. In the case of the Sun, the right ascension of its ascending node is 0° — because it's the defined to be the reference against which we measure all other ascending nodes. So the right ascension of the ascending node of a satellite sounds complicated, but it has a simple meaning: it's the angle, measured at the centre of the Earth, between the place where the Sun's orbit takes the Sun up past the celestial equator and the place where a satellite's orbit takes *it* up past the celestial equator.

CONSTELLATION OF PISCES

I've mentioned the ecliptic several times before — it's the path traced on the celestial sphere by the Sun over the course of a year as Earth moves in its orbit. Ancient astronomers chose to divide the ecliptic into twelve 30° divisions or signs: the zodiac. Their choice has lasted, and we still have the zodiac. Because the divisions are equally spaced, the Sun spends an equal amount of time — about 30 days, 10 hours — in each sign. The signs of the zodiac are conventionally associated with particular constellations, but this makes little sense because there isn't a one-to-one correspondence between sign and constellation. There *can't* be a correspondence: the constellations are arbitrary patterns of stars that occupy varying widths of the ecliptic. For example, the Sun stays for only 8.4 days in the constellation Scorpius (which the astrologers call Scorpio) but spends well over 44 days in the constellation Virgo. But that's the way things are.

Starting with Aries (which, as we've already seen, has symbol ♈), the Latin names of the zodiacal signs are Taurus (♉), Gemini (♊), Cancer (♋), Leo (♌), Virgo (♍), Libra (♎), Scorpio (♏), Sagittarius (♐), Capricorn (♑), Aquarius (♒), and Pisces (♓).

Many newspapers and magazines run horoscope sections so I guess almost everyone knows the signs of the zodiac, even those of us to whom horoscopes are anathema. Even I know my 'star sign' — it's Pisces. The constellation signs used in astrology possess zero significance for a scientist, but they are so widespread that a book on symbols surely has to contain at least one of them. And since this is my book, I've chosen to discuss ♓ as a representative.

So where does ♓ come from?

There are several possibilities for the symbol ♓, but the one that's best known refers to the Greek myth involving the monster Typhon, the goddess Aphrodite, and her son Eros.

The story goes that Typhon, following an argument with Zeus, descended upon Mount Olympus and threatened the gods and goddesses who lived there. Most of the gods and goddesses changed form and ran away. (Typhon was incredibly tall, had a hundred dragon heads in place of a human head, and had a bottom half consisting of gigantic viper coils. Had you been there, you'd have legged it too.) Aphrodite and Eros, however, were too slow. Typhon spotted the pair on the banks of the Euphrates river, and gave chase.

And this is where the story turns into one of those 'choose your own adventure' tales. One version has Aphrodite and Eros turning themselves into fish, bound together with a cord attached to their mouths so they didn't lose one another, and jumping into the river to safety. Another version has two fish approaching them and encouraging them to jump into the river to safety. A third version has them transform into two fish and then two other fish lead them to safety. Whatever... the two fish, representing either the gods themselves or the piscene creatures that helped them, were placed in the sky to commemmorate the event. The constellation Pisces, then, represents two fish bound together by a cord and ♓ is a pictorial representation of this.

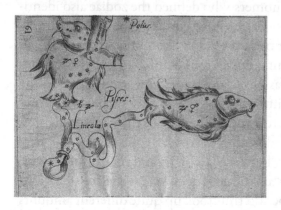

This is an image of Pisces as drawn by Zacharias Bornmann, a German cartographer who in 1596 published an atlas of the 48 constellations listed by Ptolemy. Each map was of size 16.5 cm by 13 cm, and was a copper engraving onto paper. (Credit: public domain)

Apparently, as a Pisces man, I'm powerfully emotional and intuitive, and sense or feel things that non-Piscean men simply miss; I'm sensitive, and perhaps my most attractive qualities are my humility and my love of romance. I told my wife this. I can't bring myself to record her response.

CONSTELLATION OF OPHIUCHUS

I find it astonishing how daily newspapers still waste ink and paper (and their online equivalents waste pixels and screen real estate) by publishing astrology columns. If you need any evidence that astrological predictions are bunkum, consider the fact that astrologers can't even agree on the signs of the zodiac.

To recap: the Sun appears to make a lap of the sky each year, and follows a path called the ecliptic. The ancient astronomers divided the ecliptic into twelve equally spaced divisions of 30°. This is the zodiac, and each division is called a sign. So far, so simple.

The fact that the celestial sphere is studded with stars complicates matters because the same ancient astronomers who defined the zodiac also identified patterns in the stars. Those patterns, or constellations, were entirely arbitrary — one pattern might be said to look like a bear, another like an archer, and so on—and different cultures found different patterns of constellations in the sky. There was never any underlying significance to the constellations, but they came into common use and are with us still. Anyway, because the ecliptic cuts across the constellations each sign or division of the zodiac became associated with a particular constellation — even though there was little relation between the signs and the constellations: each sign took up precisely 30° of the ecliptic, whereas the constellations differed widely in size and shape and thus took up quite different amounts of the ecliptic. Furthermore, the precession of the equinoxes causes the signs to drift: for example the first point of Aries, as we discussed in an earlier section, is currently in the constellation of Pisces and will cross into the constellation of Aquarius in the year 2600 or so. Quite how astrologers

were ever supposed to be able divine our future from this mess is beyond me but at least the *number* of signs is a given, right? Well, no.

In 1930 the International Astronomical Union codified the constellation boundaries, and under this codification Ophiuchus — a large constellation, one of the 48 defined by the famous Greek astronomer Ptolemy in the second century — became a zodiacal constellation. The Sun is 'in' Ophiuchus between the dates 29 November and 17 December, which means Ophiuchus is just as much a part of the zodiac as the 12 other, more familiar, zodiacal constellations. Now this doesn't matter in terms of zodiacal signs: by definition there are 12 equally spaced signs bearing no relation to constellations, and that should be the end of the matter. However, it seems some astrologers have worked backwards and argue that since there are 13 zodiacal constellations there must be 13 signs. Astrology is bunkum whether astrologers think there are 12 signs or 13, but it's interesting they don't even agree on that basic number. Anyway, some astrologers have come up with a symbol for the thirteenth sign and it has somehow found its way into Unicode: ⛎.

A more appropriate symbol for the constellation Ophiuchus, and one that's sometimes used, is ⚕. Ophiuchus, the 'serpent bearer', was identified by the Romans with the healer Asclepius, the Greek god of medicine. As mentioned in the section on the caduceus, the rod of Asclepius — a single staff with a single snake coiled around it — is the traditional symbol of medicine. It would therefore be an apt symbol for the constellation too (if indeed it requires a symbol).

Why is Asclepius in the sky in the first place?

Well, Asclepius was the son of the god Apollo and a mortal woman who died in childbirth. Apollo took the baby to be raised by the centaur Chiron. Chiron taught the child the healing arts and when Asclepius grew up he served as ship's doctor on *Argo*, the vessel Jason used in the quest for the Golden Fleece. Asclepius, unfortunately as it turned out, became a very good doctor indeed. He was so good at healing he was able to bring people back from the dead. Hades, the ruler of the underworld, wasn't too pleased about this intrusion on his territory (after all, it had the potential to put him out of a job) and so he complained to his brother Zeus, who promptly zapped Asclepius with one of his lightning bolts. On the plus side, Zeus gave him a place in the sky as Ophiuchus — where he remains to this day as a challenge to astrologers.

BLACK MOON LILITH

The confusion over the zodiacal status of the constellation of Ophiuchus (see the discussion in the previous section) is far from being the silliest episode in the history of astrology. Consider, for example, the case of Black Moon Lilith.

The Moon is our cosmic neighbour, the closest celestial object to Earth. (So-called near-Earth objects — comets and asteroids whose orbits have been disturbed — occasionally pass by Earth closer than the Moon ever comes. Sometimes, indeed, they even hit Earth. But these are all transient objects.) Astronomers have studied the Moon for centuries, with instruments of ever-increasing sophistication. Science and technology has even managed, despite what some conspiracy theorists claim, to land men on the Moon and bring them home. Scientists understand the Earth–Moon system in detail. So the idea Earth might possess a second satellite, one with the same mass as the Moon but with a surface so dark we can't usually see it, is just daft. But it's an idea that's still out there. This hypothetical object, which can't possibly exist, is called 'Dark Moon' Lilith.

The story begins in 1898 when Georg Waltemath, a German amateur astronomer from Hamburg, claimed to have observed a second moon orbiting Earth. Waltemath had observed no such thing, of course, and the complete lack of corroborating observations ensured the scientific community never took his claim seriously. Nevertheless, that didn't stop an English astrologer called Walter Gorn Old from claiming to have seen this mysterious object as it transited the Sun. Old, or Sepharial as he preferred to be called in the astrological community, chose the name Lilith for this new found satellite of Earth. (According to medieval Jewish folklore, Lilith

was the first wife of Adam. Poor Adam — she dumped him, even though he was the only man on Earth. Harsh.) Sepharial employed Dark Moon Lilith in his astrological 'calculations', and apparently some astrologers still do — although how any rational person can trust in meaningless calculations involving a non-existent body is quite beyond me.

To complicate matters, some other astrologers use a concept that's related to Lilith. They argue (correctly) that Moon's orbit around Earth is an ellipse and, as with any ellipse, there are two focal points. One focal point is deep inside Earth itself; the other focal point, out in space, they call 'Black Moon' Lilith. This version of Lilith even has a symbol, which can be found in Unicode: ⚸. Needless to say, this mathematical point has no physical significance — so why anyone should think it can have an influence upon humankind is a mystery.

Sepharial's Dark Moon Lilith doesn't exist and Black Moon Lilith, ⚸, is just a mathematical construction. But are astronomers *sure* that Earth has no other natural satellites? Well, yes: it's quite certain that there's nothing of significant size orbiting Earth. Of course there might well be small boulder-sized objects out there, which we haven't yet detected. There are certainly larger objects out there that share some orbital characteristics with Earth. For example, Earth has at least one Trojan: the asteroid 2010 TK$_7$ shares Earth's orbit around the Sun — but orbital mechanics mean it is always tens of millions of kilometres away. And there are so-called 'quasi-moons': an object such as 3753 Cruithne orbits the Sun in a resonance with Earth. But 3753 Cruithne isn't gravitationally bound to Earth; it doesn't orbit Earth; it isn't a moon. Our only true moon is the Moon.

Lilith isn't the only astronomical body that doesn't actually exist. Over the years, scientists have hypothesised the existence of various objects in the solar system. For example, Le Verrier, the chap who first predicted the whereabouts of the planet Neptune, postulated the existence of a planet called Vulcan in order to explain anomalies in the observed motion of Mercury. He calculated that if Vulcan were a small body orbiting close to the Sun then it would affect Mercury's orbit while being extremely difficult to detect (which would explain why we don't see it). However, the anomalies in Mercury's orbit are explained not by the presence of another planet but by Einstein's theory of general relativity. Vulcan does not exist. Note the difference in how astronomers and astrologers behave: astronomers discarded Vulcan; astrologers cling to Lilith.

ARC SECOND

″

Astronomy is the oldest science. And the oldest branch of astronomy is *astrometry*: the making of precise measurements of the positions and movements of celestial bodies. Astrometry has played a key role in the development of our understanding of the cosmos. Astrometry is what the great Greek astronomers such as Hipparchus and Ptolemy were doing when they developed their star catalogues. Their star catalogues, in turn, allowed them to discover phenomena such as Earth's precession — the slight 'wobble' of Earth's axis of rotation, which causes the positions of the stars to change slowly. Tycho Brahe, who died in 1601, just before the invention of the telescope, made the most precise and accurate measurements of stellar positions of any naked-eye astronomer. Brahe's star catalogues enabled him to show that 'new stars', or supernovae as we now call them, were not an atmospheric phenomenon: if they were close by they would have exhibited parallax — that tiny shift in position when you look at an object from different vantage points — and, since they didn't, they must be distant. That in turn shattered the belief, common since Aristotle, that the celestial sphere was unchanging. By 1838, astronomers were using precise measurements of stellar positions in order to calculate for the first time the distance to stars.

The key to astrometry is the ability to measure angles with precision. The position of a star on the sky can be defined by its angular distance north or south of the celestial equator (its declination) and its angular distance eastward along the celestial equator using the vernal equinox as the reference point (its right ascension). Angles are of course measured in degrees (with symbol ° as discussed in a later section) and there are 360 of them in a circle. The degree, however, is far too crude a measure for astrometry.

In some circumstances it's too crude even in everyday life: a person with 20/20 vision, for example, has the ability to resolve a pattern separated by 1/60 of a degree. In cases such as this, the minute of arc (symbol ′) is appropriate. There are $360 \times 60 = 21\,600$ minutes in a circle; one minute of arc is the angle subtended by a tennis ball at a distance of 218 m. It's tiny.

Since astrometry is the study of very distant objects, angles can be so small that even the minute of arc is inconvenient. For angles that are relevant in astrometry the second of arc (symbol ″) is the appropriate unit. The second of arc is 1/60 of a minute. It's *really* tiny. Observe a nearby star in March and then observe the same star in September, after Earth has moved across its orbit, and you'll find (if you are a careful observer) it has shifted its apparent position. This parallax effect is exactly the same as what happens when you hold a pencil in front of your face and observe it first with only your left eye and then with only your right eye: the pencil moves against the background because you observe it from different vantage points. But a star is very much further away than the pencil and so the parallactic shift is very much smaller: the *closest* star has an annual parallax of only 0.77 seconds of arc. Even the nearest star, then, has a parallax less than 1″. Since fractions of an arc second are used so often in astrometry and similar studies, astronomers often use the milliarcsecond (mas) — or sometimes a symbol formed from a double prime over a decimal point. The parallax of the nearest star Proxima Centauri, for example, is 768 mas — the same sort of angle as a 1p coin viewed at a distance of 5.3 km.

Modern techniques are so advanced that even the milliarcsecond can be unwieldy. In 2013 the European Space Agency launched the Gaia space mission. Gaia measures stellar parallaxes to an accuracy of 10 *millionths* of a second of arc: $10\,\mu\text{as}$. Incredible.

A football, viewed from a distance of about 45 km, subtends one second of arc. (Credit: adapted from public domain)

REDSHIFT

Z

You will have heard the Doppler effect in action. When an emergency vehicle approaches you, siren blaring, the siren's frequency is higher on approach than on recession. The siren's pitch falls as it passes you. What's happening is that upon approach each successive sound wave from the siren is emitted from a position closer to you: since each wave takes less time to reach you the frequency you hear is higher than if the siren were stationary relative to you. Similarly, when the siren recedes each successive wave is emitted from a position farther away from you: since each wave takes more time to reach you the frequency you hear is lower than if the siren were stationary relative to you. In equivalent language: the wavelength you hear when the siren approaches is shorter than when it's stationary relative to you; when the siren recedes then the wavelength you hear is longer.

Here's the clever thing: if you know what frequency the siren is emitting then, by measuring the frequency you actually hear, you can calculate the speed of the siren's approach or recession. (The speed cameras on our roads do something similar. The cameras bounce a radio signal of known frequency off a moving vehicle; the reflected waves arrive back at the camera with a different frequency. The measured difference in frequencies allows the speed of the vehicle to be calculated.)

Although the details are slightly different, the Doppler effect also occurs in astronomical observations. A source such as a star might *emit* light waves of a given wavelength but the wavelength an astronomer here on Earth *observes* will depend upon the relative motion of Earth and the source. If Earth and source are moving towards each other then the observed wavelength will be shorter: it will be shifted towards the blue end of the

spectrum (in other words it will be blueshifted). And if Earth and source are moving away from each other then the observed wavelength will be longer: it will be shifted towards the red end of the spectrum (in other words it will be redshifted).

The Doppler effect furnishes astronomers with an invaluable tool because atoms emit and absorb electromagnetic radiation at certain well defined and well understood wavelengths. The radiation emitted by an atom is characteristic of the type of atom: the different wavelengths emitted by an atom can be thought of as an atomic 'fingerprint'. So if an instrument detects wavelengths from a star that are characteristic of a particular atom then astronomers can not only infer the presence of that particular chemical element, they can also determine how fast the star is moving towards us or away from us by measuring how much the radiation is blueshifted or redshifted.

In the 1920s and 1930s, a number of astronomers began to measure the Doppler shifts of light from distant galaxies. The American astronomer Edwin Hubble is the name most commonly associated with this work. Hubble and his colleagues discovered something exceedingly strange: nearly all galaxies exhibit a redshift — in other words, nearly all galaxies are moving away from us. Moreover, the more distant the galaxy the greater the redshift (and thus the greater the speed of recession). It was a discovery that could only reasonably be understood in terms of an expanding universe: as time passes the fabric of spacetime is stretching, and that causes electromagnetic waves to stretch too. Wavelengths appear to be longer. We measure a redshift.

Redshift is defined as $\delta\lambda/\lambda$: the change in wavelength of light ($\delta\lambda$) divided by the wavelength (λ) of the light in the 'rest' frame when it was emitted. However, as more galaxies were observed the term redshift became so common, and it started to be used in so many places, that it made sense for astronomers to give it a symbol of its own rather than write the expression $\delta\lambda/\lambda$ in full every time. In a 1935 paper, Hubble and the American physicist Richard Tolman, introduced the term z to stand for redshift. Eventually, other astronomers started to use z rather than $\delta\lambda/\lambda$ when they wanted to refer to redshift and the symbol stuck. It's now one of the most widely used symbols in astronomy. Why did Hubble and Tolman choose z rather than some other letter? I have no idea, except they couldn't use the obvious candidate r — they'd already used it in their paper to stand for something else.

HUBBLE CONSTANT

$$H_0$$

Edwin Hubble, as outlined in the previous section, became famous for plotting a graph of galaxy redshift against galaxy distance. The graph *could* have turned out to be a scatter plot, with as many galaxies having a blueshift as a redshift and with no relationship between redshift and distance. But instead Hubble's graph was a straight line. The more distant the galaxy, the greater its redshift. This is the behaviour one expects to observe if the universe is expanding.

Once astronomers had accepted the redshift–distance relation applies to cosmological objects — a relation that became known as Hubble's law as early as 1933, just four years after the discovery — they soon moved on to try and estimate the slope of the straight line in Hubble's graph. The slope is important because it tells us how fast the universe is expanding, how much extra recessional speed we will observe for every extra step in distance. (Note that cosmic distances are often measured in megaparsecs, or Mpc. Since a parsec is 3.26 light years, 1 Mpc is 3.26 million light years or, if you prefer, about 30 billion billion km.)

In 1938 the slope, which Hubble himself symbolised by K, was being called 'Hubble's factor'. In 1951, a German astronomer called it 'Hubbleschen Expansions-Konstante'; the English equivalent, the 'Hubble constant', first appeared a year later. And in 1958, about three decades after the initial discovery, the American physicist Howard Robertson was the first to do the obvious and use H to represent the constant. Since the value of H can change over time, astronomers usually stick a subscript zero onto it to make explicit that they are talking about the Hubble constant's value at the present time: H_0.

To recap, then, the value of the Hubble constant H_0 tells an astronomer how much faster in km/s a galaxy recedes for every extra Mpc of distance it is away from us. It's one of the most important symbols in astronomy.

Hubble himself gave an estimate of 500 km/s per Mpc for this constant of universal expansion. We now know he was way off in his initial estimate, but his error is hardly surprising: in order to determine the Hubble constant astronomers need to know, with accuracy, the distance to many galaxies (and they have to measure those distances using some technique other than redshift itself). The problem is that distance determination is the most difficult problem in astronomy. In the old TV sitcom *Father Ted* there's a scene where Father Ted shows the spectacularly obtuse Father Dougal some plastic toy cows and compares them with real cows in the fields outside. Ted says: 'OK, one last time. These are small, but the ones out there are far away. Small... far away... ah, forget it!' Astronomers are of course not as dense as Father Dougal, but the problem they face is they don't know beforehand the real size of the objects they observe, nor their intrinsic brightness. A star can be bright because it really *is* bright or because it happens to be nearby; a galaxy can have a large observed central region because that region really *is* large — or because it happens to be a cosmic neighbour.

It took decades of painstaking work, building on Hubble's approach, to determine cosmic distances with sufficient accuracy and precision to pin down the value of H_0. More recently, the *Planck* space mission has been able to use quite different and more modern methods to estimate the value of H_0. The result? Well, *Planck* puts the value of H_0 at 67.8 ± 0.9 km/s per Mpc. In other words, for every additional million parsecs a galaxy is from Earth, the galaxy is traveling about 68 km/s faster away from us. (It's worth noting that recent measurements made by the *Hubble Space Telescope*, using a more traditional method for calculating the Hubble constant, came up with a value of H_0 of 73.2 ± 1.7 km/s per Mpc. These two values might seem similar, but there's a clear discrepancy: the largest value for H_0 allowed by *Planck* is smaller than the smallest value allowed by the *Hubble Space Telescope*. At present, no one knows the source of the discrepancy.)

If they know the value of H_0 astronomers can determine other quantities of interest. For example, astronomers now know the age of the universe to a precision that would have been unthinkable when I was a student. For the record, the universe is 13.8 billion years old (give or take 37 million years).

4

It's Greek to me

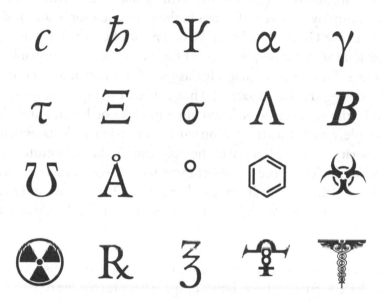

Scientists employ letters and symbols as a sort of code, a code that makes it easier to write down and calculate various quantities of interest. For example, it's much easier to write $F = ma$ than it is to write a sentence such as 'the force acting on an object is equal to the mass of the object multiplied by its acceleration'. Furthermore, the use of an equation such as $F = ma$ helps one not only manipulate the various quantities involved it also helps one search for possible relationships with other quantities. In fact, it would be difficult for scientists to investigate anything in a scientific manner without using symbols.

However, there's an obvious difficulty in using letters to represent physical quantities in this way.

In the equation $F = ma$ the use of letters is straightforward (at least it is for an English speaker): F represents force, m represents mass, and a represents acceleration. The trouble is, the Latin alphabet contains only a limited number of letters and science is interested in many things. In a problem involving force, mass, and acceleration it might also be necessary

to consider a frictional coefficient, a magnetic flux, and an angular velocity — for which F, m, and a would be reasonable choices except for the fact that, if they *were* used, confusion would reign. What to do?

One simple solution is to use an additional alphabet, one whose characters are sufficiently different to the Latin alphabet that scientists can, if necessary, employ both sets of letters in the same equation without risk of confusion. The Greek alphabet is the one most often used in this regard. (The reason for the widespread use of Greek in science is probably that, as the oldest European language, it was used for publishing scientific discoveries during the Renaissance.) Thus it is that many equations, when written in the scientific 'code', contain a mixture of English and Greek. For example, a well known equation when written in words states that 'the phase velocity of a wave is equal to the frequency of the wave multiplied by its wavelength'. The more convenient way to state this is via the equation $v=f\lambda$. Here it should be self-evident that v stands for velocity and f stands for frequency; the symbol λ is the Greek letter lambda, the equivalent of the English letter l, which stands in this case for length.

I suspect that all the Greek letters have at one time or another found a use in science. In this chapter, though, I have space to discuss only a few of those letters. Furthermore, limits of space have forced me to be selective when discussing the meaning behind the use of each symbol. The problem is that even a combination of Latin and Greek alphabets fails to provide nearly enough symbols for science, so the same Greek letter is often pressed into service on a variety of fronts. The Greek letter λ, for example, doesn't just stand for wavelength. In different contexts it stands for: the radioactive decay constant; the arrival rate in queuing theory; the failure rate in reliability engineering; longitude (both geographically and astrometrically); the latent heat of fusion; and a dozen or so other quantities and concepts. For each Greek letter I discuss, I focus on just one meaning. For example, I explain why the Greek letter τ provides the name of the heaviest lepton, but I don't touch on the many other uses of the symbol (such as its use in representing time; torque; opacity; sheer stress...)

Letters from alphabets other than Latin and Greek are used only infrequently in science. Most letters in the Cyrillic alphabet, for example, are in visual terms not sufficiently different from their Latin and Greek counterparts to be worth using in equations. If a Cyrillic letter *does* look distinctive then it can be used: some equations use the letter Ш, for example. And

The Greek alphabet

αA alpha	βB beta	γΓ gamma	δΔ delta
εE epsilon	ζZ zeta	ηH eta	θΘ theta
ιI iota	κK kappa	λΛ lambda	μM mu
νN nu	ξΞ xi	οO omicron	πΠ pi
ρP rho	σΣ sigma	τT tau	υΥ upsilon
φΦ phi	χX chi	ψΨ psi	ωΩ omega

Lowercase and uppercase versions of the 24 letters in the Greek alphabet. The Greek alphabet begins alpha, beta, gamma... and ends with omega.

Swedish contains the distinct and distinctive letter Å, which is sometimes used in science (see the discussion of the angstrom unit later in this chapter). As already stated, though, for the most part science uses Latin and Greek for its code.

Some science-related symbols aren't letters at all, Greek or otherwise, and in this chapter I also discuss a selection of these. Some of these symbols, such as the sign for degree, are in everyday use; others, such as the alchemical sign for mercury, are merely reminders of a notation that has long since died.

SPEED OF LIGHT

c

It was Albert Einstein who derived the most instantly recognisable equation in all of science, perhaps the only equation every educated person has heard of: $E = mc^2$. The equation is a direct outcome of his special theory of relativity, and it states that mass m can be converted into energy E, and vice versa; the conversion constant is the square of the speed of light. Since the speed of light is rather large (300 000 km s^{-1} or, if you prefer, 180 000 miles per second) the square of the speed of light is *very* large. A tiny quantity of mass can be converted into a tremendous amount of energy, with potentially destructive consequences — as the citizens of Hiroshima and Nagasaki can attest.

In Einstein's equation the symbols E for energy and m for mass are straightforward choices. But why did Einstein decide to use c for the speed of light? Why not v for velocity or s for speed or something else entirely?

Well, Einstein didn't always use c.

In his first paper on relativity, published in 1905, he introduced the fundamental concept that the laws of physics are the same for all *inertial observers* — observers, in other words, in a state of constant straight-line motion with respect to each other. And in this paper he used V to represent the speed of light. He was following a common usage: Maxwell used V for the speed of light in *his* work. It was only in 1907, when Einstein wrote a paper offering a different derivation of $E = mc^2$, that he switched notation and used c instead of V. The use of c to represent the speed of light subsequently became universal. But why the switch from V to c?

Unfortunately, to the best of my knowledge, no-one ever asked Einstein why he chose the symbol c. He was probably happy with the change, since

Trouble in paradise. A nuclear weapon test demonstrates that $E = mc^2$. This one at Bikini Atoll took place on 25 July 1946; the photograph was taken from a tower 5.6 km away from the explosion. The blast formed a mushroom-like geyser, which sprayed the lagoon with highly radioactive material. (Credit: public domain)

he used v to denote the velocity of a moving body, which was confusing when he was also using V. But that doesn't explain why he turned to c. The symbol *had* been used in a similar context before. The first occurrence was in 1856 in a paper by the German physicists Wilhelm Weber and Rudolf Kohlrausch. The quantity they represented by c was related to the speed of light, but the symbol had no other significance than it was a constant: so c there stood for 'constant'. Another German physicist, Paul Drude, built on the Weber–Kohlrausch constant and used c to represent the speed of light in his work on optics. Gradually c became used to denote the speed of light in a variety of contexts, and by 1907 Einstein would have been picking up a fairly common usage.

So c means 'constant'? Well, there's more to it than that. As far back as Galileo, scientists used the Latin word 'celeritas' for speed. We still have traces of the word in English: celerity (meaning swiftness) and acceleration (meaning a hastening or increase in speed). Thus later mathematicians used the symbol c, short for celeritas, to denote a variable speed: Euler, for instance, used c to denote speed. Even Einstein himself once used c to denote variable speed. So it's entirely possible that in Einstein's mind c stood for celeritas.

REDUCED PLANCK CONSTANT

ħ

Classical physics works superbly: it enables us to calculate the motion of planets, predict tides, have confidence enough to build a rocket that can put men on the Moon. In 1900, however, Max Planck introduced an idea that undermined the entire edifice of classical physics.

Planck was trying to understand the results of a simple experiment that involves heating a so-called 'black body'. (A black body is an idealised object that absorbs all the light falling on it, and so appears black.) A black body emits radiation when heated, and it does so in a very simple and characteristic fashion: the spectrum of radiation emitted by a black body depends *only* on the body's temperature, and the higher the temperature the shorter the wavelength at which the spectrum peaks. You probably have experience of the distinctive pattern of black body radiation: when iron is heated it first becomes 'red hot' and, as it is heated further and shorter wavelengths appear, it becomes 'white hot'.

Physicists, however, could not explain the characteristics of black body radiation using ideas from classical physics. They tried for decades and got nowhere until Planck succeeded in creating a model that reproduced the results of experiment. What Planck did, essentially, was simply to play with equations that *could* describe the observed black body spectrum — and in doing so he introduced a new constant. He could have chosen any letter to represent this constant, but the obvious letters were already being used to represent other quantities; he therefore chose *h*, which was short for the German word *Hilfsgröße*, or 'auxiliary quantity'.

It's not clear Planck really understood the fundamental, paradigm-shifting importance of *h*; to him it was simply a number to adjust in his model

A photograph of the German physicist Max Planck (1858–1947) taken around 1930. In 1918, Planck was awarded the Nobel prize for physics for his explanation of black body radiation in terms of quantum ideas. (Credit: public domain)

to fit an observed spectrum. But a lowly patent clerk called Albert Einstein *did* understand its importance. Einstein argued that light is emitted and absorbed by matter in 'chunks' or quanta: in these cases light acts as if it were a particle. However, the energy of a light quantum is h multiplied by the light's frequency — even though frequency is a wave property. Light thus acts as particle *and* wave; physicists had their first taste of the weird world of the quantum! The classical world is 'smooth', so it's always possible to make an object turn a fraction faster, increase its mass by a jot, cool it so its temperature is just a wee bit smaller. Not in the quantum world. There's a granularity to nature, and the size of the granularity is determined by the Planck constant h. The constant h is *extremely* small, which is why we don't notice the granularity; it's why classical physics, with its assumption of a 'smooth' universe, seems correct to us. But you simply can't understand the world at a fundamental level without quantum physics and h.

Although Einstein was one of the architects of quantum physics he never liked it. For years he tried to expose its limitations. He failed. And although his crowning achievement, the general theory of relativity, works superbly — as did the Newtonian theories it built upon — it will presumably have to be revised because it's in conflict with the quantum ideas he helped devise.

It turns out that, in applications, physicists often see the combination $h/2\pi$. This expression occurs so frequently that they assign it the symbol \hbar ('h-bar'). The reduced Planck constant \hbar is one of the fundamental constants of nature.

WAVEFUNCTION

The quantum world possesses a myriad of mysteries: particles are simultaneously in different places; atoms can pass through impenetrable barriers; events are inherently random. Ultimately, all the weird behaviour that we observe in quantum mechanics can be encapsulated in one source: the wavefunction.

The wavefunction is usually symbolised by the Greek letter psi, either the lowercase ψ or the uppercase Ψ, and every individual particle in nature can be represented by a wavefunction. Ψ is a function (of time, space, and sometimes other quantities) that evolves as a *wave* and yet it describes the quantum state of a *particle*.

When you think of a particle — an electron, say — you probably envisage it as being something like a billiard ball, only small. Well, an electron is nothing like a ball, small or otherwise. Since the electron wavefunction spreads throughout space, and since the wavefunction behaves as a wave, an electron does non-ball-like things: we observe it as a particle in some experiments, as a wave in others; it passes through separate apertures at the same time; when orbiting an atomic nucleus it can occupy only certain orbits. Some of the non-ball-like things it does are *really* weird; for example, it can simultaneously spin in two mutually opposite directions. Furthermore, no matter how well you design an experiment, you can never predict the future behaviour of an electron with certainty: Ψ contains all the information it's possible to measure about a particle, which is why the wavefunction is so important, but it tells you only about probabilities. A particle wavefunction (or rather the square of the wavefunction) only tells you where you are most *likely* to find the particle, not where you *will* find it.

The Austrian physicist Erwin Schrödinger (1887–1961) was a man of strange working habits. As well as taking a mistress with him on vacation, he would often also take two pearls: he placed a pearl in each ear to block out noise when he was thinking. (Credit: Smithsonian Institution)

The success of our modern digital technologies is proof that quantum mechanics works: our gadgets are based on quantum effects. But when you try to figure out what quantum mechanics *means*, whether the wavefunction is *real*... well, mysteries and philosophical difficulties remain. Even the choice of the symbol Ψ is a mystery.

The Austrian physicist Erwin Schrödinger introduced the idea of the wavefunction in 1926. At that time Schrödinger was a relatively undistinguished professor of physics at the University of Zurich, in Switzerland. Just before Christmas in 1925, he headed off to Arosa for a fortnight's break, leaving behind his wife Annemarie and taking with him an old girlfriend from Vienna. We know the names of many of his affairs, but not the name of the girlfriend who accompanied him to Arosa. (Schrödinger had many affairs during his life, and his self-absorbed attitude to these relationships damaged some of the women with whom he was involved.) The woman, like the Dark Lady of Shakespeare's sonnets, seems to have been a source of creative inspiration: at the end of the Christmas break, Schrödinger had introduced the concept of Ψ and the wave equation governing. Only Schrödinger and perhaps the dark lady of Arosa knows why he picked Ψ, but the symbol stuck. Since then, the Greek letter psi has appeared in hundreds of thousands of scientific publications.

FINE STRUCTURE CONSTANT

It's entirely appropriate that alpha, the first letter of the Greek alphabet, should be the symbol for one of the most important constants in all of science: the fine structure constant.

The constant was introduced in 1916 by Arnold Sommerfeld, a man who holds the unfortunate distinction of being nominated the most times for the physics Nobel prize without actually winning it. Sommerfeld was trying to explain a puzzling observation: when you pass light emitted from a gas discharge lamp through a prism you get not the familiar rainbow of colours but rather an emission spectrum containing just a few bright lines. The positions of these so-called spectral lines form a 'fingerprint' of the particular element from which the light was emitted: different elements give rise to different lines. Nowadays, physicists easily explain emission spectra using quantum mechanics but back then Sommerfeld was struggling to understand why some bright emission lines were split into pairs: the lines had a puzzling fine structure. Well, Sommerfeld developed a model that accounted for the fine structure and in his analysis there appeared quite naturally a constant — which he symbolised by α, seemingly for no deep reason — that determined the amount of splitting of a spectral line.

The fine structure constant introduced by Sommerfeld had several unusual properties. For a start, it was dimensionless. Most of the important constants in physics take different values in different units (the speed of light, for example, is $299\,792\,458\,\mathrm{m\,s^{-1}}$ in SI units or $670\,616\,629\,\mathrm{mph}$ in more old-fashioned units). The fine structure constant is a pure number; whichever system of units you use to do your experiments, you'll find that α has the following value: $7.297\,352\,569\,824 \times 10^{-3}$. (The fraction 1/137 is

The German theoretical physicist Arnold Somerfeld (1868–1951) was one of the great mentors in physics. His doctoral students included such luminaries as Werner Heisenberg, Wolfgang Pauli, Hans Bethe, and Rudolf Peierls. (Credit: public domain)

a good approximation to this value, so most physicists remember the expression $\alpha \approx 1/137$.) A second important property is that the fine structure constant ties together various other important parts of physics. For example, the fine structure constant can be expressed in terms of the reduced Planck constant \hbar, the speed of light c, and the charge on the electron e — all of which are fundamental constants of nature. Early on, then, it was clear the fine structure constant was important. But neither Sommerfeld nor his contemporaries really understood the importance of α; that understanding only came decades later. Although we still call it the fine structure constant, α is really a *coupling constant* measuring the strength of the electromagnetic force.

According to the rules of quantum mechanics, when an electron moves along a trajectory in space it has some probability of emitting a photon. That probability is directly related to α — the probability is of the order of 1/137, in other words — and it's the ceaseless emission and absorption of photons from charged particles that gives rise to the force we call electromagnetism. Ultimately, the probabilities for *all* fundamental processes in nature can be traced back to coupling constants such as α. If the value of α were different then the world would be different, too. For example, suppose α were about ten times bigger. In other words, suppose the electromagnetic force were about ten times stronger than it actually is. In that case nuclear fusion in stars would cease and life as we know it would be impossible. A value for α of about 1/137 is crucial for our very existence. But why is $\alpha \approx 1/137$ rather than 1/10 or 1 or 10? Why are the other coupling constants the size they are? The truth is, no one knows why. It's one of the deep puzzles in physics.

GAMMA RAY

People often divide the electromagnetic (EM) spectrum into various regions. The visible region, for example, covers those wavelengths to which the human eye responds. Other parts of the spectrum are perhaps less well defined (what you might call a microwave, I might call a radio wave) but at least the *names* of the regions are pretty much well understood by everyone — except for the very shortest wavelengths. The gamma ray part of the spectrum is a region named after a Greek letter. Why is the shortest-wavelength, highest-frequency light known as a γ radiation?

The reason for the term dates back to the early part of the 20th century, when physicists were trying to understand the nature of radioactivity. In 1896, Henri Becquerel noticed that uranium salts could blacken a photographic plate even when the plate was wrapped in paper. Ernest Rutherford investigated this phenomenon in detail and his elegant experiments uncovered many of the secrets of radioactivity; he was the first to show that the phenomenon involved the emission of radiation as one chemical element transmuted into another. However, getting to grips with the radiation coming from uranium was not easy: in 1899 Rutherford wrote that his experiments showed how 'there are present at least two distinct types of radiation — one that is very readily absorbed, which will be termed for convenience the alpha-radiation, and the other of more penetrative character which will be termed the beta-radiation'. There seems to have been no particular reason for Rutherford to call the radiations α and β; in essence he chose the names A and B to make life easy. It's just that someone of Rutherford's generation, even a bluff, no-nonsense scientist like him, would have studied Greek.

Ernest Rutherford (1871–1937) was one of the greatest of all experimentalists, and he has been called the father of nuclear physics. In 1908 he was awarded the Nobel prize in chemistry; he probably should have been awarded a second Nobel prize in physics for his undoubted achievements. (Credit: public domain)

Physicists now know that α radiation consists of helium nuclei (two protons and two neutrons) and β radiation consists of electrons; α particles are relatively massive and slow-moving while β particles are fast-moving and possess relatively little mass.

Just as Rutherford was starting to impose some sort of order on our understanding of radioactive phenomena, Paul Villard stirred things up again. In 1900, Villard was investigating radiation from radium salts. First he let the radiation escape from a small hole in a container and fall onto a photographic plate, which of course blackened. He then put a thin, α-absorbing lead sheet around the container and found some radiation reached the plate. Again, unsurprising: β radiation can penetrate thin lead sheets. But Villard then applied a strong magnetic field to deflect the β radiation away from the plate. Even with these barriers — lead to block α particles and a magnetic field to deflect β particles — penetrative radiation from the radium blackened the plate. It had to be a new type of radiation.

Villard didn't proffer a name for this third type of radiation, so in 1903 Rutherford decided just to call it γ radiation: the third letter of the Greek alphabet was simply next up after α and β. At first physicists thought γ rays must be like α and β rays, and consist of particles. In 1910, however, William Bragg showed γ rays to be a type of EM radiation. Four years later Rutherford measured the wavelengths of γ rays, and found them to be extremely short. Indeed, γ rays typically have a wavelength smaller than the diameter of an atom. The short wavelength/high frequency of γ rays means they pack a lot of energy and, in many ways, behave just like particles.

TAU LEPTON

$$\tau$$

Some elementary particles take their name and symbol through a circuitous route. Take the tau lepton (often just called the tau, which is the Greek letter τ). The story starts in 1897 when J.J. Thomson discovered a negatively charged particle with a mass about 1/1836 that of the proton. He called the new particle a 'corpuscle'; we know it as the electron. Thomson believed it to be a basic building block of atoms, and so it is. The electron turned out to be truly elementary: nobody has ever identified any substructure to it.

About four decades after Thomson's discovery, Carl Anderson and Seth Neddermeyer found a particle that, when passed through a magnetic field, curved in the same direction as an electron did. For any given velocity the paths of these new particles curved much less than those of electrons but more than those of protons: the particles had to be more massive than electrons but less massive than protons. Anderson eventually deduced that the new particle was about 200 times more massive than the electron, and thus about 1/9 the mass of the proton. Two years earlier, Hideki Yukawa had predicted the mass of a particle he thought carried the force holding atomic nuclei together: it was somewhere between the mass of the electron and the proton. The predicted particle was called a mesotron, the prefix 'meso' coming from a Greek word meaning 'intermediate'. Reasonably enough, the new particle was initially thought to be the mesotron. However, physicists in possession of a classical education pointed out that the Greek word for intermediate didn't contain the letters 'tr' and so 'mesotron' was shortened to 'meson'. (Half a century after Anderson's discovery, one of my lecturers at the University of Bristol still referred to this particle as a mesotron. I guess he learned the term when he was a student, and didn't change.)

In 1947, a team of physicists led by Cecil Powell at Bristol discovered a particle that had a similar mass to Anderson's particle and was thus also a meson. So were there two of Yukawa's particles, or what? To distinguish them, Anderson's particle was called a mu meson (after the Greek letter m, μ, seemingly because it was the first letter of meson) and Powell's particle was called a pi meson. Eventually many other mesons were discovered and it became clear that the mu meson was entirely different to all those other mesons; it bore no relationship whatsoever to Yukawa's particle. Instead, the mu meson appeared to have much more in common with the electron. Indeed it became apparent that the mu meson, whose name was further shortened to 'muon', was essentially just a more massive version of the electron. There seems to be some property of 'muon-ness' that distinguishes it from the electron, but electron and muon are close relatives. And both are elementary particles.

The electron and the muon are a type of elementary particle known as a 'lepton', which comes from a Greek word meaning 'small'. When the word was first used in 1948 the only known leptons were the electron and the muon, which were indeed small in mass compared to the proton and to many of the other particles then being discovered. In 1975, however, Martin Perl discovered the tau lepton. The τ has nearly twice the mass of the proton, so in no sense can it be thought of as a low mass particle. The τ isn't even an intermediate-mass particle (or meson, using the old terminology). Mass has nothing to do with whether a particle is a lepton. Three decades later and the situation has some clarity: it turns out there are three 'generations' of elementary lepton. The electron is part of the first generation; the muon is part of the second generation; and the tau is part of the third. And why is it called τ? Well it was the third charged lepton to be discovered, and τ is the first letter of 'third' in Greek.

Martin Lewis Perl (1927–2014) was awarded the Nobel prize in physics in 1995 for his discovery of the tau lepton. (Credit: public domain)

XI BARYON

There was a time when particle physics — the scientific study of the world of the extremely small — was in complete confusion. Physicists were discovering subatomic entities on a seemingly regular basis. There were dozens of oddly named particles: J/Ψ ('gypsy') mesons and Delta resonances and charmed sigma baryons and goodness knows what else. As a student my personal favourite in the particle menagerie was the Xi baryon, for no other reason than I liked its symbol, Ξ. (The symbol, incidentally, represented the sound 'ks' in the Greek alphabet. Some Greek dialects instead used the letter Chi, sometimes written as X, to represent this sound. It was this usage that found its way into Italy, and so the Latin alphabet came to use X rather than Ξ for its 24th letter.)

Gradually, in the latter quarter of the 20th century, physicists began to make some sense of this unruly mess. It turned out that particles such as J/Ψ and Ξ and the others mentioned above weren't fundamental entities. Rather, they were merely different combinations of truly elementary particles called quarks. (When I say 'truly elementary' I mean that, to date, no experiment has ever discerned any structure to the quarks. It's entirely possible that quarks are made out of something more fundamental — one popular explanation is that they are excitations of tiny, one-dimensional strings — but there's as yet no convincing experimental evidence for there being anything more fundamental.) There are six types of quark, organised into three generations: u and d quarks form the first generation; c and s quarks form the second generation; and t and b quarks form the third generation. The three generations of quark match the three generations of lepton, which we discussed in the previous section.

We never observe individual quarks in nature. Instead, they bind tightly together to form the particles we detect in experiments. Three quarks can bind together to form a type of particle called a baryon; a quark–antiquark pair can bind together to form a type of particle called a meson. The J/Ψ meson mentioned above, for example, is a combination of a c quark and a c antiquark ($c\bar{c}$); also mentioned above were Delta resonances, with a typical one such as Δ^{++} consisting of three u quarks (uuu); the charmed sigma baryon is a combination of two d quarks and a c quark (ddc). Two baryons that are perhaps more familiar to you are the proton (uud, a combination of two u quarks and a d quark) and the neutron (ddu, two d quarks and a u quark). Since protons and neutrons themselves bind together to form atomic nuclei it turns out that most of the matter you see around you is composed, ultimately, of various combinations of u and d quarks.

And what of my favourite, the Ξ baryon? Well, the electrically neutral version of the particle, which has the symbol Ξ^0, consists of a u quark and two s quarks (uss). The Ξ^0 lives a fleeting existence: it typically decays within 30 billionths of a second. It was first spotted in 1959 by a team led by Luis Alvarez. (In 1968 Alvarez won the Nobel prize in physics for the work he did that made it possible to study such short-lived particles. Alvarez, however, is better remembered for being part of the team that found the evidence that, some 65 million years ago, an asteroid impact led to the extinction of the dinosaurs.)

Luis Alvarez (1911–1988), shown here on the right as a graduate student. His thesis adviser, also shown here, was Arthur Compton (1892–1962). Compton received the Nobel prize in 1927, six years before this photograph was taken. Alvarez went on to receive the Nobel prize in 1968. Both men made important contributions to our understanding of the basic building blocks of nature. (Credit: public domain)

STANDARD DEVIATION

σ

Look at a stone step, one old enough for generations of people to have trod it. Every time a foot landed on the step it wore away the stone surface, just a little. You'll see a pattern of wear that takes decades to appear on soft stone, centuries on hard stone. And you'll see that the pattern of wear is not uniform: the stone will be deeply worn in the middle, hardly worn at all at the ends. The pattern of wear forms a distinctive bell shape.

Old stone steps such as those here from an alleyway in York-shire will exhibit a distinctive bell-shaped pattern of wear: the middle will be well worn, the sides less so. The reason is not difficult to appreciate: as people walk on the step it's more likely that their feet will land somewhere in the middle rather than at the extremes. Over time, shoes wear away the middle of the step and leave the sides relatively untouched. (Credit: Tim Green)

 The bell-shaped curve is an icon of science. Make repeated measurements of some quantity and you'll find that a graph of your results will possess a bell shape: most measurements will be close to a central value but a few will be some distance away. Toss a fair coin many times and you'll find the probability distribution of the number of heads has a bell shape: with a hundred tosses the most likely outcome is that the coin will come down heads 50 times, but random chance says that sometimes only 45 heads will occur, or 43 heads, or even fewer. Measure the height of one thousand adult males and you'll find a bell curve: in the US the average height (using feet and inches, as Americans still do) is 5' 10" and most American men are within a few inches of that height; the exceptionally tall or short are precisely that — exceptional.

 Let's investigate that height example further. If the average male height is 5' 10" then half of the male population is taller than 5' 10" and half is smaller. However, that average tells you nothing about how heights are distributed in the population. The *standard deviation*, which has the symbol σ (the Greek letter s, standing for standard), gives you a measure of the width of the bell curve. If some quantity follows the bell curve then about 68% of that quantity lies within 1σ of the average value. The standard deviation on adult male heights in the US, for example, is 3'; this means about 68% of American men have a height between 5' 7" and 6' 1".

 Mathematicians have studied standard deviations for more than two centuries (though the term standard deviation and the symbol σ weren't introduced until 1894 by Karl Pearson). They know all there is to know about bell curves and σ. They know for example that about 95% of data lie within 2σ of the average and about 99.7% within 3σ; for 5σ the figure is about 99.99994%.

 The 5σ figure is important in particle physics because to claim a discovery in this field one must to achieve this standard of evidence: a 5σ result means there's only one chance in about two million that the experimental observation was due to a random fluctuation. (And even with a 5σ observation you need independent verification. There's always a chance the experiment is systematically in error: you might have found a faulty fuse, for example, rather than a fundamental particle.) When in 2012 physicists at CERN announced the discovery of a particle consistent with the famous Higgs boson, they were confident of their discovery because two independent experiments had detected it each with a 5σ level of certainty.

COSMOLOGICAL CONSTANT

Throw an object in the air and its subsequent motion depends on its speed when it left your hand. There are three cases, first clarified by Newton.

Case one: the object moves upwards, constantly being decelerated by Earth's gravity, reaches a peak height, then falls back to Earth. The greater the initial speed, the higher the peak it reaches.

Case two: you throw the object with a velocity greater than Earth's escape velocity and the object heads off into space. It moves ever-more slowly because of Earth's gravity, but it never returns.

Case three: you throw the object with *just* the right speed — the escape velocity — and it enters orbit around Earth. It doesn't leave Earth's gravitational grip but neither does it return.

In the 1920s and 1930s scientists began to suspect the universe originated in a Big Bang and then began to expand. Einstein's general theory of relativity, which modified Newton's theory of gravity, enabled cosmologists to discuss the future expansion and fate of the universe. It turned out the options were the same as the three cases mentioned above. The expansion of the universe could eventually halt and go into reverse (in which case the universe would end in a so-called Big Crunch). The universe could go on forever in an ever-slowing expansion (and end in a Big Freeze). Or, in a perfect balance between the two cases, the expansion might *just* halt an infinite time in the future.

In 1999 two groups of cosmologists made a series of extremely elegant and clever observations in order to determine which of the three cases represents reality. Once the cosmological community had accepted their results, leaders from the two groups were awarded the 2011 Nobel prize

for physics. So: which universe do we inhabit? Big Crunch, Big Freeze, or a universe balanced precariously between the two? The answer was exceedingly strange. The universal expansion fits none of the three cases. The expansion of the universe is *accelerating*. It's as if you throw an apple in the air and find that, instead of slowing, it moves away ever faster!

Physicists don't know what force is causing the universe to blow itself apart in this way. They call it 'dark energy', but that's just a label for ignorance. Nevertheless, the current best guess about dark energy is that it is due to a so-called cosmological constant.

Soon after Einstein developed his general theory of relativity he introduced an additional term, symbolised by the Greek capital letter lambda, Λ, into his equations. (There seems to have been no deep reason for the use of Λ, incidentally; it was just a random pick.) Einstein introduced Λ because his equations predicted the universe should be dynamic but he believed (because the observations of stars made by astronomers seemed to imply) the universe was static: the cosmological constant term Λ was intended to fix things. Of course, he kicked himself when it was later discovered that the universe *was* dynamic: it was expanding. He dropped Λ and, as folklore has it, he called its introduction his 'biggest blunder'. (How we'd all love to be able to blunder like Einstein.) However, cosmologists have now re-instated Λ into his equations: it turns out that a small Λ term is sufficient to explain the accelerating expansion.

To account for the observations Λ must be vanishingly small: about 10^{-120} in so-called 'natural' units. The trouble is, when physicists use their best theories to estimate Λ they get an answer that's a factor of about 10^{120} too large! This has been called the biggest mismatch between theory and observation in all of science, and understanding its origin is perhaps one of the most pressing problem in physics.

Actually, to defend the honour of physics, I'd argue the worst mismatch between theory and observation lies in economics — if you accept that economics is a science. Explaining the poor performance of a hedge fund during the financial crisis of 2007 the Chief Financial Officer of Goldman Sachs said: 'We were seeing things that were 25 standard deviation moves, several days in a row'. (See the previous section for a discussion of what standard deviation means.) Forget about several days in a row. You'd expect to see a 25 standard deviation move on one trading day out of 3.1×10^{136}. That economist got it *humongously* wrong.

MAGNETIC FIELD

B

It's almost magical to play around with a pair of magnets, to feel the invisible lines of force between them as you hold them in your hands. The basic properties of magnets have been known for at least 2500 years. (The very word 'magnet' means 'stone from Magnesia', a place where ancient Greeks found lodestones — naturally magnetised pieces of mineral.) However, it wasn't until the 19th century that our modern understanding of magnetism — and thus several technologies we now take for granted — began to develop. Physicists such as André-Marie Ampère, Michael Faraday, and James Clerk Maxwell performed experiments and developed theories that helped clarify the nature of magnetism and explained some of those 'magical' properties possessed by magnets.

Even today, physics students are exposed to the pioneering early work of Ampère, Faraday, Maxwell, and others. But one of things that is seldom explained to students is why we use the various symbols when discussing magnetism. For example, a magnetic field or magnetic flux density usually gets the symbol B; actually, for reasons I won't go into, it usually appears in print as a bold italic *B*. A related concept, the magnetic field strength or magnetic field intensity, has the symbol *H*. (Rather confusingly, the *H*-field is also sometimes known as the magnetic field.) But why use *B* and *H*? What do the letters stand for? None of my teachers could tell me.

The answer turns out to be a simple accident of alphabetical history.

The man who did more than anyone to elucidate the relationship between electricity and magnetism (indeed, to show they are both aspects of an underlying unified phenomenon called electromagnetism) was Maxwell. He developed a mathematical theory of electromagnetism, which

The Scottish physicist James Clerk Maxwell (1831–1879) is one of the most influential scientists of all time; even discounting his important work in thermodynamics, his unification of electricity and magnetism puts him in the rank of physicists such as Einstein, Faraday, and Newton. Indeed, Einstein kept images of three scientists on his office wall: portraits of Newton and Faraday, and a photograph of Maxwell. (Credit: public domain)

contained many quantities appearing in various combinations. Quantities need to be given a name, and if you are going to use mathematics to work with them then you'd better give them a symbol too. Well, one of the quantities Maxwell worked with was called the electric displacement field (which was quite reasonably given the symbol D for displacement). Another quantity was the electromotive force (for which a reasonable symbol was E, and which often appeared in print as \mathscr{E}). The symbols D and \mathscr{E} are still used, incidentally. And back in the 19th century it was common to use C to denote current (nowadays we typically use I, from the French word meaning 'intensity'). You can just imagine Maxwell, being a keen student of the alphabet, thinking to himself: 'C, D, E, ... Hmm, let's just use A, B, C, ..., G, H to represent these quantities'. And that's what he did.

The quantity he deemed to be perhaps the most important element in his studies, the magnetic vector potential, was given pride of place: symbol A, the first letter of the alphabet. The magnetic field was next up, with B, and he continued this way until he reached H. So B and H don't stand for anything at all.

ELECTRICAL CONDUCTANCE

℧

The SI system of units, when applied sensibly, is a great invention. It gives people who are engaged in trade, science, and engineering a common set of units with which to work. Sometimes, though, it's just a bit too serious. Consider, for example, the derived SI unit for electrical conductance.

Suppose you take a piece of electrical conductor — a metal wire, say — and apply a constant potential difference across two points of the wire: an electrical current will flow between those two points. The size of the current depends on the precise nature of the conductor: it depends on the conductor's *resistance*. At the first International Electrical Congress, held in Paris in 1881, scientists agreed on a definition: if a current of 1 ampere flows when a constant potential difference of 1 volt is applied then the resistance is defined to be 1 ohm. The symbol for ohm was agreed to be the Greek capital letter omega, Ω, the equivalent of our letter O. The name and symbol honoured the German physicist Georg Simon Ohm, who was the first to demonstrate the direct proportionality between the potential difference applied across a conductor and the current that results. (Using a capital O rather than Ω as the symbol for resistance would have been a clearer way of honouring Ohm, but it would have caused immense confusion in handwritten manuscripts where O resembles 0, the number zero.)

Instead of talking about a wire's resistance to the flow of electricity one can instead talk about its ability to conduct electrical current: its *conductance*, in other words. Electrical conductance is just the reciprocal of resistance. To calculate the resistance of a wire you divide voltage by current; to calculate its conductance you divide current by voltage. If ohm is the unit of resistance, what should be the unit of conductance? How about

The German physicist Georg Simon Ohm (1789–1854) is perhaps most famous for his discovery that the electric current flowing in a conductor is directly proportional to the voltage applied across the conductor: this is the famous Ohm's law, $V = IR$. Ohm made contributions to other fields; there's a less well-known Ohm's law in acoustics, for example. (Credit: public domain)

'mho' — ohm spelled backwards? It was Lord Kelvin, one of the foremost physicists of the Victorian era, who suggested the name mho, and it works for me. And the symbol for mho is just ℧, an upside-down Ω.

Unfortunately, the International Electrical Conference held in 1933 proposed that the unit of electrical conductance should be named the siemens, after the German inventor Ernst Werner von Siemens. The unit wasn't widely used, but at the 14th CGPM in 1971 the siemens became part of the SI system of units. At that point, officially, the unit of conductance became the siemens. My problem with this is that 'siemens' just doesn't sound as good as 'mho'. More to the point, Siemens is a vast multinational company making fridges and freezers and dishwashers and loads of other stuff; it doesn't need the advertising from the SI system of units. Furthermore, the symbol S for siemens is similar to s — the symbol for second, which is a much more important SI unit. The potential mix-up between S and s is as inelegant as that between O and 0; if cacographic confusion is grounds enough to reject O for ohm it's enough to reject S for siemens.

The mho and the siemens are identical (1℧ is equivalent to 1S) so why not use the aptly named mho with its quirky symbol ℧? Unfortunately, a move back to mho is unlikely to happen. A few people still use ℧ in particular circumstances, but most people now stick to the rather boring S.

ANGSTROM UNIT

In the mid-19th century Anders Ångström was a noted researcher in fields as diverse as geomagnetism, the aurora borealis (or Northern Lights), and thermal physics. He was also a pioneer in the emerging field of spectroscopy, the study of how matter emits and absorbs light. In 1868 Ångström published a book entitled *Recherches sur le spectre solaire*, which discussed details of the radiation emitted by the Sun. There are certain wavelengths in solar radiation, certain points in the Sun's spectrum, at which the energy emitted is seen to be greatly reduced. These dark lines in the solar spectrum convey vast amounts of information to an astronomer, and Ångström's book provided an atlas giving the wavelengths of a thousand of these spectral lines.

When writing about the wavelengths of the Sun's spectral lines Ångström chose, quite reasonably, to use a unit of length equivalent to one ten billionth of a meter (0.000 000 000 01 m or 10^{-10} m). In these units the visible

The Swedish physicist Anders Jonas Ångström (1814–1874) is often called the 'father of spectroscopy', but he did notable work in a number of fields. His name lives on in the eponymous unit of length, but is also attached to a lunar crater and a main-belt asteroid. (Credit: public domain)

wavelengths — in other words, the wavelengths to which the human eye is sensitive — range from about 3900 (at the blue end of the visible spectrum) to 7500 (at the red end). Such a unit of length is thus quite handy for this sort of spectroscopic work, and eventually it was agreed that the symbol Å should be used to represent the distance unit 10^{-10} m. The unit was called the angstrom (sometimes spelled ångström) in the scientist's honour.

If a unit is appropriate and convenient for work in a particular field then people naturally tend to use them. I think that's why British and American people have an attachment to imperial measurements: these units are appropriate for everyday life. A yard is the length of a single stride; an inch is basically a thumb-length; and a foot is the length of... well, a foot. The imperial system is thus natural for measuring everyday items, and it works. (Conversions and calculations are a total nightmare in imperial, however; metric is undoubtedly much easier for calculation.) I've already explained why the angstrom was appropriate when dealing with spectral lines, but it turned out many fields in science and technology found it convenient to use the angstrom. Chemists and crystallographers, for example, might be interested in the size of an atom; or the length of a bond; or the spacing between atoms in a crystal. In each case the dimension is of the order of 1Å, which is much easier to talk about than 10^{-10} m. Astrophysicists, to give another example, might be interested in the X-rays emitted by a black hole; well, X-rays range in wavelength between about 0.1Å to 100 Å, and so conversations between X-ray astronomers are eased if they talk in terms of angstroms. The angstrom is a useful unit. It's a shame, then, that it seems to be used less and less.

The problem facing the angstrom is it doesn't fit into that nice pattern of threes that allows us to use the prefixes milli (for 10^{-3}), micro (for 10^{-6}), and nano (for 10^{-9}). Furthermore, the angstrom is not formally part of the SI system of units, and the International Committee for Weights and Measures discourages its use. Instead, scientists tend to use the nearest SI unit: the nanometer (nm) — 10^{-9} m. The nm works, I suppose. The size of a typical atom is 0.1 nm, which is manageable, and X-ray wavelengths range from 0.01–10 nm. But somehow nm just doesn't look as good as Å.

Incidentally, for angstrom fans, it's worth noting that Å should not be thought of as an A with a diacritic. In Swedish, the ring isn't 'added' to the A — it's an integral part of a quite separate letter. In the Swedish alphabet, Å comes after Z (with the letters Ä and Ö coming after Å).

DEGREE

O

The word 'degree' derives ultimately from a Latin word meaning 'step' (in the sense of stairs). As this use of the word developed it came to represent the concept of steps in a hierarchy, from which we get the modern usage referring to academic degrees, for example. But why is the raised circle symbol ° used to represent degrees of angle or temperature?

The modern use of ° for referring to angles dates back to 1569. In that year the Dutch cartographer and instrument maker Gemma Frisius published a revised edition of a book called *Arithmeticae practicae moethodus facilis* in which the symbol appears. The symbol was in fact a small, raised zero; and the use of zero underscores its meaning.

A circle is conventionally divided into 360 degrees, a convention dating back to the Babylonians and Egyptians, and which presumably arose because 360 is easily divisible by many numbers. There may have been other factors at play, in particular the fact that, because there are approximately 360 days in a year, the Sun's path through the ecliptic advances by about 1° per day. But the ease with which 360 can be divided into whole numbers must surely have been an important consideration — these people didn't have calculators, after all. Anyway, a degree could be further subdivided into 60 equal parts, called minutes, and the minute could be further subdivided into 60 equal parts called seconds. (See the previous chapter for a discussion of the use of the arc second in astronomy.)

A minute of arc was denoted by the Roman numeral I. Five minutes of arc, for example, was written 5^I. A second of arc was denoted by the Roman numeral II. Five seconds of arc, for example, was written 5^{II}. This notation evolved slightly, so in modern script we would write $5'$ and $5''$

when referring to these two angles. (When read aloud, the superscript I was called 'prime', for first. It's from this usage that the symbol ′ gets its name.) The use of zero, to represent a degree, thus refers back to this ancient system. A zero above a number denoted a whole number of degrees, with no subdivision; a prime or I above a number indicated the first subdivision of a degree; and a double-prime or II was the second subdivision.

And what about temperature?

If one defines temperature in terms of a physical pattern or sequence then it makes sense to use the word degree when talking about subdivisions of that pattern: degrees are just steps in a hierarchy. The first use of degree in this way to mean 'unit of temperature' was in 1724 by Daniel Gabriel Fahrenheit; three years later and the usage was widely adopted throughout Europe. Fahrenheit's scale used a patten or sequence based on the freezing and boiling points of water. His scale was later slightly amended, so there were precisely 180 degrees between the freezing point (32 °F) and the boiling point (212 °F).

The Fahrenheit scale lives on in America and its territories, but most of the rest of the world use a similar scale developed by the Swedish astronomer Anders Celsius: on this scale, there are 100 steps or degrees between the freezing point of water (0 °C) and the boiling point (100 °C). The Celsius scale looks at first sight to be more logical but in everyday life I still prefer the 'old-fashioned' Fahrenheit scale because it better matches the weather I'm likely to encounter: I might experience a temperature of 0 °F on a bitterly cold winter day, a temperature of 50 °F on a coolish day in spring or autumn, and 100 °F on a blisteringly hot summer day. With the Celsius scale the situation is slightly more 'restricted', with small negative numbers being used for cold days and summer days seldom getting much above 30 °C (at least not in the UK).

Modern-day physicists don't need to worry about degrees of temperature because they use the Kelvin scale. A substance has a temperature because of the energy of motion of its constituent atoms and molecules. As a substance is cooled, the atomic motions get slower. Eventually the atoms cease to move at all. This happens at a temperature of −272 °C or −459.67 °F. It's called absolute zero. Scientists use this temperature as the basis of an *absolute* temperature scale, a fixed reference against which any other temperature can be measured. With the Kelvin scale there's no need to talk of degrees or use the ° symbol. Absolute zero is simply 0 K.

BENZENE RING

Scientific research is a process of long, hard, painstaking work. Neverthe-less, when members of the general public are asked to think about scientific discoveries it's the 'Aha!' moments of insight they tend to highlight: Archi-medes running naked through the streets shouting 'Eureka!' when he understood how to measure the volume of an irregular solid, or Newton being banged on the head by a falling apple and realising that the Moon too might be falling to Earth. One of my favourite examples of sudden insight is Kekulé's explanation of the chemical structure of benzene.

The great physicist Michael Faraday first isolated and identified benzene in 1825. Over the next three decades chemists began to produce the stuff on an industrial scale, and it gradually dawned on them that benzene was the simplest of a whole family of useful and interesting chemicals that came to be called 'aromatics'. Benzene was clearly an important substance, and chemists naturally wanted to know all about it.

It gradually became apparent that the benzene molecule consists of six carbon atoms and six hydrogen atoms, so it has the chemical formula C_6H_6. This led to a puzzle, however, because of an earlier discovery made by the German chemist August Kekulé. (After Kaiser Wilhelm II ennobled him, his name became Friedrich August Kekule von Stradonitz: he added a 'von Stradonitz' and dropped an accent. However, he's nearly always known as August Kekulé.) Kekulé had clearly demonstrated that a carbon atom can make four chemical bonds. In benzene, no matter how you arranged things, the bonds just didn't seem to add up.

It was Kekulé himself who solved the thorny problem of benzene struc-ture. He argued that the carbon atoms in benzene form a six-membered

ring, with alternating single and double bonds. His discovery was so important that benzene got to have its own symbol, based upon its ring structure: ◯.

Chemists built on Kekulé's insight to explain many puzzling phenomena connected with the chemical. Kekulé's work enabled them to make vast numbers of benzene derivatives and other aromatic compounds, which found uses in medicine, industry, and technology. And how did Kekulé make his world-changing discovery? Well, he explained the development of his idea at a conference held in 1890 by the German Chemical Society to celebrate the 25th anniversary of his discovery.

Kekulé claimed he was thinking about the problem of benzene structure one day when he drifted off into a reverie: he dreamed of a snake seizing its own tail. The Ouroboros — an image of a serpent eating itself — is a common enough symbol: it dates back to ancient Egypt, and even appears in a funerary text in Tutankhamun's tomb. When Kekulé thought of it that particular day, though, it brought to his mind a dancing ring of carbon atoms. ◯ came from a daydream.

Stories of sudden insights gained by scientists are entertaining, but they don't contradict the notion that science is a slow, deliberate process. Even if Kekulé wasn't embroidering his account to entertain his audience, and his insight really did come in a flash, well believe me — his insight was preceded by years of hard thinking on the problem.

The chemical structure of benzene shown within an image of the Ouroboros. Kekulé claimed that the structure of benzene came to him in a dream. (Credit: D. M. Gaultieri)

BIOHAZARD

A biological hazard — or biohazard — is a biological substance that can pose a threat to human health. Biohazards range from the relatively low level of risk (where a pair of gloves and a face mask is probably all the protection you need) to the extremely high level of risk (where you *really* don't want to work with the hazard, except with a full positive-pressure protective suit and separate air supply and the many other safety precautions that a dedicated biolab has in place). Varicella, more commonly known as chicken pox, is a Level 1 biohazard: only minimal precautions need be taken when handling it. The Ebola virus is an example of a Level 4 biohazard — the virus is classified as being of the highest level of risk.

It makes eminent sense to stick a warning symbol on any containers that might hold biohazards: the symbol would alert people to the need to take care. But what symbol to use?

One approach to the development of a hazard symbol would be for individual institutions to create their own, but a moment's contemplation will convince you this isn't a sensible strategy: everyone in Laboratory A might know that a bright pink octagon denotes a Level 3 biohazard, but that doesn't help the visitor from Hospital B who is used to seeing hazardous substances marked by a pale green square. To work effectively, a hazard sign needs to be universally understood. It's surprising, then, that prior to 1966 there was no standardisation in this area: institutions did indeed mark biohazards in whatever way they thought appropriate.

The biohazard symbol ☣ was developed in 1966 by the Dow Chemical Co., who were at that time developing biological containment systems for the Cancer Institute at the National Institutes of Health in the US. It all

came about when Charles Baldwin, an environmental health engineer at Dow, got involved in a project to create a sign for marking the containers. He liaised with the package-design department at the company, and asked their artists to create images that were: unique, memorable, recognisable, and meaningless. Why meaningless? Well, Baldwin reasoned it would provide an opportunity for people to be educated as to its meaning.

Baldwin also identified two practical criteria. First, the symbol had to possess a high level of symmetry (so it would appear the same whichever way people happened to be looking at it). Second, it had to be capable of being copied or stencilled quickly.

The marketing people at Dow came up with several possibilities and these, along with some more common symbols, were shown to survey groups across America. People in the groups were shown a total of 24 symbols and asked to guess what each one meant: the ☣ symbol got the fewest guesses (which was good — it meant people wouldn't approach it with preconceptions). The same groups were shown the same set of symbols one week later, along with a further 36 common symbols, and asked which they best remembered. They remembered ☣ best of all. A few months later Baldwin wrote a paper describing this research for the prestigious journal *Science*, and the symbol quickly gained acceptance in the US. It's now an internationally recognised symbol for denoting a biohazard.

The symbol seems to be effective among those who might expect to come into contact with biohazards, but it has the same problem that all hazard symbols possess. As we've seen, the symbol is deliberately meaningless and thus requires education as to its meaning. The alternative is to use a symbol that comes with all sorts of cultural baggage. Either way, a problem arises where children are concerned. Would a child have an understanding of ☣? Or of ⚠, the general warning sign? Would she know that ⚡ is meant to convey the danger of a high voltage in the vicinity? Even ☠, the poison sign, has the potential to be misinterpreted by children: the skull and crossbones could conjure up exciting images of pirates, after all. This difficulty takes on an added dimension with the type of hazard discussed in the next section: radioactivity. Because of the vast stretches of time over which certain types of radioactivity remain lethal, there's a need to design a symbol conveying the concept 'danger' to people whom we can't educate (our civilisation might be long since gone) and with whom we have no cultural connections.

RADIATION HAZARD

X rays, γ rays, and some types of subatomic particle typically possess high enough energies to ionise an atom. In the ionisation process one or more electrons get 'kicked out' of an atom, leaving the atom with a net positive charge. This process can be dangerous. If the atoms in your DNA become ionised, for example, then you have an increased chance of developing cancer. In large doses, radiation kills: in 2006, the murder in London of the Russian dissident Alexander Litvinenko was committed by poisoning him with just 10 micrograms of the radioactive element polonium-210. Radiation has numerous practical applications and benefits, including in a medical setting, but it's definitely not something to mess with. And since radiation is invisible and inaudible, it's vital that radioactive sources are marked by some kind of warning sign.

The internationally agreed sign for radioactivity — ☢ — stems from a meeting that took place in 1946 at the University of California Radiation Laboratory in Berkeley. Participants sketched a variety of different motifs. One of the participants at the meeting was Nels Garden, head of the Health Chemistry Group at the laboratory, who later recalled that the trefoil design aroused interest because people readily perceived it as representing activity radiating from an atom. The trefoil was adopted by Garden's team at Berkeley.

The early Berkeley signs had a magenta trefoil on a blue background: magenta because not only was it distinctive it was also costly to print (thus discouraging others from using it widely and 'diluting' its impact); and blue because that colour was not typically used at Berkeley in areas where radioactive substance were handled. Within a few years the symbol had

moved beyond Berkeley and it became common throughout America (as a magenta trefoil on a yellow background) and then internationally (where the trefoil is black).

The ☢ symbol has been around for decades, then, but is it effective? Well, it is if you've already been educated as to its significance. But what if you haven't seen it before? What if you are a child?

The International Atomic Energy Agency conducted a survey of international schoolchildren and many of the children quite reasonably thought the symbol represented a propeller. That's probably one of the reasons why the International Atomic Energy Agency and the International Organization for Standardization agreed in 2007 to promote an additional warning symbol for ionizing radiation. The new symbol is striking (black on a red background); it contains both the trefoil and the skull and crossbones images; and it shows a person getting the hell away. The idea is to use this image as a label on the internal components of devices containing any radioactive sources: if you take a device to pieces, and you see this sign, stop what you're doing!

This symbol, a supplement to the standard radiation hazard symbol, alerts people that they are close to a source of ionising radiation — devices such as food irradiators and industrial radiography units. It was launched by International Atomic Energy Agency after being tested on a wide variety of people from 11 countries. (Credit: IAEA)

One of the greatest problems with radiation is that certain sources can remain active for tens of thousands of years, longer than the history of our civilisation. Plutonium-239, for example, has a half-life of 24110 years; it isn't too dangerous as an external source of radiation but if inhaled in dust form it can be deadly. Suppose we bury the radioactive byproducts of a nuclear power plant in a mine. We'd want to keep people away from that area for millennia. But how should we warn our distant descendants? They probably won't read English. Would they have an intuitive understanding of a sign such as ☢ or ☠? What symbol would *you* use to warn them?

PRESCRIPTION TAKE

R̹

The practice of medicine continues to become ever-more sophisticated and evidence-based, but traces still remain that hint at the long history of the discipline. The Hippocratic Oath, for example, which requires a newly qualified doctor to swear to uphold certain ethical standards, dates back to ancient Greece — it was first written some time between the third and fifth century BC. And that exercise in inverse snobbery, common in several countries, whereby surgeons revert to being called 'Mr' after years of surgical training during which they may be called 'Dr', harks back to the days when surgery was often performed by barbers who had the tools for cutting both hair and flesh. And today, when a physician writes a medical prescription it's possible that he or she will write R̹ — a symbol dating back several hundred years.

The symbol R̹ is a shorthand for the word 'prescription'. It first appeared in medieval manuscripts, where it was an abbreviation of the Latin command *recipere* — 'take thou'. A prescription in medieval times had to be written before ('pre-scripted') a drug could be mixed and then administered. The prescription would always begin with the command 'take'. (Something along the lines of 'take thou three bat wings, two eyes of newt, and apply upon the lesion a variety of leeches', or whatever — early 'medicines' often contained several ingredients and were difficult to prepare.) The medieval prescription therefore would start with the shorthand R̹. Nowadays, when your doctor scribbles R̹ on a modern prescription pad he or she is essentially telling you to take a particular drug or medicine: the prescription is thus a communication directed at *you*, the patient, rather than at a chemist or pharmacist.

Doctors employ a variety of other Latin terms on their prescription pads and notes. For example, a scribbled command such as 'R 1 cap t.i.d. pc' can be translated into plain English as 'take one capsule, three times per day, after meals': the abbreviation t.i.d. is an acronym standing for the Latin *ter in die* ('three times per day') while pc stands for *post cibos* ('after meals').

The increasing use of computer-based medical systems, and nowadays of AI-based systems, will surely reduce the incidence of such abbreviations. But the readiness of the medical profession to deploy shortcuts seems ingrained. In 2002, for example, studies were published of doctors' use of acronyms (many of which, in a display of black humour, involved terminal cases). The following UK/US acronyms were among those recorded:

ART — *Assuming Room Temperature* (the recently deceased)
DAAD — *Dead As A Doornail*
GFPO — *Good For Parts Only*
GOK — *God Only Knows*
LOLTWO *Little Old Lady Totally Whacked Out*
MFC — *Measure For Coffin*
PBBB — *Pine Box By Bedside*

Several other medical acronyms, which appear in patient notes, demonstrate — how shall I put it — a certain lack of respect by doctors for their patients (and in particular a suspicion that those undergoing treatment might be intellectually challenged). The following examples might make sense only to native English speakers, but similar examples of slang were recorded in various countries. My personal favourites of this type include:

HIVI — *Husband Is Village Idiot*
NARS — *Not A Rocket Scientist*
NFN — *Normal For Norfolk*
SNEFS — *Sub-Normal Even For Suffolk*

Such acronyms have a much more recent provenance than the venerable R, of course, and they almost certainly won't last as long. We live in litigious times, and doctors won't want to risk explaining their notes to a court. (Unless they possess the quick-wittedness of the doctor who, upon being asked by a judge what TTFO meant on a patient's notes, said it represented the command 'to take fluids orally'. The true meaning was that the patient had been 'told to fuck off').

OUNCE

3

As mentioned in the previous section the prescription you receive from your doctor might still contain the symbol ℞, a hangover from times when it was the job of apothecaries to prepare some quite outré formulations. Those ancient prescriptions often contained intricate combinations of surprising ingredients and, despite the bizarre appearance of those recipes to modern eyes, apothecaries took great care over them. Physicians would usually write prescriptions in Latin so that the widest possible audience could read them. Furthermore, they employed a particular system of weights and measures — along with special symbols to represent them. Nowadays most of the world employs the SI system and so we're used to seeing symbols such as kg and g when talking about weights; the ancient apothecaries would have been used to seeing symbols such as ℨ and ℨᵝ. Those symbols are unfamiliar to most of us, and that unfamiliarity might lead us to think they are somehow primitive, but we should appreciate that a medieval apothecary would have taken as much care in getting the correct amount of foxglove in an infusion for fever, say, as a present-day pharmacist would take in preparing drugs for an antipyretic.

In England, the system of weights used by apothecaries and doctors was related to the system of weights in everyday use. The basic unit of weight was thus the pound. However, those medieval apothecaries used a variety of smaller measures.

The pound, which had the symbol lb (from the Latin 'libra' meaning 'scales'), was divided into 12 ounces. The name 'ounce' came from the Latin 'uncia', which meant 'twelfth part': uncia also comes down to us through the word 'inch', the twelfth part of a foot. In old recipes and pre-

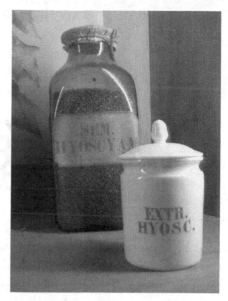

Left: an Austrian apothecary vessel, dating to the 15th or the 16th century, made of turned wood. It bears the inscription R(adix) Gladiola — powdered gladiolus seeds, taken with goat's milk, was a supposed remedy for colic. Right: two 19th century apothecary vessels for the storage of Hyoscyamus niger (henbane) preparations. (Credit: Bullenwächter)

scriptions the symbol ℥ was used to represent the ounce and the symbol ℥ᵝ to represent a half-ounce.

The ounce was further divided into eight drachms or drams. This name came from an ancient Greek measure of weight and it had the symbol ʒ. (The drachm was also associated with an ancient Greek coin; the drachma, of course, has been the currency unit in Greece during several periods of its history.)

The drachm was divided into three scruples (symbol ℈) and the scruple into 20 grains (symbol gr.) — and so 480 gr. was equal to 1 ℥ and 5760 gr. was equal to 1 lb: apothecaries working with grains and scruples were working with quite fine measures.

Units of weight formed the basis for units of volume, with apothecaries writing write about 'fluid ounces' (f℥), 'fluid drachms' (fʒ) and 'fluid scruples' (f℈). An ancient prescription would thus look like an impenetrable jumble of strange symbols and Latin abbreviations — but then don't modern prescriptions look equally baffling to untrained eyes?

ALCHEMICAL MERCURY

Isaac Newton was without peer as a scientist. Prepare a list of the top three theoretical physicists of all time and Newton has to be on it. (He developed the universal theory of gravitation and laws of motion, among other things). Prepare a list of the top three experimental physicists of all time and he's there. (His work on optics ensures this.) And a list of the top three mathematicians of all time would surely contain Newton's name. (He developed calculus.) To be at the pinnacle of three different fields of intellectual endeavour is astonishing. But the truly unbelievable aspect of this is that Newton probably thought his scientific labours were of relatively little importance. He was a man of unparalleled intellectual energy, but he seems to have put most of his energy into esoteric studies of the Bible and arcane experiments in alchemy. What else might he have achieved in science if he hadn't bothered with such daft pursuits?

From our vantage point alchemy is to be viewed with disdain, but I suppose in his defence it can be argued that the situation wasn't so obvious to someone born in the 17th century — even to someone with Newton's clarity of thought. In studying alchemy Newton was following a credible and ancient tradition, and to him it would certainly not have seemed a waste of time.

Alchemists had a variety of objectives, going far beyond the well known one of 'transmuting base metals into gold', and to deliver those objectives they developed experimental processes, laboratory techniques, and methodologies that in some cases are still around today. It's possible, therefore, to regard alchemy as a protoscience — a step on the pathway to modern medicine and chemistry.

The alchemists developed theories and detailed terminology to advance their work. Alchemical manuscripts were full of symbols that stood for chemical elements and compounds (though back then, of course, the alchemists lacked the modern understanding of what elements and compounds are). Take mercury, for example. Alchemists used a variety of symbols for mercury, including this one: ☿. The reason I mention the symbol for mercury, rather than one of the many other alchemical symbols, is that mercury has a particular role in the Newton story.

After his death, Newton's hair was found to contain substantial amounts of mercury — presumably the result of his alchemical work. It's necessary to take care with this metal. We say 'mad as a hatter' when referring to a crazy person, and the phrase originates from hat factories in which workers were exposed to mercury from the felt used in hat production. Mercury poisoning caused some hat workers to develop dementia. To think that a brain as big as Newton's was exposed to ☿! And that he even thought those alchemical pursuits were worth his time in the first place. Tragic.

Sir Isaac Newton (1642–1727) formulated the laws of motion and of universal gravity, invented calculus, built the first practical reflecting telescope, made profound contributions to optics, generalised the binomial theorem, developed an empirical law of cooling, formulated a method for approximating the roots of a function — one could go on and on about his contributions to science. He spent much of his time on non-scientific pursuits, however, including alchemical and Biblical studies. And for 30 years he was Master of the Royal Mint during which time he prosecuted 28 counterfeiters. (Credit: public domain)

CADUCEUS

For some healthcare professionals, and in particular those based in the United Sates, the symbol of medicine is the caduceus, ⊤. But the use of the symbol in medicine arises from a misunderstanding.

The caduceus is associated with the god Hermes — a patron of pilferers but never of physicians. (Hermes also led souls to the entrance to the underworld, but that seems even worse from the point of view of symbolising the medical profession.) In Greek mythology Hermes was quick-witted and fleet of foot; an orator; a messenger of the gods. He became identified with Mercury in Roman mythology. Well, the traditional symbol of the office of herald or messenger was that of a wooden staff with entwined ribbons, and so it was natural that this symbol would represent Hermes. Eventually, however, the ribbons began to be depicted as snakes. The jump from ribbons to snakes is a large one, but snakes, it needs to be pointed out, were revered by the ancient Greeks. Snakes periodically shed their skin, and because of this they became a symbol to the Greeks of renewal, regeneration, and healing. Furthermore the ability of snakes to move without the help of limbs meant they were, in Greek eyes, the wisest of all creatures. Anyway, Hermes began to be pictured holding a staff with entwined snakes.

In order to support this representation of Hermes holding a snake-wrapped staff, the Greeks constructed a myth. The story went that one day, when Hermes was traveling in the Peloponnese, he saw two fighting snakes. He threw his magic wand at them to make them stop and, as the snakes ceased fighting, they became entwined together in peace. The wings were added, presumably as a reference to Hermes's fleetness of foot, and voila... the caduceus.

So the symbol ⊤, which incidentally looks great as an emblem but works much less well at the size of type used in this book, is a representation of the magic staff of Hermes, son of Zeus and Maia. And the caduceus, by association, came to represent a number of the fields with which Hermes was involved. The caduceus is a symbol, for example, of commerce (Hermes was the god of commerce). The caduceus has a long history in printing and publishing and even today some publishers use the caduceus in their insignia. (This usage presumably refers to Hermes' association with negotiation, eloquence, and the swift delivery of messages.) But why, for some people, does it represent medicine?

The association of the caduceus with medicine follows a tortuous trail.

In the mid-19th century John Churchill, a London-based printer of medical books, used the caduceus as the symbol of an imprint; as just mentioned, this was common in publishing. Although this was a publisher's insignia, the fact it appeared in medical books perhaps created an impression that it somehow represented medicine. What is certain is that in 1902 the US Army Medical Corps adopted the caduceus as its symbol. The driving force behind its adoption was Colonel John van Rensselaer Hoff, but he seems to have intended the caduceus not as an emblem of medicine but as an emblem of the noncombatant. (This emphasised the role of Hermes as a negotiator of treaties and also his status as the god of merchants. During war, a merchant vessel could indicate it was a noncombatant by flying a flag bearing the caduceus.) Since personnel in the Army Medical Corps were noncombatants this usage was appropriate, but from that point on, in many people's minds, ⊤ became linked with medicine.

I'm sure the acceptance of ⊤ as representing medicine was made easier because of its resemblance to the traditional symbol for medicine: a staff with a *single* snake coiled around it. This is the rod of Asclepius, which has the symbol ⚕.

Asclepius was the Greek god associated with medicine and the healing arts. (See the section on the constellation of Ophiuchus in the previous chapter for more on the Asclepius story.) Serpents, with their powers of regeneration, played a large part in the veneration Greeks had for Asclepius: in his honour, the sick and wounded who slept in Asclepian healing temples found themselves sharing their beds with snakes. (Non-venomous snakes, it must be said, but even so...) One of the most famous of the Asclepian healing temples was on Kos, where Hippocrates himself started out.

5

Meaningless marks on paper

Mathematics, even more than science, employs symbols. (A famous quote states that 'mathematics is a game played according to certain simple rules with meaningless marks on paper'.) It's difficult to imagine doing mathematics without using symbols. Although one can write a sentence such as 'one plus one is equal to two' it's simpler and quicker to write $1+1=2$. When you start to make slightly more complicated calculations, such as $[(2+3) \times \sqrt{9}]^2 = 225$, you realise what a boon symbolic notation is: writing this calculation using words would take up a paragraph. And some people, of course, operate at levels far beyond mere arithmetic. Here, for example, are the Einstein field equations in compact form:

$$G_{\mu\nu} + \Lambda g_{\mu\nu} = (8\pi G/c^4) T_{\mu\nu}$$

The symbols above represent ten separate equations relating local spacetime curvature to the energy and momentum within that spacetime. Would Einstein have been able to derive general relativity, a wonderfully profound theory of gravity which says that spacetime is a dynamic entity

capable of being pulled and stretched by the presence of energy, if he'd no symbols with which to express his insights?

Not everyone is a fan of symbols in mathematics. Bret Victor, an influential interface designer, has a project called *Kill Math*. Victor makes the point that being able to predict real-world quantities is a source of power and, currently, that power is restricted to the few people who are comfortable with manipulating abstract symbols — those who are comfortable with mathematical analysis, in other words. He believes this power inequality is wrong. I agree with him on that point. But Victor believes this wrong can be righted by developing computer simulations to allow anyone to gain mathematical insight by manipulating an appropriate interface: even non-mathematicians should be able to discover mathematical truths. He also believes such an approach would allow professional scientists to develop a deeper understanding of systems than is permitted by the traditional symbolic-manipulation approach. I'm not entirely convinced.

It is quite true, as Victor states, that symbol-based mathematics evolved because it was the most efficient way of understanding physical models given the constraints of pencil and paper. And if you can't interpret those symbols and make them dance then mathematics will be difficult for you. But one problem with an approach based on making discoveries through playing with simulations is that it's difficult to trust your discoveries: you might be able to discern a pattern between certain parameters in a simulation, but how do you know whether you are missing some deeper, underlying relationship? How can you know whether your discovery holds with other choices of parameter? How do you determine the precise quantitative nature of your discovery?

Equations, particularly in simple cases, help rather than hinder. Consider another equation that's often used to describe gravity, an equation that's much simpler than the Einstein field equations. It gives the force of gravity between two masses:

$$F = Gm_1m_2/r^2$$

This is Newton's law of universal gravitation. We can tell at a glance that the force between two objects depends directly on the product of their masses and inversely on the square of the distance between them. We can also tell that the force *doesn't* depend on the masses' colour, or how fast they move, or how big they are. This equation encodes swathes of

information, makes predictions, and prompts questions that lead to new lines of research. Yes, computer simulations are necessary when things get 'messy' — when you want to model what happens where there are lots of masses interacting gravitationally, say — but they shouldn't replace the traditional analytic approach. Mathematical symbols, of which there are many hundreds, are here to stay. In this chapter you'll meet 20 of the most interesting.

ZERO

0

We are all so thoroughly familiar with the number zero it can be difficult to appreciate that it's not an intuitive concept. Early civilisations just didn't 'get' zero, perhaps because when ancient people used mathematics they did so to address concrete questions. If you're going to calculate how many oxen it will take to plough your land you're not going to need the number zero; nobody ever left his hut intending to buy zero arrowheads from his neighbour; and I'm not going to waste mental effort to remember that you owe me zero apples. The development of an abstract concept such as zero requires several mental leaps and so its introduction was far from inevitable. The Babylonians, for example, used a quite advanced mathematical system for more than a thousand years before they felt the need to start working with zero. So where did zero come from, who invented it, and when was it first used?

The history of zero is a tangled one, in part because there are two slightly different ways in which we use zero.

One use of zero is to indicate an empty place in a positional number system. For example, zero helps us ensure we can distinguish between two similar numbers, such as 4505 and 455. The use of zero is not *obligatory* in a positional system: one can use context to distinguish between numbers. That's what the Babylonians did for so long. (We still do it to some extent. We readily understand that 'four fifty-five' means £4.55 if we're talking about a short taxi ride but £455 if we're talking about a plane journey.) Eventually, around 700 BC, the Babylonians got around to introducing punctuation marks — sometimes a hook, sometimes two wedges, sometimes three hooks — to denote an empty place in a number. But it's in the

work of the ancient Greek astronomers, also from about 700 BC, where we first see a symbol we could interpret as zero. The Greek astronomers employed a positional number system and chose the symbol O as the empty placeholder. No one is entirely sure why O was chosen. Perhaps it stood for omicron, the first letter of the Greek word 'ouden' meaning nothing (but that's unlikely, since omicron was already the symbol for the number 70). Perhaps it stood for 'obolus', a coin of small denomination and therefore something of little value. Perhaps it represented the small O-shaped depression in a sandboard — a type of abacus — when a counter was removed to leave an empty column. Or perhaps it was something quite different.

Despite the clear advantages of using O as a placeholder, even the Greeks did not employ zero particularly widely. The numerals and the number system with which we are all familiar today, including zero, were developed in India. There is an inscription on a stone tablet in the town of Gwalior, in central India, dated 876, which unambiguously uses zero in the form we use today. And around this time one of the greatest thinkers of all time, the Persian mathematician Muhammad Ibn Mūsā al-Khwārizmī, published a manuscript giving rules on how to perform various calculations. He wrote that if, when calculating, no number appeared in a particular decimal place then a little circle should be used 'to keep the rows'. In Arabic this circle was called sifr from which, via various tongues, we get our word zero (and the related word cipher).

And what about the other use of zero — 0 not as a placeholder but as a number in its own right?

The first person to consider how to use zero as an ordinary number, putting it on a footing with other numbers, was the Indian mathematician Brahmagupta. In a book written in 628 he laid down rules for doing arithmetic with zero. (One of Brahmagupta's rules was: 'The sum of zero and zero is zero'. Another was: 'The sum of zero and a positive number is positive'.) Not all of Brahmagupta's rules are consistent with our modern understanding, and even 500 years after Brahmagupta mathematicians were struggling with division by zero, but his work was a major advance.

The use of zero in mathematical calculation makes lots of things easy. It's no exaggeration to say that without the ability to use zero our present-day civilisation might never have developed. It's astonishing, then, that zero did not come into widespread use in the West until the early 1600s.

RATIO OF CIRCUMFERENCE TO DIAMETER

$$\pi$$

It's the mathematical fact surely everyone knows: the ratio of a circle's circumference to its diameter is a constant. This fact means if you double a circle's diameter then its circumference will be twice as large; if you increase a circle's diameter by a factor of three then its circumference will increase by a factor of three; and so on. The ratio of circumference to diameter is of course represented by pi, π, the sixteenth letter of the Greek alphabet. (Actually, the definition of π given above only works on flat surfaces. The definition as stated breaks down if you consider circles on curved surfaces. Draw some circles on an uninflated balloon, for example, and you'll see what I mean once you inflate it.)

It's not known who discovered this fundamental property of circles; the name of that mathematical genius is lost in the mists of history. We *do* know that an Egyptian papyrus dating to 1650 BC gives a value of 3.16 for the circle constant, which is better than the Bible manages: I Kings 7, 23 presents a specification for the temple of Solomon, built around 950 BC, stating: 'And he made a molten sea, ten cubits from the one brim to the other: it was round all about, and his height was five cubits: and a line of thirty cubits did compass it about' — giving a value for π of precisely 3. (The well known story that in the United States the Indiana legislature once tried to legislate the value of π to be precisely 3 is an urban myth. The legislature *almost* passed a bill that was equally silly, regarding the squaring of the circle, but someone was awake when the bill was being read and he recognised the stupidity. The bill didn't pass.) Around 250 BC Archimedes gave a surprisingly accurate value for π, and the values became increasingly accurate as time passed.

Many people over the years have been fascinated by the number π; many people still are. The fascination perhaps arises because, despite the fact that π is irrational (in other words, π can't be expressed exactly as the ratio of two whole numbers, so a fraction such as 22/7 can only ever be an approximation) and transcendental (in other words, π can't be produced through a finite sequence of arithmetical and algebraical operations such as addition, multiplication, and the taking of roots), it nevertheless seems to turn up everywhere — not just in geometry, where its properties first came to light, but in trigonometry and arithmetic and nearly every branch of physics and engineering.

Why, though, do we use the particular symbol π to represent the ratio of a circle's circumference to its diameter?

The first to use the symbol π in this way was the Welsh mathematician William Jones, who was a colleague of Isaac Newton. In 1706 Jones published a book in which he mentions π and gives an approximation for it of 3.141 59. Jones presumably chose the symbol because it is the first letter of the Greek word 'perimeter' — in other words, the circumference. The symbol didn't catch on until 1737, when the world-famous mathematician Leonhard Euler started using it. Euler was so influential, and corresponded with so many mathematicians around the world, that π became established through his usage. It's now almost impossible to conceive of any other symbol being used to represent the familiar irrational number 3.141 592 653 589 793 238 462 643.... .

Not everyone is a π fan, however.

The mathematician Bob Palais notes, quite correctly, that the natural definition of the circle constant is that it is the ratio of the circumference to the *radius*. Furthermore, it's not π itself that crops up so frequently in science and engineering — it's the combination 2π. Palais, and before him Joseph Lindberg, argue that the true circle constant is given by the Greek letter tau, where $\tau = 6.283\,185\,307\,179\,586....$ Why τ and not some other letter? Well, look closely at the equation $\tau = 2\pi$. The two Greek letters look rather similar, except that pi has two 'legs' and tau only one. More seriously, τ is the first letter of the Greek word for 'turn', and the ratio τ is related to one turn through a circle.

There's a strong argument for using τ instead of π for the circle constant, but those who would change it are fighting centuries of usage. I can't see π being replaced anytime soon.

EXPONENTIAL CONSTANT

$$e$$

Whenever some quantity grows or decays at a rate proportional to its current value the exponential function is involved. Exponentials occur in many different fields of knowledge. To take the first few examples that pop into my head, the exponential growth function is of significance in biology (population growth), physics (nuclear chain reactions), finance (compound interest), and technology (computer processing power). In none of these instances does the growth increase without bound; some limiting factor always comes into play and growth levels off. Even so, the exponential function is of fundamental importance.

Let's look at the function in terms of the finance example I mentioned above. Consider a compound interest account. Suppose you have £1 at the start of the year and your bank pays you 100% interest. (This is what's known as a 'thought experiment'; bankers have never been so generous. Antipathy towards bankers aside, let's just do the maths.) After 12 months, if the interest is credited once at the end of the year, you'll have £2. But what if you get the interest credited twice in the year, with an interest rate of 50% compounded for each 6-month period? In that case you'll earn £0.5 interest after 6 months and £0.75 interest in the second 6-month period and you'll have $£1 \times (1 + 1/2)^2 = £2.25$ at the end of the year. Following the same logic, if you get your interest quarterly at 25% compounded you'll have $£1 \times (1 + 1/4)^4 = £2.44$ at the end of the year; if you get the interest monthly you'll have $£1 \times (1 + 1/12)^{12} = £2.61$.

We can generalise the argument given above. If there are n compounding intervals then in each interval the interest will be $100/n\%$, and at the end of the year you'll have $£1 \times (1 + 1/n)^n$. This is the exponential function: the

A pastel portrait of Leonhard Euler (1707–1783) by the Swiss painter Jakob Handmann. Euler was probably the most prolific mathematician of all time. (Credit: public domain)

more money you have at any instant, the quicker the money grows. And what is the value of this function as the number n gets large? It tends to the value 2.718 281 828 450.... The decimal expansion of this fundamental mathematical constant continues without end because, like π, it is an irrational number (and, like π, it's transcendental, too).

Jacob Bernoulli discussed compound interest as long ago as 1683. In 1690, Gottfried Leibniz identified the exponential constant and even gave it a symbol: b. It gradually became clear that this constant was intimately involved in earlier work on logarithms, dating back to Napier in 1618, and mathematicians began to recognise it in other connections. But it was the mathematician Euler who first really understood the importance of the number (and since he introduced much of the mathematical notation we use today it's not surprising we use his choice of symbol for the constant). Around 1727 Euler began using e to symbolise the exponential constant, and in 1748 he published a book in which he used e — the notation was cemented from that point on. You may think he chose e to stand for Euler, but he didn't. It doesn't even stand for exponential. It's just that he was already using a to d in his work; e was simply the next up.

I can't write a piece about the exponential (or Euler) constant without mentioning a beautiful equation — also due to Euler — that links the five most important numbers in mathematics: 0, 1, π, e, and i. We all know what the number 1 means and we've already looked at 0 and π in the previous sections; we'll look at i in a later section. It's nothing less than astounding that a simple equation links these five numbers:

$$e^{\pi i} + 1 = 0$$

If you don't find this equation beautiful then you have no soul.

GOLDEN RATIO

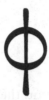

I've seen it claimed that the number which appears in the widest variety of contexts is the one variously known as the golden section, the golden mean, or the golden ratio, ϕ (the Greek letter phi). Apparently you can see signs of ϕ in geometry, architecture, finance, painting, industrial design, biology — in an astonishing array of contexts, in fact. The number ϕ does indeed have many interesting properties but the claim itself is hyperbole. The claim won't vanish because of anything I write, but I'll try anyway.

The golden ratio is easy enough to define. Take a line and divide it into two unequal parts (with lengths A and B, say), ensuring that the ratio of the smaller part (A) to the larger part (B) is equivalent to the ratio of the larger part (B) to the whole ($A + B$). Thus the golden ratio ϕ is defined by $A/B = B/(A + B)$. If you work it out you'll find the ratio is about 1.618 033. (You won't be able to calculate it exactly: the golden ratio is one of those numbers, like π and e, that's irrational.)

The golden ratio is most readily visible in the golden rectangle, a rectangle whose sides are in the ratio 1:1.618... . Mathematicians love to play around with the golden rectangle because it possesses several interesting properties. Here is one notable characteristic: remove a square section from a golden rectangle and the bit that's left over is also a golden rectangle; keep on removing squares in this fashion, and mark the corresponding corners of the squares, and you'll see that the infinite sequence of points form a rather impressive spiral — the golden spiral. Nice.

So ϕ is of some interest to mathematicians. However, certain authors claim that ϕ is involved in our aesthetic sense. You'll find it stated that the ancient Egyptians employed ϕ when building the pyramids. Some sources

state the ancient Greeks believed φ had divine and mystical powers and so used it in their architectural masterpieces. (The Greeks were certainly aware of φ. Indeed it was Euclid, in his book *Elements*, who provided the first recorded definition of the ratio. He called it the 'extreme and mean ratio', which doesn't sound as good as 'golden ratio'.) They'll state that Leonardo da Vinci used φ in his paintings and that people instinctively prefer golden rectangles over other rectangular shapes. Wrong, wrong, and wrong.

The problem is that such claims are all based on a methodology which Martin Gardner called the pyrimidology fallacy. If you measure the Great Pyramid you end up with lots of numbers: height; length from base to apex along various lines; length of base; length of sides at various heights — whatever you want to measure. If you then have sufficient patience you'll be able to juggle those numbers to get whatever result you want. Similarly, if you were silly enough to let me measure your various body parts, Gentle Reader, I'd be able to relate some subset of those measurements to some other thing — the height of Big Ben, the length of your living room, whatever. Fans of φ do the same thing. Go looking for φ in something, and be willing to ignore parts that don't fit while remaining vague about your acceptance criteria (is 1.7 good enough to be called the golden ratio? what about 1.8?), then you'll certainly find φ. But it will have no significance. If you torture data they will confess to anything.

And why the symbol φ for the golden ratio? In 1912 the British art critic Theodore Cook, who was interested in the golden spiral, wrote that it should be called φ after the first letter of Phidias — the Greek sculptor who supervised construction of the Parthenon. It was deemed appropriate because the Parthenon's facade, famously, is in the shape of the golden rectangle. Except, of course, that it isn't.

A view of the Parthenon from the south east. It's often claimed that the building's facade is in the shape of the golden rectangle. The claim is false. (Credit: C messier)

FACTORIAL

!

The exclamation mark (known in my household as 'shriek'; old-time type-setters, who are less gentile than the family Webb, sometimes refer to it as a 'dog's cock') made its way into English punctuation in the 15th century. Up until the middle of the 17th century the mark was called the 'note of admiration' — 'admiration' here being an archaic form, meaning 'wonder' or 'wonderment', since originally the mark represented the Latin exclamation of joy, io. In other words, when they wanted to denote joyous exclamation the earliest printers simply stacked an i above an o. Perhaps if this rather beautiful name had persisted, if we had continued to call the symbol a note of admiration, we would have been spared the modern fad of adding strings of them to the end of simple declarative sentences. OMG, it's *sooo* annoying!!!

The exclamation mark has uses far beyond adding fake enthusiasm to otherwise banal sentences. In the field of mathematics, for example, it denotes a factorial.

Factorials appear naturally in situations where we are interested in permutations. For example, suppose we have five counters of different colours (say red, green, blue, black, white). How many different ways are there of arranging these counters in a row? Well, there are five ways of choosing the first counter: it could be red, green, blue, black, or white. Suppose we pick white. That means there are four different ways of choosing the second counter: we can't choose white again, since the counter can't be in two places at once. By the same logic there are three different ways of choosing the third counter, two different ways of choosing the fourth counter, and for the last counter we have no choice at all — there's only one coun-

ter left. So, the total number of different permutations of these objects is $5 \times 4 \times 3 \times 2 \times 1 = 120$.

This sort of expression — a sequence of integers multiplied together, with each integer being one less than the preceding integer— is a factorial, and often crops up when probabilities are involved.

For example, if you want to calculate the probability that your Lotto ticket will match all six numbers in the draw you need to know how many different ways there are of picking six numbers from 59. (This is the set-up for the UK Lotto; it used to be six numbers from 49, but a rule change was made to make it even harder to win the jackpot). Well, the number of ways of picking six numbers from 59 is:

$$\frac{(59 \times 58 \times 57 \times ... \times 3 \times 2 \times 1)}{(6 \times 5 \times 4 \times 3 \times 2 \times 1) \times (53 \times 52 \times 51 \times ... \times 3 \times 2 \times 1)}$$

It's a pain writing strings of numbers in this way. Mathematicians, who are always on the lookout for labour-saving notation, employ ! in order to denote the factorial function. Thus, for example, $6! = 6 \times 5 \times 4 \times 3 \times 2 \times 1$ and $59! = 59 \times 58 \times 57 \times ... \times 3 \times 2 \times 1$; and one can read these expressions respectively as 'six factorial' and 'fiftynine factorial' (or 'six shriek' and 'fiftynine shriek' in the Webb household). The expression for the number of all possible different UK Lotto tickets becomes much more manageable using the factorial notation. It's:

$$\frac{59!}{6! \times 53!}$$

Whichever notation you use, the string of multiplications or the shorter factorial notation, your chances of being the sole jackpot winner remain one in 45 057 474. You may as well save your money.

The use of ! to denote a factorial was introduced in 1808 by the French mathematician Christian Kramp in his book *Elements d'arithmétique universelle*. I don't know why Kramp decided to use ! in this way. Perhaps it harked back to the 'note of admiration' or wonderment: the wonderment here is how quickly factorial numbers grow. For example, with 10! we are already beyond one million: $10! = 3\,628\,800$. With 70! we are beyond one googol: $70! \approx 1.197... \times 10^{100}$. And with 100! we reach a truly staggeringly large number: $100! \approx 9.332... \times 10^{157}$. If that isn't worth a few notes of admiration, what is?!!!

KNUTH'S UPARROW

Here's a problem to ponder the next time you're in some boring commit-tee meeting.

List every possible subcommittee that can be formed from the people there and consider every possible pair of subcommittees. Assign each pair to one of two groups. How many people must be in the committee to guarantee that, no matter how the assignment is made, there will be four subcommittees in which all pairs are in the same group and all the people belong to an even number of subcommittees?

In 1971, the American mathematicians Ronald Lewis Graham and Bruce Lee Rothschild proved that there exists a solution to this problem that lies below a certain number. That upper bound is called Graham's number, and it's big. Very, *very* big. It's almost impossible to comprehend the utter humongousness of Graham's number. Even to represent it requires a spe-cial notation.

Very large numbers occur naturally in problems involving combinations and permutations. (We saw in the previous section how quickly factorials grow.) One notation that's commonly used to represent very large num-bers is due to Donald Knuth of TEX fame but, as we'll see, even this nota-tion doesn't work with a number the size of Graham's number.

Knuth introduced the operator \uparrow. A single \uparrow is the same as exponentia-tion: $m \uparrow n = m \times m \times ... \times m = m^n$. Thus we have $2 \uparrow 2 = 2 \times 2 = 2^2 = 4$ and $3 \uparrow 4 = 3 \times 3 \times 3 \times 3 = 3^4 = 81$ and so on. Things get interesting when you have a pair of arrows, $\uparrow\uparrow$. This represents a tower of exponents:

$$m \uparrow\uparrow n = m^{m^{\cdot^{\cdot^{\cdot^{m}}}}}$$

where the tower is *n* rows high. This lets you generate some big numbers very quickly. For example:

$$3\uparrow\uparrow2 = 3^3 = 27$$
$$3\uparrow\uparrow3 = 3^{3^3} = 3^{27} = 7625\,597\,484\,987$$

Play around with the double arrow notation to get a feel for it, to get some sense of how quickly it grows. See if you can comprehend just how big $3\uparrow\uparrow4 = 3^{7625\,597\,484\,987}$ is. If you can, you're doing better than me. The number is already *vastly* greater than the number of particles in the known universe. But we haven't even started yet.

Consider the operator $\uparrow\uparrow\uparrow$, which generates a tower of a tower of exponents. Let's look at $3\uparrow\uparrow\uparrow3$:

$$3\uparrow\uparrow\uparrow3 = 3\uparrow\uparrow7625\,597\,484\,987 = 3^{3^{\cdot^{\cdot^{3}}}}$$

where the total height of the tower contains 7625 597 484 987 levels. It's a crazily large number. But we still haven't scratched at Graham's number. Let's consider the operator $\uparrow\uparrow\uparrow\uparrow$, which generates a tower of a tower of a tower of exponents. Think of the number $3\uparrow\uparrow\uparrow\uparrow3$ which is... well, it's so big that it's very difficult to write out. Try it and you'll see.

When thinking about Graham's number we *start* with this number, which we represent by g_1. In other words, $g_1 = 3\uparrow\uparrow\uparrow\uparrow3$. The next number to consider is g_2, which is *vast*:

$$g_2 = 3\uparrow\uparrow...\uparrow\uparrow3 \text{ with } g_1 \text{ arrows between the 3's.}$$

Just four uparrow operators between the 3's generates a number that's way too big to write comfortably. Here, we're trying to think about a number so big that it has $3\uparrow\uparrow\uparrow\uparrow3$ uparrow operators between the 3's. That's g_2. The number g_3 has g_2 uparrow operators between the 3's. And so on.

Graham's number is g_{64}.

This number unimaginable. It dwarfs anything your mind can comprehend. Yet we get a bigger number just by adding 1 to it.

And the answer to the original problem posed above, the problem for which Graham's number provides an upper bound? No one knows... except that it's bigger than 11.

INFINITY

Mathematicians work with some big numbers. For example, that favourite of schoolchildren — the googol — is a 1 followed by 100 zeros. We can write it more concisely using exponential notation: 10^{100}. A googol is big; it's far, far bigger than the number of particles in the observable universe, which is a mere 10^{80}. Then there are the humongously big numbers: the googolplex, for example, is a 1 followed by a googol zeros: 10^{googol}. This number is so big you couldn't possibly write down a decimal representation of it: there is neither world enough, nor time. Then there are numbers that make even a googolplex look tiny. Graham's number, which we discussed in the previous section, is so incredibly, insanely, ungraspably big we can't even write it using the usual tower-of-exponents method. But these numbers — the googol, the googolplex, Graham's number — are all vanishingly small when compared to infinity.

Infinity is perhaps better thought of as a concept than a number, so it isn't surprising that philosophers have tried to get to grips with the idea since ancient times. However, it's an awkward concept to grasp; it caused Greek philosophers, for example, no end of trouble. After various false starts, mathematicians eventually tamed infinity and began to use the concept in applications. It helps of course to have a symbol with which to represent it, and our modern symbol for infinity, ∞, along with its current mathematical meaning, was first given by the British mathematician John Wallis in his treatise *Arithmetica Infinitorum* published in 1655.

It's not entirely clear why Wallis picked this symbol. One possibility is that he chose it because of its similarity to the symbol CƆ, which is how the Etruscans represented the number 1000. (The Etruscans represented

John Wallis (1616–1703) was one of the most influential English mathematicians before Newton. Wallis was apparently able to perform quite extraordinary feats of mental arithmetic. It's said he was once challenged to extract the square root of a number containing 53 digits, and he did it in his head. (Credit: public domain)

500 with the symbol IƆ, which in turn developed into the Roman numeral D for 500; the symbol CIƆ developed into M for 1000.) The suggestion is that CIƆ came to represent large numbers in general along with the vague concept 'many', and that Wallis was alluding to that. Another possibility is that he chose ∞ as a form of the last Greek letter in the alphabet, ω. Whatever the reason, it's certain that printers would have applauded the choice of symbol: they could set the infinity sign simply by placing the numeral '8' on its side.

The symbol ∞ is sometimes called a *lemniscus*, a Latin word meaning 'pendant ribbon'. In 1694, the mathematician Jacob Bernoulli (the chap who investigated compound interest, as discussed in the section on the exponential function) used the word to describe the shape of a particular curve. If you're interested, one algebraic representation of the curve is given by $(x^2 + y^2)^2 = 2a^2(x^2 - y^2)$. The curve is called the lemniscate of Bernoulli, and if you plot out points of the equation you'll see it looks just like the infinity symbol.

SET OF NATURAL NUMBERS

N

The use of symbols lends clarity to mathematical arguments. For example, it's much easier to use the symbol N than to keep on referring to 'the set of natural numbers, i.e. the ordinary numbers used for counting: 1, 2, 3,...'). Similarly, it's easier to use Q than 'the set of all rational numbers' (Q here stands for 'quotient', since a rational number is one that can be expressed as a quotient, the result of a division of two integers). Far better to write Z than 'the set of all integers' (Z here stands for 'Zahlen', the German word for 'numbers'). And, not wishing to labour the point, writing R is simpler than writing 'the set of all real numbers' (a real number being one that can be located as a point on the infinitely long number line). Paragraphs of dense, technical prose can be replaced by a smattering of symbols.

There's a problem with using symbols, however. It's fine to use N to refer to the set of natural numbers, say, but what if we want to use N to refer to some *particular* natural number? That would be quite a common requirement. Or what if N had to stand for some *general* number? Or, indeed, what if N also stood for some quite different concept, such as a vector? The use of symbols would create confusion not clarity.

When mathematics is typeset in professional journals or books then there's a simple solution to this problem: typesetters can make use of the different attributes of a font in order to distinguish between different meanings of a symbol. For example, they could use an italic version of a symbol to represent some quantity (*N* rather than N; perhaps the symbol *N* could refer to a specific number, for instance *N* = 5). The could use a bold version to represent some other quantity (**N** rather than N; perhaps the symbol **N** could be used to refer to a vector). They could even use a bold italic version

to represent some other quantity (N rather than N). These four versions of a symbol (N, N, **N**, \boldsymbol{N}; R, R, **R**, \boldsymbol{R}; and so on) are sufficiently different in visual appearance in a typeset book for there to be little chance of confusion. Thus the four sets mentioned in the first paragraph typically came to be symbolised by bold letters: **N** (the set of natural numbers); **Q** (the set of rational numbers); **Z** (the set of integers); and **R** (the set of real numbers).

The use of bold, italic, and bold italic works well if you're typesetting a book, but it doesn't work if you're writing maths by hand. You can't write bold on a blackboard, for example — what do you do then? And it didn't work for those who used old-fashioned typewriters to write maths. Typists could at least try to double-strike the N (and Q, Z, R, and so on) and try to 'fake' the bold in that way — but this approach didn't work consistently. A slightly better solution, which it seems originated with a group of French mathematicians in the late 1950s and then take hold in the mid-1960s in the world-famous Princeton University mathematics department, was for the typist to overstrike the relevant symbol with an uppercase letter I. This led to the appearance of an open-face font. In turn, mathematicians who wanted to represent a bold N (or a bold Q, Z, or R) in chalk on the blackboard began to do so by drawing an open-face letter: \mathbb{N} (or \mathbb{Q}, \mathbb{Z}, or \mathbb{R}).

This 'blackboard bold' notation caught on and mathematicians around the world began to use it. However, something rather odd then happened. Rather than keeping blackboard bold for handwriting and the usual bold font for typesetting, some mathematicians started using \mathbb{N}, \mathbb{Q}, \mathbb{Z}, \mathbb{R}, and their cousins in print. Several influential mathematicians, including Don Knuth of TEX fame, advised against this usage in print. But they lost the battle. The use of open face as a distinct style caught on and its use as a means of representing various number sets is now standard.

Here is one example where you'll encounter the style. We are often interested in the cardinality of a set, the number of elements in it. Well, \mathbb{N} has an infinite number of elements. If we can map the members of some other set in a one-to-one correspondence with members of \mathbb{N} then we can count the set. Consider \mathbb{Z}, the set of integers. If we arrange things as follows:

\mathbb{N}:	1	2	3	4	5	6	7	...
\mathbb{Z}:	0	1	−1	2	−2	3	−3	...

then we can count \mathbb{Z} since each element of \mathbb{Z} maps on to one (and only one) natural number. Thus \mathbb{Z}, the set of integers, is 'countably infinite'. A surprising result, discussed in the next section, is that \mathbb{R} is too big to count.

SIZE OF AN INFINITE SET

Some infinities are bigger than others. To see how this can be, we need to look at irrational numbers — those such as $\sqrt{2}$, π, and ϕ that can't be expressed as a simple fraction a/b, where a and b are integers. The decimal expansion of an irrational goes on forever, never repeating or terminating.

The existence of irrationals has been known for a long time. Tradition says Hippasus of Metapontum discovered the irrationality of $\sqrt{2}$ in the fifth century BC, a discovery so shocking he drowned at sea as a punishment from the gods. Surely just as shocking, though, was Georg Cantor's discovery that you can't count the number of irrationals: the infinity of irrational numbers is greater than the infinity of counting numbers. Cantor demonstrated this seemingly bizarre property of irrationals through the following argument.

Suppose you claim to have a list of all possible irrational numbers — non-repeating, non-terminating decimal expansions. And suppose you try to count them, as we did previously for \mathbb{Z}, by listing them alongside the natural numbers. The first four entries in your list might look something like this:

1	1.1342516 ...
2	0.7281821 ...
3	5.4286351 ...
4	7.6181303 ...
⋮	⋮

If every irrational number on your list is next to a counting number then you can, as if this needed spelling out, count them. But not every irrational

number is on that list. You may think you've listed them all, but you haven't. To see this, generate a number by writing down the first digit from the first in the list, the second digit from the second in the list, and so on:

1 $\underline{1}$.1342516 ...
2 0.$\underline{7}$281821 ... → 1.728...
3 5.4$\underline{2}$86351 ...
4 7.61$\underline{8}$1303 ...
 ⋮ ⋮

Now generate a different number by, for example, subtracting 1 from each of the digits so that in the example above 1.728... becomes 0.617... .

The number 0.617... isn't on the list of irrational numbers you claimed was complete. It differs from the first number in the first digit, the second number in the second digit, the third number in the third digit, and the nth number in the nth digit. In other words, you can't put the counting numbers in a one-to-one correspondence with the irrational numbers. You can't count the irrational numbers because there are, in a sense, too many of them.

To the infinity of natural numbers \mathbb{N} Cantor assigned the symbol \aleph_0 ('aleph null', aleph being the first letter of the Hebrew alphabet). The larger infinity of real numbers \mathbb{R}, which includes the irrationals, was assigned the symbol \aleph_1 ('aleph one'). There are an infinite number of such infinities.

The German mathematician Georg Ferdinand Ludwig Cantor (1845–1918) invented set theory, a fundamental component of modern maths. It's not easy to get one's head around Cantor's ideas, and initially his work was attacked. He suffered bouts of depression and got involved in such loony pursuits as trying to prove Bacon wrote Shakespeare's plays. Some believed he took too seriously the criticism of his ideas; a few argued his consideration of the infinite drove him insane; the most likely explanation is he suffered a bipolar disorder. (Credit: public domain)

IMAGINARY NUMBER

$$i$$

The concept of number has expanded over the centuries as the sorts of mathematical question people ask have increased in sophistication. To answer the question 'How many pigs do I have?' one need only consider positive integers. If you ask 'How can I share my wealth between my six offspring?' then you need fractions. And if the question is 'How wealthy am I, considering I still have to pay those losing bets at the casino?' then the concept of negative numbers might come into play. A number, then, can be thought of as a point on the so-called number line, a line that stretches to infinity in the positive and negative directions. The number line contains all the integers, all the fractions, all the irrational and transcendental numbers. It seemingly contains *all* the numbers.

The number line doesn't contain just the integers! (Credit: author's own work)

But what about the question 'What number, multiplied by itself, is equal to −1?' The answer can't be 1 (because $1 \times 1 = 1$) and it can't be −1 (because $-1 \times -1 = 1$). It seems to be a question without an answer. Nevertheless, mathematicians discovered it makes sense to expand the concept of number so that questions such as this can be answered.

The mathematicians of ancient Greece seem to have encountered the idea of numbers that, when multiplied by themselves, give a negative answer. However, it wasn't until 1545 that mathematicians explicitly started to discuss these numbers (the first to do so was an Italian gambler and probabilist called Gerolamo Cardano) and the Renaissance mathematicians struggled just as much as the Greeks had with the concept. Indeed, even as late as 1637 the French philosopher René Descartes was using the term 'imaginary numbers' as a derogatory reference to such entities. Unfortunately, the term 'imaginary number' stuck. It's unfortunate because they turn out to be incredibly useful. You simply can't do modern science or maths without making use of imaginary numbers.

It was Leonhard Euler (who else?) who introduced the symbol i for imaginary number: i is the solution to that question 'What number, multiplied by itself, is equal to -1?' In other words, $i \times i = -1$. You can readily conceive of other imaginary numbers: for example $2i$, $0.5i$, or $1/i$. These have squares -4, -0.25, and -1 respectively. Indeed, there's an infinite number of imaginary numbers. And once you have the notation i to represent an imaginary number, it becomes possible to generalise the whole concept of number. The general form of a number is given by $z = x + iy$. This equation is simply saying that the number z has a 'real' part x and an 'imaginary' part y. If $y=0$ then the number z falls on the usual, familiar real number line. If $x=0$ then the number z is purely imaginary. In general, the number z is a *complex* number. The most general way to think about a number, then, is as a point on the complex plane.

Numbers on the x-axis are the real numbers — the numbers we use in everyday life. Numbers on the y-axis are the imaginary numbers. In general, a complex number can be represented as a point on the complex plane. (Credit: author's own work)

IMAGINARY PART

$$\mathfrak{I}$$

The appearance of certain glyphs induces anxiety in me. Take \mathfrak{I}, for example. When I first encountered \mathfrak{I} in a maths book I found its gothic appearance so strange and offputting I was sure the concept it symbolised must be deep, difficult, and beyond my capacity to understand. Eventually I realised \mathfrak{I} was merely being used to denote the imaginary part of a complex number (see the previous section). It was labelling the imaginary axis, the line on which all imaginary numbers ($-1.5i$, $2.7i$, πi, whatever) fall. And the equally hideous \mathfrak{R}, with its angular flourishes, was merely labelling the real axis, the line on which all real numbers (-6.2, 1.8, e^2, whatever) fall. Far from being deep, the concepts behind \mathfrak{I} and \mathfrak{R} were simple. But my anxiety with those horrible gothic letters never fully went away.

For example, when I came to study physics I met the concept of a group. Now, groups are simple to define. Suppose you have some set of objects — integers, say. And suppose you have some operation you can perform on the elements of the set — addition, say. Well a group is defined if four conditions are met. First, there's an *identity*: if you use the operation on any element and the identity you get the element back. (For integer addition the identity is 0. Consider: $2+0=2$ and $0+2=2$.) Second, there are *inverses*: for any element there's another element which, when the operation is used on both of them, generates the identity. (For integer addition the inverse of a positive integer is its negative, and vice versa: $2+-2=0$ and $-2+2=0$.) Third, there's *associativity*: the order in which you do the operation doesn't matter. (The addition of integers is associative: $2+(3+5)=(2+3)+5$.) Fourth, the operation is *closed*: whenever you apply the operation to elements in the set, the result is also in the set. (When you

Marius Sophus Lie (1842–1899) was a Norwegian mathematician who did important work in the theory of continuous symmetries. This work helped develop physicists' understanding of conservation laws and quantum field theory. (Credit: public domain)

add any two integers the result is an integer, so clearly addition is closed.) Thus the integers form a group with respect to addition; you should easily be able to see why they *don't* form a group with respect to multiplication.

It turns out groups are wonderful things with wonderful properties, and they have a myriad of applications. (Next time you pay with a Chip&Pin card remember that the security of the system relies on group theory.) In physics, a type of group called a Lie group can be used to better understand elementary particles — and when I began studying Lie groups it was all fine. The typical symbol for a group would be a nice, simple, non-threatening G. However, I soon learned that associated with any Lie group is its Lie algebra, whose definition I won't bore you with. And if G represents the group, the angular \mathfrak{g} represents the associated algebra. Cue panic attacks.

Why do mathematicians use symbols such as \mathfrak{I} and \mathfrak{g}? Well, many of those who developed the study of imaginary numbers were German, and it was natural for them to use 'I' to represent 'imaginary'. And Sophus Lie, the chap who developed Lie groups, did some of his best known work in Germany. It was natural for him to use 'g' to represent 'group'. But in Germany books were often typeset in blackletter type — Fraktur, Schwabacher, Textualis, and so on. So 'I' and 'g' were typeset as \mathfrak{I} and \mathfrak{g}. Unfortunately its use has lingered, and mathematicians who study objects called rings will quite happily use symbols such as \mathfrak{A}, \mathfrak{E}, and \mathfrak{S}. Not only are these symbols ugly (at least to my sensitive eye), they are almost unreadable — did you spot that the three letters in the previous sentence were A, E, and S?

DIVISION

The notation we use for simple arithmetical operations, symbols such as + for addition, − for subtraction and = for equality, are so engrained that it's difficult to imagine using some other notation. And yet there's nothing about these symbols that make them uniquely suited for arithmetic. We could easily have ended up using quite different symbols for these operations. Take the symbol +, for example.

The ancient Egyptians denoted the operation 'plus' with a pair of legs walking forward (a pair of legs walking backward it signified 'minus'). It wasn't until about 1360 that anything resembling our modern symbol appeared: the French polymath Nicole Oresme appears to have used +, or at least something similar-looking, as an abbreviation for the Latin *et*, which means 'and'. And it wasn't until after 1557 that the symbol + was used in a widespread way in the UK: that year saw the publication of a mathematics book called *The Whetstone of Whitte* by the Welsh physician and mathematician Robert Recorde, which contained the first use of = as the equals sign and the first appearance in English of the common arithmetical operators + and −.

In the UK the commonly used symbol for division is ÷, and this is of even more recent vintage than +, −, and =. Furthermore, the use of the symbol is not as widespread as you might think.

The obelus (for that is the name of the ÷ symbol) has a long history before its use in mathematics. The word derives ultimately from the Greek word for a sharpened stick — a spit, used for cooking. This word in turn became used to denote a tapered pillar, and so obelus shares the same root as the word 'obelisk'. Editors of ancient manuscripts employed the symbol

Johann Heinrich Rahn (1593–1669), pictured here, was involved in the administration of the city of Zurich. In particular, he was responsible for military supplies, artillery and the supervision of shooting practice. It was only after being tutored by the English mathematician John Pell that he developed a high level of mastery in mathematics, and it's likely that Rahn used ÷ as a division sign only after learning it from Pell. (Credit: public domain)

÷ to mark passages of text that might be spurious or doubtful. It wasn't until 1659 that the obelus was used as a symbol for division, when the Swiss mathematician Johann Heinrich Rahn used it in his algebra book *Teutsche Algebra*. (In fact, the symbol was probably first used by an English mathematician named John Pell. Pell was sent on a diplomatic mission to Switzerland by Oliver Cromwell and, while he was there, he tutored Rahn. Nevertheless, it was Rahn's book that first used ÷ as the division sign in print.) An English translation of *Teutsche Algebra* was completed in 1665, but the symbol ÷ almost didn't make it into print: the translator had changed Rahn's notation to ease the typesetting of the book. The publisher invited Pell to oversee the final project and Pell insisted that Rahn's obelus be reinstated. Had he not done that, we probably wouldn't have the ÷ sign on our calculators but rather the replacement symbol used in the initial translation of that 1659 book.

The use of obeli (which, I'm reliably informed, is the plural of obelus) is perhaps declining. It's hardly a worldwide symbol. You might expect there to be widespread use of ÷ in Germany, since it was after all a mathematician from a German-speaking country who invented the sign; but they tend to use the colon to represent division $(4:2=2)$. Several other European countries do the same. And, until recently at least, in some Scandinavian countries the obelus is used as a symbol for *subtraction*. The symbol ÷ is widely used in elementary mathematics in the UK, certainly, but once teachers get their students beyond the $4 \div 2 = 2$ level they are much more likely to use a solidus (as in $4/2 = 2$) or a vinculum (the horizontal line that separates the numerator of a fraction from the denominator). The days of the obelus may be numbered.

THEREFORE

How much confidence do you place in the knowledge produced by various disciplines? Personally, I place as much confidence in the pronouncements of politicians as I do in the patter of snake-oil salesmen; the events of 2016 in the US and UK demonstrated that politicians constitute a group for whom truth seemingly has no privileged status. The discipline of economics is several steps up from politics; nevertheless, many economists seem loathe to accept that their economic models are faulty, even though those models spectacularly failed to predict the financial crash of 2007. Their models clearly don't always predict the outcomes of real-world behaviour but, so far, new models have not been accepted by the economics community. The natural sciences do much better. Natural scientists test their theories against observation and experiment; and then, acting on the feedback Nature provides, they refine their theories. Thanks to science you can have confidence that a bridge is unlikely to fail on you while you are crossing and that your aeroplane won't drop like a stone from the sky. At the extreme end of the trust scale stands the knowledge produced by mathematicians. The reason we can have confidence in mathematical knowledge is that it advances through the clear application of logical argument.

All arguments have a basic structure: A therefore B. In other words, you clearly state your premises (A) — the fact(s) or assumption(s) upon which you are basing your argument — and then you apply a logical principle to arrive at a conclusion (B). If the argument's logic is valid then the conclusion must be valid, so if the premises are true then the conclusion must be true. If the logic is invalid then you have a logical fallacy and the conclusion is invalid.

As an example of a logical argument, consider the following well-known syllogism:

All men are mortal.	(The major premise)
Socrates is a man.	(The minor premise)
Therefore Socrates is mortal.	(The conclusion)

In syllogisms the word 'therefore' typically appears in the conclusion. Here's another example:

All useful concepts require a symbol.	(The major premise)
'Therefore' is a useful concept.	(The minor premise)
Therefore 'therefore' requires a symbol.	(Conclusion)

That last example shows how, if one or more of the premises are false, even valid logic leads to an incorrect conclusion. Nevertheless, mathematicians do indeed want a symbol to represent 'therefore' and the symbol they use is three dots in the form of a triangle (∴). Here's that Socrates syllogism again:

All men are mortal.
Socrates is a man.
∴ Socrates is mortal.

According to Florian Cajori, an influential historian of mathematics, the symbol ∴ was first used in print to denote 'therefore' in 1659 (it appeared in Rahn's book *Teutsche Algebra*; see the previous section). What Cajori omits to say is *why* Rahn decided to use ∴ rather than some other symbol. In fact, I've never read of a good explanation for this symbol. My own belief is that the two lower dots represent the two premises in a syllogism and the upper dot the logical conclusion. But that suggestion, as far as I'm aware, is original to me. In other words, it's merely a guess based on no evidence and is about as far away from the logical certainty of a mathematical argument as you can get.

Incidentally, the upside down therefore sign (∵) denotes the concept 'because'. Symbols such as ∴ and ∵ help one to express arguments unambiguously; that's why they'll never catch on with politicians.

THERE EXISTS

Mathematicians strive for clarity and precision when developing their arguments, and a whole slew of terminology has been introduced to aid that endeavour. Symbols such as ∴ and ∵ (see previous section) can help clarify an argument, but mathematicians use logic symbols that go far beyond mere punctuation. The first one I came across, and still one of my favourites, is ∃.

The symbol ∃ is the existential quantifier. It's often read as 'there exists'. So $\exists x$, for example, can be read as 'there exists at least one object x such that...'. Sometimes mathematicians will use a variant ∃!, which means 'there is one and only one', and \exists_n, which means 'there exists exactly n' — so clearly ∃! is the same thing as \exists_1.

The symbol ∃ looks strange, granted, but it allows mathematicians to be absolutely precise when making statements about the existence (or non-existence ∄ — the symbol ∃ with a line through it) of objects.

The symbol appears to have first been used by Giuseppe Peano, the founder of mathematical logic, in a book published in 1896 (although it was Bertrand Russell who first popularised its use as the existential quantifier). In addition to ∃ Peano was responsible for several pieces of terminology that logicians still use today — particularly in set theory.

The concept of a 'set' is one of the most fundamental in all of mathematics. A set is a collection of well defined, distinct elements. The elements of a set can be anything at all — people, vowels, colours in the Union Jack, whatever. Peano introduced the notation ∈ to denote set membership (thus $a \in S$ means 'a is a member of the set S'; if $S = \{$red, white, blue$\}$, the colours in the Union Jack, then red $\in S$). He also introduced ∩ to denote the intersection of sets (so $A \cap B$ means 'the set containing all those ele-

The Italian mathematician Giuseppe Peano (1858–1932) helped found the fields of mathematical logic and set theory. Much of the notation still used in these fields are due to Peano. (Credit: public domain)

ments that are in both A and B'; if $S = \{$red, white, blue$\}$, the colours in the Union Jack, and $T = \{$red, yellow$\}$, the colours in the Chinese national flag, then $S \cap T = \{$red$\}$). And he introduced \cup to denote the union of sets (thus $A \cup B$ means 'the set of all those elements that are either in A, or in B, or in both'; for the sets defined above, $S \cup T = \{$red, white, blue, yellow$\}$).

A symbol I find even more quirky than \exists is \forall, which is often read as 'for all'. So $\forall x$, for example, can be read as 'for all objects x it is true that...'. This one *wasn't* due to Peano. The German mathematician Gerhard Gentzen first used \forall, in the sense meant here, in a 1935 paper. Gentzen explained he was using the inverted A in analogy to Russell's use of the backwards E (a backwards A, of course, would be of no use whatsoever since it's symmetric about the vertical axis). Gentzen didn't have time to do much more mathematical work; he died of malnutrition while being interned by Russian forces after the Second World War. He met his end peacefully, by all accounts, since his internment gave him time to think about mathematics.

All these symbols — \exists, \forall, \in, \cap, \cup — permit clarity of expression. You can follow a logician's argument and are either forced to agree with the conclusion or else point out where the argument fails. But clarity has a price. I went to my university library, randomly picked a book on logic, and flicked through its pages. I saw: $\Diamond P \longleftrightarrow \neg \Box \neg P$. Apparently this means 'P is possible if and only if it is not necessary that P is not the case'. There may be logical clarity here, but it's about as easy to read as Klingon. (Peano, incidentally, developed a logic-based artificial language called Latino sine flexione; this garnered considerably less attention than his mathematical work.)

PARTIAL DERIVATIVE

If I say my car is travelling at 30 mph, what do I mean? (I'm using miles per hour here for car speed, which is the everyday unit used in the UK and US. The argument in this section works just as well with km/h as the unit of speed.).

Well, speed is distance travelled in a certain time. The usual notation for representing a change in a quantity is the Greek uppercase letter delta, Δ, so if there's a displacement Δs over a time period Δt then the speed is $\Delta s/\Delta t$. In other words, a Δs of 30 miles in a Δt of 1 hour gives a speed of 30 mph. But that isn't what I mean when I say my car is travelling at 30 mph, is it? I might not drive for a full hour. Even if I cover 30 miles during one full hour, my speed will almost certainly have varied throughout the journey. I might have crawled along for most of the journey, then accelerated and covered most of the distance in a few minutes. What I mean by 'travelling at 30 mph' is that this is my speed *right now*.

Instead of using Δ, which denotes quite large changes (measured in miles and hours), let's instead use the Greek lowercase letter delta, δ, to represent small changes: so in the problem above we have δs and δt.

If δt is 1 minute and δs is 880 yards then my average speed over that interval is 30 mph. That's much closer to the real-world meaning of car speed, but it still doesn't quite represent what is meant. After all, cars can accelerate over the course of a minute. The only car I lust after, the stunning Aston Martin Vantage S, can accelerate from 0–60 mph in under 3.5 s. Even the car I own can go from 0–60 mph in 13.4 s. Within one minute the Aston can be travelling at 201 mph; even my car, it is claimed, can reach 120 mph. One minute is too long an interval; much better would be one second.

If $\delta s = 44$ feet and $\delta t = 1\,s$ then you'd probably agree that I am indeed travelling at 30 mph. But even *this* might not satisfy an engineer or a pedant. The trend is clear: by measuring increasingly smaller intervals I get increasingly closer to my *instantaneous* speed. In order to get that instantaneous speed I need to let $\delta t \rightarrow 0$ and so $\delta s \rightarrow 0$. It's only in the limit when these quantities become infinitesimally small that I can talk about my speed at any particular point in time.

It was Newton who first realised one can take the ratio of infinitesimally small quantities and end up with a sensible answer. Newton, however, was an odd man (the brief biography of him in the previous chapter only hints at the level of his oddness) and he didn't publish his revolutionary ideas for many years. Gottfried Wilhelm Leibniz developed the ideas independently, long after Newton, but he published first so it's to Leibniz we owe our notation. Leibniz used d to represent δ in the limit when δ tends to zero. The d notation can be seen in all branches of science because we often need to know how one quantity changes with respect to another. Speed is ds/dt, but one might see dP/dh (change in atmospheric pressure with height); dT/dx (temperature change with distance); dN/dt (how the number of organisms changes with time). The applications are endless.

These ideas form the basis of differential calculus, an invention that transformed civilisation: it allowed scientists to study a dynamic world through mathematics. Calculus tamed the universe. But a question arises: what happens when one quantity depends on more than one variable? Atmospheric pressure might change with temperature as well as with height; we might be interested in temperature changes in two dimensions, not just one; we might want to investigate the influence of several different factors on population growth. When some quantity depends on several variables we can't just use the differential d notation; we must make explicit that we are considering an infinitesimal change in one quantity when all other quantities are fixed. For this we use ∂, a variant of the Greek letter delta, a symbol introduced by Adrien-Marie Legendre in 1786. Thus scientists write things like $\partial s/\partial t$, $\partial P/\partial h$, and $\partial T/\partial x$. It looks odd, but it's just a simple ratio (just as instantaneous speed is a ratio ds/dt) when other relevant quantities are kept fixed. I'm not aware that ∂ has a particular name. It's often read as 'partial', but I've heard it called by many different names. My maths teacher told us to call it 'dabba', but probably just so he could hear his students say things like 'dabba bee by dabba pee' — $\partial b/\partial p$.

DEL OPERATOR

Some things are specified by a quantity defined at every point in space, and it's often interesting to look at how that quantity changes throughout space. For example, suppose geographers wanted to investigate the topography of some surface. The relevant quantity in this case might be height h; the space would be defined by two numbers (x and y coordinates, perhaps); and the geographers would be interested in the surface's peaks and troughs. Or civil engineers might want to study the thermal properties of a room in which they've installed a new heating system. The relevant quantity here would be temperature T; the space would be defined by three coordinates ($x, y,$ and z); and the engineers would be interested in temperature variations throughout the room. Or meteorologists might want to explore air flow at a particular location. The relevant quantity would be the pressure P; the space could be defined by latitude, longitude and height; and the meteorologists would examine pressure gradients at each point.

Scientists routinely study such situations, and they often want to know how quantities change at each point in space. In the first example they'd want to know the steepest slope at each point, and the direction of the steepest slope. In the second example they'd want to know how fast the temperature rises at each point and the direction in which it's rising fastest. In the third example they'd want to know the direction and rate at which pressure changes most rapidly. This is where differential calculus comes in.

If you've read the previous section, you'll know that partial differentials can be used to describe quantities of interest: $\partial h / \partial x$ and $\partial h / \partial y$ in the first example; $\partial T / \partial x$, $\partial T / \partial y$, and $\partial T / \partial z$ in the second; $\partial P / \partial \lambda$, $\partial P / \partial \phi$, and $\partial P / \partial r$ in the third. To answer the questions posed above, though, requires

The harp was almost certainly invented before historic times. The oldest known picture of an angular harp, from which the symbol for the del operator derives its name nabla, dates from about 2000 BC. Similar-looking instruments are still in existence. Although Maxwell used the term nabla in correspondence he was reticent in using the term in formal writing; he suggested the term atled — since ∇ is an inverted delta Δ — and he settled on calling it 'the slope'. Personally, I'm glad nabla won out. (Credit: public domain)

these partial differential terms to be combined in a particular way. And because these situations arise so often, and since it's a pain having to write out all those ∂ terms, mathematicians have invented a special symbol: ∇. The mathematical operation that ∇ represents is applied in a variety of ways.

When ∇ is applied appropriately to certain important quantities it enables physicists to describe complicated phenomena with ease. For example, the Schrödinger wave equation of quantum physics contains the term ∇^2 acting on the wavefunction Ψ; ∇ shows up in fluid mechanics when one describes vortices; and, perhaps best known of all, Maxwell's equations of electromagnetism are expressed in terms of ∇ acting on E and B fields. Indeed, Maxwell was one of the first to refer to the name for the symbol.

Staid people call ∇ del, after the mathematical operations it represents, but the symbol itself has a different name. The Irish physicist William Rowan Hamilton introduced the symbol ∇ in 1837, but he didn't give ∇ a name. Decades later the Scottish theologian William Robertson Smith remarked that it looked like an Assyrian harp, the Greek word for which is nabla, and Maxwell used it jokingly in correspondence with friend Peter Guthrie Tait ('Still harping on that nabla?', he wrote to Tait in 1871). Tait used nabla in a series of papers. The name stuck. And surely 'nabla' is better than 'del' — much more interesting, and vaguely comic, like the name of a slightly scruffy but loveable dog.

SUM

$$\sum$$

Zeno of Elea, the pre-Socratic Greek philosopher, is famous for his para-doxes — simple arguments that seem to deny the possibility of everyday phenomena such as motion. The paradox of Achilles and the tortoise is perhaps his most famous. Zeno argued that if Achilles gives the tortoise a head start then, even if he runs faster than the tortoise, he can never over-take the creature. His dichotomy paradox — so-called because the argu-ment involves continually splitting a distance into two parts — is in many ways similar to 'Achilles and the tortoise'. Here's why.

Suppose you've trained hard and you're going to attempt to better the great Usain Bolt's world record time of 9.58 s for the 100 m. You're off on the b of the bang, but to reach the 100 m finish line you first must reach half of that distance. Then, to cover the remaining 50 m, you must reach half of *that* remaining distance, leaving you with a quarter of the overall distance (25 m) still to go. And before you can travel the remaining quarter of the distance, you'll have to travel half of *that* distance (12.5 m), leaving you with an eighth of the overall distance still to go. Repeat the argument for a sixteenth of the distance, a thirty-second part of the distance, and so on ad infinitum. You can never reach the finish line.

Of course, you'll never better Usain Bolt's time anyway, but that's not the point. Zeno's argument suggests that motion is impossible. His conclusion is clearly wrong, and the easiest way of refuting the paradox is to do what Diogenes the Cynic did when he heard the argument: stand up and walk to your destination. You may not get there quickly, but you'll get there despite Zeno's argument to the contrary. However, Diogenes showed only that the *conclusion* is wrong. What's wrong with the *argument*?

Whenever you move to some destination you travel half of the total distance, then a quarter of the total distance, then an eighth, and so on to infinity. The distance you travel is thus given by the following series:

$$\frac{1}{2}+\frac{1}{4}+\frac{1}{8}+\frac{1}{16}+\frac{1}{32}+\cdots.$$

The denominator of each of the fractions in the above expression is a power of 2, so we can rewrite the series as:

$$\frac{1}{2^1}+\frac{1}{2^2}+\frac{1}{2^3}+\frac{1}{2^4}+\frac{1}{2^5}+\cdots$$

and after n terms (n just stands for any number) you must cross $1/2^n$ of the total distance to reach your goal. The series has an infinite number of terms: there are an infinite number of spatial divisions to traverse. Zeno argued you can't take an infinite number of steps so you can't reach the endpoint.

However, each term in the series is smaller than the previous one. If you stop the series after one term the sum is 0.5. If you stop the series after two terms the sum is 0.75. After three, four, and five terms the sum is respectively 0.875, 0.9375, and 0.96875. The sum increases, but ever more slowly. It *converges*. Mathematicians know how to calculate the sum of such convergent infinite series, and the answer in this case is 1. In other words:

$$\frac{1}{2^1}+\frac{1}{2^2}+\frac{1}{2^3}+\frac{1}{2^4}+\frac{1}{2^5}+\cdots=1.$$

The sums of series arise naturally in many fields of knowledge and the notation that's used to represent summation came first (as usual) from Euler. In 1755, Euler suggested that the symbol Σ be used. It's the capital Greek letter sigma — the first letter of 'sum'. (In practice, a slight variant of the letter is used.) The infinite sum mentioned thus becomes:

$$\sum_{n=1}^{\infty}\frac{1}{2^n}=\frac{1}{2^1}+\frac{1}{2^2}+\frac{1}{2^3}+\frac{1}{2^4}+\frac{1}{2^5}+\cdots=1.$$

The lower limit on the symbol refers to the first term in the series ($n=1$) and the upper limit refers to the final term (n goes to infinity — the symbol for which we considered earlier). Euler's notation is a simple, elegant way of getting a handle on the sums of infinite series. And it highlights just where Zeno got it wrong: he didn't know how to find the sum of an infinite series.

INTEGRAL

Zeno's dichotomy paradox, which we discussed in the previous section, is resolved when one realises that it is possible to sum an infinite series of quantities and end up with a meaningful, finite answer. This notion provides the basis for one of the most powerful techniques in all of science: integral calculus.

Suppose you want to calculate the area under a curve. (Why would you want to do this? Well, the area often has a physical meaning of interest. For example, for a curve drawn on a graph of speed against time, the area under the curve between any two points gives the distance travelled between those points. For a curve drawn on a graph of force against distance as you pull a spring, the area under the curve between any two points gives the work done in stretching the spring between those points. For a curve drawn on a graph of electrical current against time as a capacitor is being charged, the area under the curve between two points tells you how much charge has been added to the capacitor plates between those times. And so on. Finding the area under a curve is often incredibly useful.) There's no problem if the 'curve' happens to be a straight line: the area under a line is just a triangle or a rectangle, and then the area is easy to calculate. But what if the curve is a *curve*?

As with differential calculus, integral calculus was invented by Newton and Leibniz independently. The great idea they had is to approximate the area under a curve by a series of rectangles (the area of each of which is of course easy to calculate — it's just the width of the rectangle multiplied by its height). If you have just one fat rectangle then the approximation will be poor. With lots of thinner rectangles the approximation will be much

The area underneath the curve is clearly much less than the sum of the areas of the 'fat' light-gray rectangles. On the other hand, the area underneath the curve is only a little bit more than the sum of the areas of the 'thin' dark-gray rectangles. As the rectangles become thinner and more numerous, they better approximate the area underneath the curve. (Credit: author's own work)

more accurate. As the width of the rectangles gets smaller and smaller, and you have more and more of them, then the approximation gets better and better. If you have an infinite number of infinitely thin rectangles then the answer is exact: you get the area under the curve.

The same sort of argument can be applied to all manner of situations. Integration lets you calculate the lengths of curves, the surfaces of objects, the volumes of solids... and that doesn't begin to give a flavour of the importance of the concept.

And what about the symbol for this infinite sum of infinitely small quantities? As with differentiation, our notation is due to Leibniz. (Considering that Newton is the most influential scientist of all time he left a surprisingly small legacy regarding notation.) Initially, Leibniz called the sum 'omnia', or 'omn.' for short. But on Friday 29 October 1675 he decided to use the symbol ∫ instead of omn. He thought of it as an elongated S, which we can think of as standing for 'sum'. That's the sign we use today, and you can't pick up a physics or engineering journal without encountering it.

SMALL POSITIVE QUANTITY

$$\varepsilon$$

Mathematicians crave rigour and precision. Consider, for example, the old joke about an engineer, a physicist, and a mathematician who are in a car heading west into Wales. Just as the car leaves the Second Severn Crossing and enters Wales the engineer looks out of the window and says 'Look! Welsh sheep are black.' The physicist shakes his head sagely and says, 'No, no, no. *Some* Welsh sheep are black.' The mathematician is irate at these examples of sloppy thinking. 'There is at least one field, containing at least one sheep, of which at least one side is black.'

Ask someone what it means to say a car is travelling at 30 mph and you'll probably get a sensible answer. For the mathematician, though, the answer is unlikely to be rigorous enough. As we saw in an earlier section, asking about instantaneous speed is a question for differential calculus; speed, at a particular instant, is the tiny distance s travelled in a small time t. So ask a mathematician and they'll tell you that 30 mph actually means something like the following (where, in the formula below, $s_2 - s_1$ is the distance travelled in a time interval $t_2 - t_1$): given any $\varepsilon > 0$, there exists a δ such that if $|t_2 - t_1| < \delta$, then

$$\left| \frac{s_2 - s_1}{t_2 - t_1} - 30 \right| < \varepsilon.$$

The use of terms such as δ and ε, in an expression that simply defines what a travel speed of 30 mph means, might strike you as being ridiculously over the top. Even the inventors of calculus, Newton and Leibniz, didn't try to shore up the foundational aspects of their work in that much detail. Neither, indeed, did the many great mathematicians and physicists

Augustin-Louis Cauchy (1789–1857) was an extremely prolific mathematician, second only to Leonhard Euler in terms of the number of papers he wrote. He has more theorems and concepts named after him than perhaps any other mathematician. It was Cauchy who began the project of formulating calculus in a rigorous manner. (Credit: public domain)

who followed in the next two centuries or so. All of these thinkers were far more interested in applying calculus to solve outstanding problems — and there plenty of problems that the new techniques cast light upon. Why bother developing rigorous foundations for calculus when it was clear to everyone that the mathematics *worked*?

Attitudes slowly changed, however, and mathematicians began to realise they needed to put calculus on a firm footing. The French mathematician Augustin-Louis Cauchy gave the first modern treatment of the subject. In doing this, Cauchy made use of a concept he symbolised by the Greek letter ε, a notation we've just encountered. In Cauchy's work, ε is used to represent an arbitrarily small positive quantity. He showed how limits could be defined in terms of ε.

There are two things about ε that I like. First, it is sometimes used metaphorically to represent *any* small quantity: ε is a 'little one'. I love the fact that Ralph P. Boas dedicated his book *A Primer of Real Functions* 'To my epsilons' — to his children, in other words.

Second, Cauchy introduced the symbol ε because it was the initial letter of the French word 'erreur'. What is now used to help define mathematical concepts with rigour and precision started out as the designation of the error in an approximation.

RIEMANN ZETA FUNCTION

$$\zeta$$

Want to earn a million dollars? Want your name to be mentioned in the same breath as Newton, Euler, Gauss? Simples, as the saying goes — just prove the Riemann hypothesis. The Clay Institute has offered a $1 million prize for a proof of the hypothesis; the result would be so important the mathematical community would hail you as a genius. The drawback? This is a *difficult* problem. It's the most important, and famous, unsolved problem in mathematics. If you solve it, you'll have earned your money.

It's tough trying to explain the Riemann hypothesis in a few paragraphs, not least because a halfway-decent explanation requires some advanced mathematics. Here's the gist, though, without the maths.

In 1859, Bernhard Riemann wrote a paper about a function called zeta (or ζ, the sixth letter of the Greek alphabet). Input a pair of numbers, such as the real and imaginary parts of a complex number, and the function ζ will spit out third number. So if you think of the input as a pair of coordinates on the complex plane then the ζ function can be thought of as describing a three-dimensional landscape. The output of the ζ function, this three-dimensional landscape, has peaks and troughs. Riemann was interested in the troughs, those points in the landscape where the ζ function outputs a zero.

There exists an infinite number of so-called 'trivial' zeros, which occur when the first coordinate of the pair is a negative even number (-2, -4, -6, and so on). There are others places where the landscape contains troughs, however. When Riemann plotted the location of the first ten non-trivial zeros he noticed something truly astounding. The positions of the zeros were not distributed randomly, as he might have assumed they would be; instead, the zeros all fell on a straight line through the landscape. All the

The German mathematician George Friedrich Bernhard Riemann (1826–1866) was one of the most influential mathematicians of the 19th century. (Credit: public domain)

zeros had the same value for the first coordinate of the pair: 1/2. In his paper Riemann hypothesised that *all* the non-trivial zeros of the ζ function fall on this line. Riemann's hypothesis has subsequently been shown to be true for the first 100 billion of the zeros. Everyone believes the hypothesis holds true. But no one has been able to *prove* the hypothesis is true.

Why should this seemingly arcane hypothesis be so important to us today? Well, even before Riemann got involved it was known that ζ is related to the distribution of prime numbers. (A prime number is one that is divisible only by 1 and itself: 3 and 5 are prime, for instance, but 4 isn't because $4 = 2 \times 2$.) Primes are important because all numbers can be broken down into a product of primes. To pick a pair of numbers at random, $381 = 3 \times 127$ and $483 = 3 \times 7 \times 23$. This decomposition of a number into a product of primes always works, so in some ways prime numbers are the 'atoms' of arithmetic. Mathematicians dearly want to understand more about the distribution of prime numbers and, since the ζ function encodes information about primes, a proof of the Riemann hypothesis has become something of a holy grail. A proof would transform many branches of mathematics, but it wouldn't be of purely intellectual concern: prime numbers are critical to the modern cryptographic techniques upon which e-commerce is founded. Proving the hypothesis really matters.

I'm not sure why Riemann chose the symbol ζ to represent the function, but in a way it's appropriate: in the ancient Greek system of numerals the number 7 was represented by ζ. And 7, of course, is a prime number.

Notes

Chapter 1

ampersand For a discussion of how the word ampersand came about as a corruption of the phrase 'and per se &', see Glaister (1960).

question mark For Chip Oakely's research on the zagwa elaya, and his interpretation of it as a question mark, see University of Cambridge (nd).

semicolon Partridge (1953) has an entire chapter devoted to the semicolon. Kurt Vonnegut's distaste of the semicolon appears in his essay collection *A Man Without a Country* (Vonnegut, 2005). Samuel Beckett's mention of the semicolon appears in his second published novel, *Watt* (Beckett, 1953). The Thoreau quote comes from his 1849 essay 'On the duty of civil disobedience'. The Semicolon Appreciation Society has its website at semicolonappreciationsociety.com and is worth supporting!

at For details of the appearance of @ in the 1345 translation of the Manasses Chronicles, see Dimov (2012). The website Typefoundry (2013) has an interesting discussion of the symbol, along with a link to a video (see Smith, 2013) of an illustrated lecture on the at symbol in French.

percent The prolific mathematician and educator David Eugene Smith (1860–1944) wrote about the history of the percent sign in volume 2 of his *History of Mathematics* (Smith, 1925).

tilde The tilde is a complicated character. There is the tilde itself, which began life as a diacritic mark and then found employment in a number of other fields, and the tilde operator that's used in mathematics. Although different in a logical sense, in most fonts they appear to be identical. See Korpela (nd) for more technical information about the tilde. Details of the beatmap juggling notation can be found at Juggle Wiki (nd).

pilcrow There is an entire book on the historical development of the paragraph in English: see Lewis (1894). According to Sandys (1903), the only punctuation mark explicitly mentioned by Aristotle was a short horizontal line, called in Greek παραγραφή, drawn underneath the first word of the line in which the sentence was going to end. The name of the punctuation mark became attached to the closing sentence itself, or to a connected group of sentences, and it is from this that we get the word 'paragraph'.

section The section sign or section mark, as it's known in Britain, has been around for a long time; the Oxford Universal Dictionary tells that printers were using it in this sense as far back as 1728. However, I have been unable to find a detailed history of the symbol.

copyright The website of the UK Copyright Service contains a lot of information about copyleft, copyright, and intellectual property in general, see UKCS (2017). Inevitably, the site focuses on UK issues, but there is an international element too. Increasingly, at least in education and publishing, it seems likely that Creative Commons will become standard; see Creative Commons (nd) for details of the various licenses and available content.

guillemet Adobe Systems software has two characters it names guillemotleft and guillemotright; Adobe should have named then guillemetleft and guillemetright, as they later acknowledged (Adobe Systems Inc., 1999).

interrobang A discussion of the interrobang, along with further information about its use, appears in Grammarly (2015).

emoticon Bierce's essay 'For brevity and clarity' appears in Bierce (1909). Nabokov's exchange with the New York Times reporter, in which he describes a supine round bracket, appears in Nabokov (1973). The early emoticons shown in the figure, which were authored by an unknown writer, appeared in Puck (1881).

ash, thorn See Page (2006) if, like me, you have an interest in coins or Tolkien; this scholarly work is extremely readable, and it clearly explains the development of runes in Anglo-Saxon. For Caxton's use of Y rather than thorn, see Ward's Book of Days (2006).

schwa Strunk and White (1999) has the twin virtues of being short and readable, but I'm not sure that its prescriptive nature sits well in the age of the internet. For a biography of Gell-Mann, see Johnson (1999). Details of the international phonetic alphabet can be found at IPA (nd).

hedera For more about fleurons, and typography in general, see Bringhurst (2012).

versicle Knuth (1984) is the definitive guide to TeX; he used the software he had developed to typeset his beautiful biblical commentary (Knuth, 1991).

binding signature The technical reasons behind having a rotated capital Q in Unicode are given by Whistler (2000).

Cirth letter J A variety of scripts and writing systems appear in *The Hobbit* (Tolkien, 1937), *The Lord of the Rings* (Tolkien, 1954/55), and *The Silmarillion* (Tolkien, 1977). Appendix E of the third volume of *The Lord of the Rings* provides an overview of the writing systems of the various peoples in the Second and Third Ages.

Klingon letter S For a link to *Ansible*, see Langford (nd). For an official guide to Klingon words and phrases, see Okrand (1985).

Chapter 2

swastika Campion (2014a, b) gives a fascinating history of the swastika.

peace The Campaign for Nuclear Disarmament website (CND, nd) tells the story behind the peace symbol.

Maltese cross See Foster (2004), and references therein, for the relationship of the Maltese cross to the Order of St John.

anarchy The 'property is theft' slogan was coined in Proudhon (1840). Infoshop (n.d.), and references therein, has background on the circled-A.

Apple command Chan (2014) has an interview with Susan Kare, the Apple designer of the command key. One element of the interview strikes me as being implausible: it's explained that a fan sent Kare a postcard of an aerial view of Borgholm castle, and the fan claimed this view inspired the cloverleaf-like symbol. The outline of the castle does indeed resemble the symbol — but the castle was constructed much later than the picture stones on which the symbol already appears.

smiley Leaf (1936) might have contained a version of the smiley face but in truth, as Stamp (2013a) points out, the design is so simple it makes little sense to credit any individual with 'inventing' it. Indeed, Stamp provides a link to a website that exhibits a happy face in a French cave dating back to 2500BC.

barcode Harford (2017) discusses the invention of the barcode.

quick response code I'm sure it comes as no surprise to learn that there exist websites devoted to the history and application of QR codes; see, for example, Denso Wave Inc (nd) and Mobile QR Codes (nd).

hash Dowling (2010) is a humorous account of the octothorpe, written as the # symbol was well on its way to ubiquity.

power standby There's an organisation in charge of power symbols and such like: the International Electrotechnical Commission. See IEC (2017) for the url of its website.

euro The European Commission has part of its website devoted to all aspects of the euro. For details of the euro symbol, see EC (2015). Eisenmenger's claim to be the father of the euro symbol is reported (in German) in Spiegel (2002).

dollar Lexicographers at the OED have entries devoted to the history of the dollar sign (Oxford Dictionaries, 2017a) and the pound sterling sign (Oxford Dictionaries, 2017b).

spade suit Hargrave (1930) reviews the history, development, and use of playing cards across the world; she also examines the various ways in which cards have been decorated. More recent reprints of the original edition are available.

treble clef Many works trace the development of musical notation. See for example Stamp (2013b) and references therein.

recycling Dyer (nd) features an interview with Gary Anderson, in which its discussed how he came up with the recycling symbol.

braille ligature th The Royal National Institute of Blind People has vast amounts of information about Braille and related systems. See for example RNIB (2016).

star-and-crescent The Welcome to Portsmouth (2014) website contains background on the relationship between the city and the star and crescent.

ankh Mark (2016) contains a wealth of information about the origin and meaning of the ankh, and the history of its use.

yin yang For details of the 'astronomical' theory of the origin of the yin yang symbol, see Jaeger (2012).

pentagram The astrophysicist Mario Livio presents an interesting account of the pentagram in his book on the golden ratio (Livio, 2002).

Chapter 3

Sun, Moon, planet Mercury, planet Venus, planet Mars, planet Jupiter, planet Saturn Annie Maunder, a 'lady computer' at the Royal Observatory in Greenwich, was one of the pioneers of women in astronomy. She was married to Edward Maunder, who is still remembered for his work on solar activity. According to Brück (1994), the Maunders became interested in the origin of planetary symbols while studying old astronomical texts in the Observatory library. See Maunder and Maunder (1920) and Maunder (1934) for more historical details of the symbols for the Sun, Moon, and the five classical planets. Note that these seven celestial bodies were closely related in the minds of the ancients to metals: the colour of the Sun meant it was related to gold; the slow motion of Saturn across the sky meant it was related to lead; and so on. The signs for seven common metals are thus the same as for the planets.

planet Earth Until the development of a heliocentric theory, Earth was of course not considered to be a planet in the same way that Venus, Mars, and Mercury were planets. Nevertheless, the circled-cross symbol for Earth appears to be ancient. The cross in the symbol has obvious religious connotations, but the symbol can also be thought of as representing a globe with equator and meridian; as the four points of the compass; as the four seasons; and so on.

planet Uranus The Royal Astronomical Society website contains a link to an interesting short video about Herschel's discovery of Uranus; see RAS (2015).

planet Neptune See chapter 2 of Lequeux (2013) for a modern account of the discovery of Neptune, including a discussion of the Adams controversy.

dwarf planet Pluto Byers (2010) gives a fictional, but historically accurate, account of Tombaugh's discovery of Pluto.

Ceres The wonderful (and, it must be said, rather weird) array of symbols attached by astronomers to the asteroids can be seen in Hilton (2016); Hilton's article also contains many useful references. See also Schmadel (2015).

vernal equinox, constellation of Pisces, constellation of Ophiuchus Olcott (1911) recounts the myths and legends behind star groups — not just the zodiacal constellations such as Pisces, Ophiuchus, and Aries (which, as I explained in the text, gives rise to the sign for the vernal equinox) but constellations you probably haven't heard of. The book is more than a century old, but the myths don't age and a 2004 reprint is readily available.

ascending node As mentioned in the notes regarding planetary symbols, Edward Maunder and his wife Annie took a close interest in the history of astronomy. Maunder (1908) has a nice discussion of the 'dragon's head' and the 'dragon's tail'.

Black Moon Lilith Upgren (2012) takes a fascinating look at what the night sky would have looked like, and the impact that would have had on life, if cosmic history had turned out differently — if Earth had been the only planet orbiting the Sun, for example, or if the Sun had been a binary star. Upgren devotes an entire chapter to an alternate history in which Earth had many moons. However, it's important to realise that the book is purely a thought experiment: Earth has only one major satellite, the Moon. If you really want to learn more about Dark Moon Lilith, and how it features in astrology, then a quick internet search will throw up tens of thousands of references. But I tell you now — it's nonsense.

arc second The Gaia website (ESA, 2017) contains information not only about the satellite, but about the history of astrometry and what it means to be able to measure stellar positions to an accuracy of a few millionths of a second of arc.

redshift The use of z to represent redshift was introduced in Hubble and Tolman (1935).

Hubble constant For some of the history of the Hubble constant, see Smith (1979).

Chapter 4

speed of light Asimov (1959) wrote an article in which he argued c stood for celeritas. He offered no historical evidence to bolster the claim, but it seems to me to be a reasonable assumption.

reduced Planck constant, wavefunction, fine structure constant, gamma ray, tau lepton, Xi baryon In the first half of the 20th century Planck, Einstein, Rutherford, Schrödinger, and many other brilliant physicists battled to understand how the world works on the smallest scales. For a fine history of particle physics, which describes the struggle that these intellectual giants faced, see for example Pais (1986) and the numerous references therein. Crease and Mann (1986) is strong on the discoveries that led to the development of the standard model of particle physics.

standard deviation For a YouTube video that clearly demonstrates the bell shape of the normal distribution, see IMAmaths (2012).

cosmological constant Any modern book on cosmology will give a treatment of the cosmological constant. For further information about the quote from the Goldman Sachs employee, and how spectacularly incorrect it was, see Dowd, Cotter, Humphrey, and Woods (2008).

magnetic field The website of the James Clerk Maxwell Foundation (JCMF, 2016) contains a wealth of information about one of the greatest scientists, and a list of books that discuss Maxwell's explorations into electromagnetism.

electrical conductance, angstrom unit, degree Fenna (2002) gives the historical background to over 1600 different units from a variety of disciplines.

benzene ring For a thorough account of the (contested) story of the discovery of the structure of benzene, see Rocke (2010).

biohazard The paper that recommended the adoption of the biohazard symbol was Baldwin and Runkle (1967).

radiation hazard For details of the radiation hazard symbol, see Stephens and Barrett (1979).

prescription take The Oxford English Dictionary gives the history behind the word 'recipe' and its relation to a prescription. For examples of slang

in medical and clinical practice, including the acronyms mentioned in the text, see for example Fox, Cahill, and Fertleman (2002); Fox, Fertleman, Cahill, and Palmer (2003); and McDonald (1994, 2002). The research by Fox etal. provoked a slew of media reports, focusing on the black humour aspects of medical slang (humour which, I appreciate, might not travel well).

ounce Coates (nd) is a website devoted to apothecaries weights, and includes information about ounces, drachms, scruples, grains, and much else beside.

alchemical mercury To my mind, the best biography of Newton is by Westfall (1981).

caduceus Friedlander (1992) is a history of the caduceus symbol in medicine.

Chapter 5

zero See Barrow (2001) and Seife (2000) for more information about the surprisingly subtle concept of nothing and the number zero.

ratio of circumference to diameter For some fascinating facts about the number 3.14159... see Blatner (1997).

exponential constant Just as 0 and π have been the subject of book-length biographies, so has e; see for example Maor (1994).

golden ratio And just as for 0, π, and e so also for ϕ: see Livio (2002), for example, for a biography of the golden ratio. Devlin (2007) presents an examination of the myths regarding ϕ, and why those myths are so persistent.

factorial For more on the origins of the factorial, and for many other interesting facts about numbers, see Higgins (2008).

Knuth's uparrow If you really want the gory details about the uparrow notation, see Knuth (1976). An accessible introduction to Graham's number can be found in the relevant chapter in Gardner (1989).

infinity, size of an infinite set There are many books about the concept
of infinity. See, for example, Maor (1991) and Rucker (2004).

set of natural numbers MathForum (2003) captures a discussion on the
history of blackboard bold. The earliest appearance of blackboard bold
in print seems to have been in the textbook *Analytic Functions a Several
Complex Variables* (Gunning and Rossi, 1965), but be warned if you're
tempted to read it: this is a high-level mathematical text unlikely to be of
interest to anyone other than a professional mathematician!

imaginary number, imaginary part Just as for 0, π, e, and ϕ so also for
i: see Nahin (1999), for example, for a biography of the square root of mi-
nus one. For a biography of Sophus Lie, the mathematician mentioned in
the text who was instrumental in developing group theory, see Stubhaug
(2002).

division, therefore, there exists, partial derivative, del operator,
sum, integral, small positive quantity Cajori (1928/9) is the best source
for the history of the signs, symbols and notations used in mathematics.
The book dedication mentioned in the discussion of ε appears in Boas
(1960).

Riemann zeta function The Riemann hypothesis has spawned an un-
imaginably vast literature, which is unsurprising because whether the
hypothesis is true or not is probably the most important open question
in mathematics. Three excellent popular expositions of the problem ap-
peared in 2003 alone; see for example Derbyshire (2003), de Sautoy (2003),
and Sabbagh (2003).

Bibliography

Adobe Systems Inc. (1999) *PostScript Language Reference.* 3rd edn. Addison Wesley, New York

Asimov I (1959) C for celeritas. *Magazine of Fantasy & Science Fiction.* (November)

Baldwin CL, Runkle RS (1967) Biohazards symbol: development of a biological hazards warning signal. *Science* 158 264–265

Barrow JD (2001) *The Book of Nothing: Vacuums, Voids, and the Latest Ideas about the Origins of the Universe.* Pantheon, New York

Beckett S (1953) *Watt.* Olympia Press, Paris

Bierce A (1909) *The Collected Works of Ambrose Bierce.* Neale, New York

Blatner D (1997) *The Joy of Pi.* Allen Lane, London

Boas RP Jr (1960) *A Primer of Real Functions.* MAA, Washington, DC

Bringhurst R (2012) *The Elements of Typographic Style.* 4th edn. Hartley and Marks, Vancouver

Brück MT (1994) Alice Everett and Annie Russell Maunder: torch bearing women astronomers. *Irish Astron. J.* 21 281–291

Byers M (2010) *Percival's Planet: A Novel.* Holt, New York

Cajori F (1928/9) *A History of Mathematical Notations.* (2 vols) Open Court, London

Campion MJ (2014a) How the world loved the swastika. *BBC News.* www.bbc.co.uk/news/magazine-29644591

Campion MJ (2014b) Reclaiming the swastika. [Radio broadcast] *BBC Radio 4.*

CND (nd) *The CND symbol.* www.cnduk.org/about/item/435-the-cnd-symbol

Coates D (nd) Apothecaries weights. www.apothecariesweights.com

Crease RP, Mann CC (1986) *Second Creation: Makers of the Revolution in Twentieth Century Physics.* Macmillan, New York

Creative Commons (nd) Home page. https://creativecommons.org/

Denso Wave Inc (nd) History of QR code. www.qrcode.com/en/history/

Derbyshire J (2003) *Prime Obsession: Bernhard Riemann and the Greatest Unsolved Problem in Mathematics.* Joseph Henry Press, Washington, DC

de Sautoy M (2003) *The Music of the Primes.* HarperCollins, London

Devlin K (2007) The myth that will not go away. *Devlin's Angle.* www.maa.org/external_archive/devlin/devlin_05_07.html

Dimov S (2012) The @ sign adorns medieval books. *Europost.* www.europost.eu/article?id=4065

Dowd K, Cotter J, Humphrey C, Woods M (2008) How unlucky is 25-sigma? https://arxiv.org/pdf/1103.5672.pdf

Dowling T (2010) How the # became the sign of our times. *The Guardian.* www.theguardian.com/artanddesign/2010/dec/08/hash-symbol-twitter-typography

Dyer JC (nd) The history of the recycling symbol: how Gary Anderson designed the recycling symbol. www.dyer-consequences.com/recycling_symbol.html

EC (2015) How to use the euro name and symbol. http://ec.europa.eu/economy_finance/euro/cash/symbol/index_en.htm

ESA (2017) Gaia. http://sci.esa.int/gaia/

Fenna D (2002) *A Dictionary of Weights, Measures, and Units.* OUP, Oxford

Foster M (2004) *History of the Maltese Cross, as used by the Order of St John of Jerusalem*. www.orderstjohn.org/osj/cross.htm

Fox AT, Cahill P, Fertleman M (2002) Medical slang. *Brit. Med. J.* 324 S179

Fox AT, Fertleman M, Cahill P, Palmer RD (2003) Medical slang in British hospitals. *Ethics and Behaviour* 13 173–189

Friedlander WJ (1992) *The Golden Wand of Medicine: History of the Caduceus Symbol in Medicine*. Greenwood Press, Westport, CT

Gardner M (1989) *Penrose Tiles to Trapdoor Ciphers*. Mathematical Association of America, Washington, DC

Glaister GA (1960) *Glossary of the Book*. George Allen & Unwin, London

Harford T (2017) How the barcode changed retailing and manufacturing. *BBC News*. www.bbc.co.uk/news/business-38498700

Gunning RC, Rossi H (1965) *Analytic Functions of Several Complex Variables*. Prentice-Hall, Englewood Cliffs, NJ

Hargrave CP (1930) *A History of Playing Cards and a Bibliography of Cards & Gaming*. Houghton Mifflin, Boston

Higgins PM (2008) *Number Story: From Counting to Cryptography*. Springer, Berlin

Hilton JL (2016) When did the asteroids become minor planets? aa.usno.navy.mil/faq/docs/minorplanets.php

Hubble E, Tolman RC (1935) Two methods of investigating the nature of the nebular red-shift. *Astrophys. J.* 82 302–337

IEC (2017) IEC home page. www.iec.ch

IMAmaths (2012) Galton board. www.youtube.com/watch?v=6YDHBFVIvIs

Infoshop (n.d.) *An anarchist FAQ*. www.infoshop.org/AnarchistFAQAppendix2

International Phonetic Association (nd) *IPA Home*. www.internationalphoneticassociation.org/

Jaeger S (2012) Yin yang symbol. www.jaeger.info/2012/01/18/yin-yang-symbol/

JCMF (2016) James Clerk Maxwell Foundation home page. www.clerkmaxwellfoundation.org/index.html

Johnson G (1999) *Strange Beauty: Murray Gell-Mann and the Revolution in Twentieth-Century Physics*. Alfred Knopf, New York

Juggle Wiki (nd) http://juggle.wikia.com/wiki/Beatmap

Grammarly (2015) A brief and glorious history of the interrobang. www.grammarly.com/blog/a-brief-and-glorious-history-of-the-interrobang/

Knuth DE (1976) Mathematics and computer science: coping with finiteness. *Science* 194 1235–1242

Knuth DE (1984) *The T$_E$Xbook*. Addison-Wesley, Boston

Knuth DE (1991) *3:16 Bible Texts Illuminated*. A-R Editions, Middleton, WI

Korpela JK (nd) Character histories: notes on some ASCII code positions. www.cs.tut.fi/~jkorpela/latin1/ascii-hist.html

Langford D (nd) *Ansible*. http://news.ansible.uk/Ansible.html

Leaf M (1936) *Manners Can Be Fun*. Lippincott, Philadelphia, PA

Lequeux J (2013) *Le Verrier — Magnificent and Detestable Astronomer*. Springer, Berlin

Lewis EH (1894) *The History of the English Paragraph*. University of Chicago Press, Chicago

Livio M (2002) *The Golden Ratio: The Story of Phi, the World's Most Astonishing Number*. Broadway Books, New York

Maor E (1991) *To Infinity and Beyond: A Cultural History of the Infinite*. Princeton University Press, Princeton

Maor E (1994) *"e": the Story of a Number*. Princeton University Press, Princeton

Mark JJ (2016) The ankh. *Ancient History Encyclopaedia*. www.ancient.eu/Ankh/

MathForum (2003) History of blackboard bold? http://mathforum.org/kb/message.jspa?messageID=515841

Maunder ASD (1934) The origin of the symbols of the planets. *Observatory* 57 238–247

Maunder ASD, Maunder EW (1920) The origin of the planetary symbols. *J. Brit. Astron. Assoc.* 30 219

Maunder EW (1908) *The Astronomy of the Bible*. Sealey Clark, London

McDonald PS (1994) The heartsink problem in general practice. *PhD thesis*. University of Nottingham

McDonald PS (2002) Slang in clinical practice. *Brit. Med. J.* 325(7361) 444

Mobile QR Codes (nd) History of QR codes. www.mobile-qr-codes.org/history-of-qr-codes.html

Nabokov V (1973) *Strong Opinions*. McGraw-Hill, New York

Nahin PJ (1999) *An Imaginary Tale*. Princeton University Press, Princeton

Okrand M (1905) *The Klingon Dictionary*. Pocket Books, New York

Olcott WT (1911) *Star Lore: Myths, Legends, and Facts*. Putnam's, London

Oxford Dictionaries (2017a) What is the origin of the dollar sign ($)? https://en.oxford-dictionaries.com/explore/what-is-the-origin-of-the-dollar-sign

Oxford Dictionaries (2017b) What is the origin of the pound sign (£)? https://en.oxford-dictionaries.com/explore/what-is-the-origin-of-the-pound-sign-ps

Page RI (2006) *An Introduction to English Runes*. Boydell Press, Woodbridge

Pais A (1986) *Inward Bound: Of Matter and Forces in the Physical World*. Clarendon Press, Oxford

Partridge EH (1953) *You Have a Point There: A Guide to Punctuation and its Allies*. Hamish Hamilton, London

Proudhon P-J (1840) *What is Property? Or, an Inquiry into the Principle of Right and of Government*. (Paris; Engl. trans. 1890, Humbold, New York)

Puck (1881, March 30) Issue 212, pg 65

RAS (2015) Treasures of the RAS: the discovery of Uranus. www.ras.org.uk/library/treasures-of-the-ras/2426-treasures-of-the-ras-the-discovery-of-uranus

RNIB (2016) Invention of braille. www.rnib.org.uk/braille-and-other-tactile-codes-portal-braille-past-present-and-future/invention-braille

Rocke AJ (2010) *Image and Reality: Kekulé, Kopp, and the Scientific Imagination*. University of Chicago Press, Chicago

Rucker R (2004) *Infinity and the Mind: The Science and Philosophy of the Infinite*. Princeton University Press, Princeton

Sabbagh K (2003) *Dr. Riemann's Zeros*. Atlantic, London

Sandys JE (1903) *A History of Classical Scholarship*. (Vol 1). CUP, Cambridge

Schmadel LD (2015) *Dictionary of Minor Planet Names: Addendum to 6th Edition: 2012–2014*. Springer, Berlin

Seife C (2000) *Zero: The Biography of a Dangerous Idea*. Viking, New York

Smith DE (1925) *History of Mathematics*. Vol 2. Ginn, Boston

Spiegel (2002) Das vergessene Vater des uro. www.spiegel.de/wirtschaft/waehrungsum-stellung-der-vergessene-vater-des-uro-a-175875.html

Smith M (2013) Conférence « La véridique histoire de l'arobase ». *YouTube* www.you-tube.com/watch?v=zZLWtvfSqCY

Smith RW (1979) The origin of the velocity–distance relation. *J. History Astron.* 10 133–164

Stamp J (2013a) Who really invented the smiley face? *Smithsonian.Com* www.smithsoni-anmag.com/arts-culture/who-really-invented-the-smiley-face-2058483/

Stamp J (2013b) The evolution of the treble clef. *Smithsonian.Com* www.smithsonian-mag.com/arts-culture/the-evolution-of-the-treble-clef-87122373/

Stephens LD, Barrett R (1979) A brief history of a "20th century danger sign". *Health Physics* 36 565–571

Strunk W, White EB (1999) *The Elements of Style*. 4th edn. Allyn and Bacon, Boston

Stughaug A (2002) *The Mathematician Sophus Lie*. Springer, Berlin

Tolkien JRR (1937) *The Hobbit*. George Allen & Unwin, London

Tolkien JRR (1954/55) *The Lord of the Rings*. George Allen & Unwin, London

Tolkien JRR (1977) *The Silmarillion*. George Allen & Unwin, London

Typefoundry (2013) Commercial at. http://typefoundry.blogspot.co.uk/2013/10/com-mercial-at_6.html

UKCS (2017) Copyright information. www.copyrightservice.co.uk/copyright/

University of Cambridge (n.d.) The riddle of the Syriac double dot: it's the worlds earliest question mark. www.cam.ac.uk/research/news/the-riddle-of-the-syriac-double-dot-it's-the-world's-earliest-question-mark

Vonnegut K (2005) *A Man Without a Country*. Seven Stories Press, New York

Ward's Book of Days (2006) *November 18th*. www.wardsbookofdays.com/18november.htm

Welcome to Portsmouth (2014) Star and crescent. www.welcometoportsmouth.co.uk/star%20and%20cresent.html

Westfall RS (1981) *Never at Rest: A Biography of Isaac Newton*. CUP, Cambridge

Whistler K (2000) *Re: Use of 213A*. http://unicode.org/mail-arch/unicode-ml/Ar-chives-Old/UML022/0891.html

Index

Printed in the United States
By Bookmasters